**타이포잔치 2023
국제 타이포그래피 비엔날레
《따옴표 열고 따옴표 닫고》**

초판 1쇄 발행
2023년 11월 15일

펴낸 곳
(주)안그라픽스
10881 경기도 파주시 회동길 125-15
전화. 031-955-7755
팩스. 031-955-7744
이메일. agbook@ag.co.kr
www.agbook.co.kr

ISBN 979-11-6823-042-2
03650

기획. 타이포잔치 2023 기획팀
편집. 박연주, 전유니
교열. 이정신
디자인. 프론트도어
번역. 서울리딩룸(박재용)
사진. 글림워커스
인쇄·제작. 세걸음

타이포잔치 2023 도록은 두성종이의
용지 후원을 받았습니다.
표지. 미세스비 화이트, 209g / m^2
내지. 비세븐 스노우, 83g / m^2

**Typojanchi 2023
International Typography Biennale —
Open Quotation Marks,
Close Quotation Marks**

First published in
November 15, 2023

Publishing House
Ahn Graphics
125-15 Hoedong-gil, Paju-si,
Gyeonggi-do 10881
Tel. 82-31-955-7755
Fax. 82-31-955-7744
Email. agbook@ag.co.kr
www.agbook.co.kr

ISBN 979-11-6823-042-2
03650

Concept by Typojanchi 2023
 Planning Team
Edited by PARK Yeounjoo,
 JEON Yuni
Copyedited by LEE Jeongsin
Designed by front-door
Translated by Seoul Reading
 Room (Jaeyong PARK)
Photography by gilmworkers
Printed and bound by
 Seguleum

Doosung Paper generously
sponsored paper for the
Typojanchi 2023 exhibition
catalog.
Cover. Mrs.B White, 209g / m^2
Inside. Be Seven Snow, 83g / m^2

TYPOJANCHI
타이포잔치

International Typography Biennale

문자 디자인의 매력과 가치를 보여 주는 타이포잔치 2023 국제 타이포그래피
비엔날레《따옴표 열고 따옴표 닫고》의 개최를 진심으로 축하드립니다.
흥미롭고 멋진 전시를 준비해 주신 유정미 국제 타이포그래피 비엔날레
조직위원장님과 박연주 예술 감독님을 비롯한 관계자분들, 훌륭한 작품으로
전시에 참여해 주신 작가분들께 감사를 드립니다.

2001년 처음 시작해 어느덧 8회를 맞은 국제 타이포그래피 비엔날레는
단순히 아름다운 활자의 전시를 넘어 예술의 한 영역으로 진화해 왔습니다.
우리 한글의 뛰어난 조형성을 바탕으로 세계 각국의 작가들과 협업하며,
전 세계 유일의 타이포그래피 비엔날레로 확고한 위상을 정립하였습니다.

이번 전시의 주제어는 '타이포그래피와 소리'입니다. 소리가 문자가 되고
문자가 소리가 되는 관계를 실험적으로 탐색하고 조명함으로써 관객들의
지적 호기심과 상상력을 자극할 것으로 확신합니다. 전시에 참여한 국내외
39명(팀)의 작가들은 탁월한 독창성과 감수성으로 시각과 청각이 교차하며
발생하는 현상들을 시각 예술, 문학, 공연 등 다채로운 형식으로 선보이며
타이포그래피의 지평을 확장할 것입니다.

이번 전시를 계기로 인류 최고의 발명품인 문자의 아름다움을
만끽하고 그 속에서 새로운 의미를 발견하시길 바랍니다. 나아가 전 세계인이
갈채를 보내는 K-컬처의 바탕인 한글의 경쟁력과 창의력이 세계 무대에서
더욱 주목받기를 바랍니다.

윤석열 정부의 국정 철학은 자유와 연대입니다. 자유 정신은 문화 예술에
창의력과 파격을 생산합니다. 연대 정신은 누구나 차별 없이 문화 예술을 누리는
공정을 보장합니다. 문화체육관광부는 이러한 자유와 연대의 정신으로
K-아트가 전 세계에서 꽃필 수 있도록 짜임새 있는 정책으로 뒷받침하겠습니다.

타이포잔치가 그래픽 디자이너들과 예술가들의 교류와 소통의 장으로
작동하고 나아가 K-컬처 신드롬을 이끌어 가는 세계적인 예술 축제로
더욱 발전하기를 기대합니다. 감사합니다.

문화체육관광부 장관
박보균

Congratulations on the opening of Typojanchi 2023: International Typography Biennale — Open Quotation Marks, Close Quotation Marks, an exhibition that showcases the beauty and value of typographic design. I would like to express my gratitude to the chairperson of the organizing committee of the International Typography Biennale, Yu Jeongmi, and the artistic director, Park Yeounjoo, for organizing this interesting and wonderful exhibition, and to the artists who participated in the exhibition with their wonderful works.

The International Typography Biennale is now in its eighth year since its inception in 2001 and has since evolved into an area of art that is more than just a display of beautiful typefaces. The biennial collaborated with artists from around the world and established itself as the world's only dedicated typography biennial, capitalizing on the formative power of the Korean alphabet, Hangeul.

The theme of this year's Biennale is "Typography and Sound." I am confident that this exhibition will stimulate the intellectual curiosity and imagination of the audience by experimentally exploring and illuminating the relationship between sounds becoming letters and letters becoming sounds. The thirty-nine participating teams from Korea and abroad will present the intersection of sight and sound in various forms, such as visual art, literature, and performance through their outstanding creativity and sensitivity, expanding the horizons of typography.

I hope this exhibition inspires you to appreciate the beauty of mankind's greatest invention, the written language, and to find new meanings in it. With this exhibition, I also hope that the competitiveness and creativity of Hangeul, the foundation of K-culture that people around the world love, will be highlighted on the global stage.

The YOON Suk Yeol Government's administrative philosophy is freedom and solidarity. A free spirit produces creativity and exceptional attempts in culture and arts. The spirit of solidarity ensures that everyone can enjoy culture and arts without discrimination. In this spirit of freedom and solidarity, the Ministry of Culture, Sports, and Tourism will support K-Art with comprehensive policies to help it blossom around the world.

I look forward to seeing Typojanchi 2023 serving as a place of exchange and communication between graphic designers and artists, and further developing into a global art festival leading the K-culture phenomenon. Thank you.

PARK Bo Gyoon
Minister of Culture, Sports and Tourism Republic of Korea

타이포그래피의 다양한 특성과 가능성을 탐색하고, 세계 각국의 그래픽 디자이너와 예술가의 교류를 도모하는 타이포잔치 2023 국제 타이포그래피 비엔날레《따옴표 열고 따옴표 닫고》의 성공적인 개최를 진심으로 축하합니다.

타이포그래피는 문자의 아름다움과 시각 문화의 창의성이 교차하는 예술의 한 영역입니다. 서로 다른 문자 문화가 가진 고유성과 독창성이 우리의 상상력을 자극하고, 감성과 감정을 전달합니다. 그러한 점에서 타이포잔치 2023은 그래픽 디자인과 타이포그래피 관계자들은 물론 시각 예술을 사랑하는 많은 분과 일반 관람객들에게 큰 감동과 영감을 선사할 것입니다.

올해 타이포잔치는 그 주제어를 '타이포그래피와 소리'로 정하고, 시각과 청각, 물질성과 신체성이 교차하며 만드는 다양한 현상을 조명합니다. 소리를 매개로 한 새로운 형식의 타이포그래피 실험들은 관람객의 호기심을 자극하고, 창의적인 장면들로 디자인 문화의 가치를 새삼 일깨울 것입니다.

타이포잔치는 2015년부터 매회 4만 명 이상의 관람객이 찾는 한국의 대표적인 국제 디자인 행사로, 이를 통해 디자인 관계자들뿐 아니라 국민들도 디자인을 일상 문화로 경험하고 누려 왔습니다. 이러한 성과는 그동안 많은 디자이너의 참여와 열정 위에 모든 분의 관심과 애정이 더해졌기에 가능한 결과입니다.

한국공예·디자인문화진흥원은 앞으로도 타이포잔치를 통해 타이포그래피의 역사와 현재를 조화롭게 발전시키는 데 이바지하고자 합니다. 타이포잔치 2023을 찾아 주신 모든 분께 감사의 말씀을 전하며, 한국 타이포그래피의 위상과 그 새로운 가능성을 마주하는 시간이 되시기를 바랍니다.

더불어 이번 전시를 위해 애쓰신 박연주 예술 감독님과 큐레이터, 코디네이터 여러분, 국제 타이포그래피비엔날레 조직위원회 유정미 위원장님과 각 위원님, 그리고 무엇보다 멋진 작품으로 전시에 참여해 주신 작가분들과 다양한 역할로 전시 개최에 힘써 주신 많은 분께 진심 어린 감사의 마음을 전합니다. 앞으로도 함께하는 여정을 기대하며, 미래 지향적인 비엔날레가 될 수 있도록 꾸준한 관심과 지지를 부탁드립니다. 고맙습니다.

(재)한국공예·디자인문화진흥원장
장동광

I would like to sincerely congratulate everyone on the successful opening of Typojanchi 2023: International Typography Biennale. This event explores the diverse qualities and possibilities of typography and promotes the exchange of graphic designers and artists from around the world.

Typography is an area of art where the beauty of letters and the creativity of visual culture intersect. The originality and uniqueness of different text cultures spark our imagination and convey emotions and feelings. In that respect, Typojanchi 2023 will appeal to and inspire more than just those involved in graphic design and typography, but also to many people who love the visual arts and the general public.

This year's Typojanchi is centered around the theme of "Typography and Sound," and explores the intersection of sight and sound, materiality and physicality. Experiments in new forms of typography with sound will inspire the audience's curiosity, and creative scenes will remind them of the value of design culture.

Typojanchi is South Korea's leading international design event, attracting more than 40,000 visitors every edition since 2015. With this event, not only design professionals but also the public have experienced and enjoyed design as an everyday culture. This accomplishment is the result of the involvement and passion of many designers, combined with everyone's care and love.

The Korea Craft & Design Foundation hopes to continue contributing to the harmonious development of the history and present of typography through Typojanchi. I would like to express my gratitude to all of the visitors to Typojanchi 2023 and hope that you enjoyed the opportunity to see the status of Korean typography and its new possibilities.

I also express my sincere gratitude to artistic director Park Yeounjoo and the planning team for their hard work on this exhibition, to Yu Jeongmi, chairperson of the Organizing Committee of International Typography Biennale, and each committee member. And most importantly, I would like to thank the thirty-nine teams who participated in the exhibition with their wonderful works, and the many people who worked in various roles to bring this exhibition to the public. I look forward to our journey together and thank you for your continued interest and support as we continue to build the Biennale for the future. Thank you.

CHANG Dong-kwang
President of Korea Craft & Design Foundation

타이포잔치 2023 국제 타이포그래피 비엔날레《따옴표 열고 따옴표 닫고》의 개최를 축하합니다. 타이포잔치는 타이포그래피의 다층적인 세계를 탐구하는 국제 행사이자 전 세계 그래픽 디자이너와 예술가가 함께하는 축제입니다. 특히 고유 문자 한글을 지닌 한국에서 세계적인 작가들이 모여 타이포그래피로 소통한다는 점에서 그 의미가 큽니다.

타이포잔치는 문자를 중심에 두고 시의성 있는 주제와 시각 예술을 결합하며 그 가치를 확장해 왔습니다. 2001년 '새로운 상상'이라는 화두로 처음 문을 연 이래 10년간 방향을 모색하다가 2011년 '동아시아의 불꽃'을 주제로 부활했습니다. 이후 2013년에는 '문학', 2015년에는 '도시', 2017년에는 '몸', 2019년에는 '사물'을 주제어로 선보였고, 팬데믹 시기였던 2021년에는 '생명'을 살폈습니다. 이렇듯 타이포잔치는 시대정신에 부합하는 개념을 타이포그래피의 관점에서 해석하고 반응하며 성장해 왔습니다.

타이포잔치 2023의 주제어는 '타이포그래피와 소리'입니다. 소리는 문자 이전에 말로 존재했습니다. 소리의 파동으로 감각을 자극하고 보이지 않는 움직임을 전달했습니다. 그런 의미에서 올해 전시 제목을《따옴표 열고 따옴표 닫고》로 풀고, 타이포그래피를 매개로 한 실험적인 관점에서 시각과 청각의 상호작용으로 만들어지는 다채로운 풍경에 주목했습니다.

전시 개최를 총괄해 온 박연주 예술 감독님, 큐레이터들과 사무국 여러분, 그리고 참여해 주신 작가분들의 노고에 깊은 감사를 전합니다.

국제 타이포그래피 비엔날레 조직위원장
유정미

I would like to congratulate everyone on the opening of Typojanchi 2023: International Typography Biennale. Typojanchi is an international festival that explores the multilayered world of typography and brings together graphic designers and artists from around the world. It is especially significant because it brings together some of the world's best artists to communicate through typography in Korea, a country with its own unique alphabet, Hangeul.

Typojanchi has been expanding its value by putting letters at the center and combining timely topics with visual art. The Biennale first opened in 2001 with the theme "New Imagination," and after a decade of searching for a direction, it was revived in 2011 with the theme "Fire Flower of East Asia." Since then, it has explored different topics: "literature" in 2013, "city" in 2015, "body" in 2017, "object" in 2019, and "life" in 2021 during the pandemic. As such, Typojanchi has evolved by interpreting and reacting to concepts in the Zeitgeist from a typographic perspective.

The theme of Typojanchi 2023 is "Typography and Sound." Sounds have existed in speech before letters. Sound waves stimulate the senses and convey invisible movements. In keeping with this idea, this year's exhibition is titled Open Quotation Marks, Close Quotation Marks. It focuses on the diverse landscapes created by the intersection of sight and sound in terms of experimentation and practice using typography as a medium.

I would like to thank artistic director Park Yeounjoo, the curators, the administration team, and the artists who participated in the exhibition.

YU Jeongmi
Chairperson of the Organizing Committee of
International Typography Biennale

타이포잔치 2023 국제 타이포그래피 비엔날레
따옴표 열—고 따옴표 닫/고

Typography 2023 International Typography Biennale
O-p-e-n Quotation Marks, C/l/o/s/e Quotation Marks

타이포잔치 2023 국제 타이포그래피 비엔날레 《따옴표 열고 따옴표 닫고》는 문자와 소리, 시각과 청각, 사물과 신체를 연결하고 실험과 실천을 촉발하는 타이포그래피에 주목합니다.

《따옴표 열고 따옴표 닫고》는 정체성과 권력의 맥락에서 음성 언어와 문자 언어의 충돌, 소거, 생성과 같은 언어의 틈새를 다룹니다.

《따옴표 열고 따옴표 닫고》는 시각과 청각을 상호 번역하거나 교차시켜 서로 다른 감각이 만드는 차이를 드러냅니다.

《따옴표 열고 따옴표 닫고》는 반복과 변화, 어긋남에서 문자와 소리에 담긴 리듬을 찾고 그 바탕에 자리한 노동과 공예성을 환기합니다.

《따옴표 열고 따옴표 닫고》는 기술과 매체를 활용해 선형적 질서를 뒤섞는 디지털 화음 또는 불협화음에 호응합니다.

《따옴표 열고 따옴표 닫고》는 시각 기호를 벗어난 구음과 움직임에서 즉흥성과 우연을 발견하고, 사물과 신체 사이에서 진동하는 타이포그래피의 활기를 나눕니다.

예술 감독
박연주

큐레이터
신해옥, 여혜진, 전유니

*
전시 제목에 쓴 "따옴표 열고" "따옴표 닫고"는 테레사 학경 차의 『딕테』(1982)에서 각각 인용, 번역했습니다. 이 제목은 곧 들려올 소리를 암시하고 읽힌 문자의 흔적을 내포합니다.

Typojanchi 2023: International Typography Biennale—
Open Quotation Marks, Close Quotation Marks focuses
on typography that connects letters and sounds, sight and
sound, objects and bodies, and sparks experimentation
and practice.

Open Quotation Marks, Close Quotation Marks addresses
linguistic interstices, such as the collision, erasure,
and creation of spoken and written language in the context
of identity and power.

Open Quotation Marks, Close Quotation Marks cross-
translates or intersects vision and hearing to reveal the
different senses' differences.

Open Quotation Marks, Close Quotation Marks finds the
rhythm of letters and sounds in repetition, change, and
dissonance, and recalls the labor and craft behind them.

Open Quotation Marks, Close Quotation Marks responds
to a digital chord, or dissonance, that utilizes technology
and media to disrupt linear order.

Open Quotation Marks, Close Quotation Marks finds
spontaneity and serendipity in sound and movement
outside of visual symbols, and shares the vitality of
typography that oscillates between objects and bodies.

PARK Yeounjoo
Artistic Director

JEON Yuni, SHIN Haeok, and YEO Hyejin
Curators

*
The phrases "open quotation marks" and "close
quotation marks" in the exhibition title are extracted
from Theresa Hak Kyung Cha's *DICTEE*. The title
alludes to the sounds we are about to hear and
the traces of the letters we have read.

이 LEE

Dun

이동언은 그래픽 디자인을
사고와 탐구의 도구로 활용하는
방법론에 관심이 많다. 그에게 그래픽
디자인은 기존 개념을 조합해
새로운 정의를 제안하고 예상치 못한
가능성을 찾는 사고의 도구이자
사람들이 어떻게 말하고, 듣고, 쓰고,
읽는지에 주목해 언어를 대하는
우리의 태도와 사용 방식을 관찰하는
탐구의 도구다.

Dun Lee is interested in
methodologies that use graphic
design as a tool for thinking
and inquiry. For Lee, graphic
design is a tool for thinking,
combining existing concepts
to propose new definitions
and find unexpected possibilities.
Lee also considers graphic
design as a tool for exploration,
observing our attitudes
toward language and how we
use it by paying attention to how
people speak, listen, write,
and read.

한국 서울 출생/네덜란드 암스테르담에서 활동

"(말을 시작하는 들숨) 이 작품은 사람들의 대화를 '말과 말 사이에 생기는 여백'과 '비언어적 소리'라는 두 가지 방향에서 관찰한다. 말의 여백은 대화에서 문장 부호의 흔적이 어떤 형태로 남아 있는지에 관한 이야기다. 우리는 말할 때 '잘 지내십니까 물음표', '네 잘 지냅니다 마침표', '어머나 세상에 느낌표 느낌표' 같은 식으로 문장 부호를 발음하지 않는다. 문장 부호 자체가 말의 흐름이나 억양 등 구술 언어의 특성을 문자로 표현하기 위해 고안한 것이니 문자가 소리가 될 때는 보통 그 역할이 사라진다.

흥미로운 것은, 때때로 이 문장 부호가 살아남아 말과 말 사이에 여백을 만든다는 점이다. 예를 들어, 영어를 제2외국어로 쓰는 사람들은 종종 모국어 문장을 머릿속에서 영어로 바꾸는 과정에서 문장 부호를 특정 단어로 대체한다. 일본인 Y는 말을 끝맺을 때마다 'something like that'이라고 말한다. 이 표현은 Y씨에게 마침표와 같다. 네덜란드인 A의 말에는 'let's say'라는 표현이 매우 자주 등장한다. 이것은 그에게 쉼표이자 다음 문장을 생각하려고 말을 잠시 멈출 때 쓰는 습관적인 접속사 같은 것이다.

〈의미 형성에 필요하지 않은 어떤 습관적 발성〉은 문장 부호가 대화의 여백을 어떤 방식으로 채우는지 살피며, 정적, 침묵, 공기, 기다림, 메아리 등 말의 여백이 가지는 다양한 존재 양식을 알아본다.

이 작품에는 영국의 낭만주의 시인 존 키츠가 나이팅게일의 노랫소리를 듣는 장면을 담은 조지프 세번의 그림이 등장한다. 이는 비언어적 소리,

이동언／Dun LEE

born in Seoul, South Korea / based in Amsterdam, Netherlands

"(Inhale to start speech) This work observes human conversation from two directions: 'the space between words and speech' and 'non-verbal sounds.' The margin of speech is about the form in which punctuation marks remain in a conversation. When we speak, we don't pronounce punctuation marks in sentences, like 'How are you a question mark,' 'Well, yes I'm fine period,' or 'Oh my god exclamation mark exclamation mark.' Since punctuation marks themselves are designed to express the characteristics of oral language, such as speech flow and intonation, their role is usually lost when letters become sounds.

Interestingly, these punctuation marks sometimes survive and create a space between words. For example, people who speak English as a second language often replace punctuation marks with certain words in the process of translating original sentences into English in their minds. A Japanese person Y says 'something like that' at the end of every sentence. For Y, this expression works like a period. The phrase 'let's say' appears very often in Dutch person A's speech. To him, it's a comma, a habitual conjunction he uses when pausing to think about his following sentence.

Any Verbal Habit That Is Non-essential to One's Meaning examines how punctuation fills the margins of conversation and explores the different modes of existence of the margins

즉 의미가 없거나 말에서 의미를 제거한 소리 자체에 주목해 그것이 다른
감각을 어떻게 자극하는지 살피고, 소리 있음 사이에서 소리 없음의 존재감을
부각한다. 관람객들이 입으로 내뱉는 소리와 숨에 담긴 공간감, 무게,
질감, 자극을 존 키츠의 시선으로 경험해 보기를 바란다. (말을 끝내는 날숨)"

의미 형성에 필요하지 않은
어떤 습관적 발성
2023년
단채널 비디오, 컬러, 사운드,
3분 7초

이동언／Dun LEE

of speech: static, silence, air, waiting, and echo.
 The work also features a painting by Joseph Severn that
depicts the English romantic poet John Keats listening to a
nightingale sing. It focuses on non-verbal sounds, i.e., sounds
that have no meaning or have meaning removed from speech,
and examines how they stimulate other senses, highlighting
the presence of soundlessness in the presence of sound. I want
the audience to experience the spatiality, weight, texture, and
stimulation of the sound of the mouth and the breath through
the eyes of John Keats. (Exhale to end speech)"

Any Verbal Habit That Is
Non-essential to One's
Meaning
2023
single-channel video, color,
sound, 3 min. 7 sec.

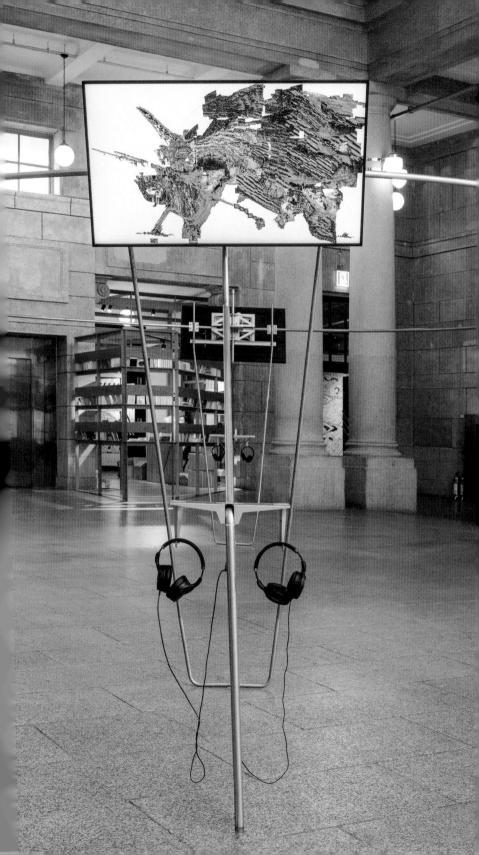

조효준은 2012년부터 서울에서
김대웅과 함께 디자인 스튜디오 겸 리소
인쇄소인 코우너스를 운영하고 있다.
센트럴 세인트 마틴스에서 그래픽
커뮤니케이션 디자인을 공부하고
서울시립대학교에서 시각 디자인으로
석사 학위를 받았다. 아이디어를 실제
사용할 수 있는 형태로 전환하는 데
관심을 두고 그래픽 디자인 작업과
리소 인쇄 워크숍을 병행하며, 기획부터
디자인, 제작까지 모든 단계를 스스로
수행하는 작업을 진행 중이다.

Jo Hyojoon has been running
a design studio and risography
printing house Corners in
Seoul with Kim Daewoong since
2012. Jo studied graphic
communication design at Central
Saint Martins and received a
master's degree in visual design
from the University of Seoul.
With an interest in turning ideas
into something that can be used
in the real world, he combines
his graphic design work with
risography printing workshops,
doing all the steps from planning
to design to production all by
himself.

Hyojoon

〈문자들: 쎘뾻긿〉은 조효준이 2022년 발표한 〈문자들〉을 타이포잔치 2023의 주제를 담아 재구성한 작품으로, 작가가 디자인한 가변 폰트 〈화이팅〉을 사용한다. 이 폰트는 세 개의 축(두께, 너비, 기울기)으로 구성되며, 두께 10에서 100픽셀, 너비 1,000에서 2,000픽셀, 기울기는 -45에서 45도 사이에서 사용자가 원하는 축을 설정할 수 있다. 〈문자들: 쎘뾻긿〉은 관람객이 직접 제어 장치를 움직여 〈화이팅〉의 세 축을 조절하며 화면에 표시되는 글자꼴을 원하는 형태로 바꿔 볼 수 있는 설치 작품이다.

　　작가가 〈문자들: 쎘뾻긿〉에 사용한 문자들은 어도비가 산돌커뮤니케이션과 함께 정한 한글 폰트 국제 규격 'Adobe-KR-9 캐릭터 컬렉션, 보충 0' 목록에서 탈락한 음절(8,392개) 중에서도 발음이 쉽사리 떠오르지 않는 것들이다. 즉, 한글 자모 조합으로 만들 수 있는 11,172개 음절 가운데 한글 폰트를 디자인할 때 권장하는 2,780개에서 빠진 음절들이다. 그런 만큼 '쎘', '뾻', '긿', '깺', '롱', '뒊', '삑', '솣' 같은 자모의 낯선 조합들은 눈에도 설고, 발음해 본 적도 드물다. 작가는 제어 장치를 활용해 이 생경한 문자들의 두께, 너비, 기울기를 바꿔 가면서 글자의 모양에 따라 소리의 뉘앙스가 달라지는 공감각을 경험하고, 현대 한글이 호명하지 않는 문자의 소리를 상상해 볼 제안한다.

　　조효준은 코우너스라는 팀 이름으로 참여한 타이포잔치 2015에서 〈사장님 화이팅〉이라는 레터링 작품으로 〈화이팅〉을 처음 선보였고, 2023년 말 상용 폰트로 출시할 예정이다.

조효준 / JO Hyojoon

Letters: 쎘뾻긿 is a recomposition of the artist's 2022 work *Letters*, recreated in accordance with the theme of Typojanchi 2023. The work is created using the variable font Fighting, which is designed by the artist. The font is composed of three axes (thickness, width, and slope), enabling its users to set parameters between 10 and 100 pixels in thickness, 1000 and 2000 pixels in width, and -45 to 45 degrees in slope. *Letters: 쎘뾻긿* is an installation that allows the audience to move the control device to adjust the three axes of the font Fighting, transforming the letters displayed on the screen into the desired shape.

　　The characters used by the artist in the work are syllables that don't come easily to mind for pronunciation, taken from the list of syllables (8,392) that have been removed from the list of "Adobe-KR-9 Character Collection, Supplement 0," which is the international standard for Hangeul fonts established by Adobe in collaboration with Sandol Communication. In other words, these are the syllables missing from the 2,780 choices recommended for designing Hangeul fonts out of the 11,172 syllables that can be made with Hangeul alphabet combinations. As a result, unfamiliar combinations of consonants like "쎘," "뾻," "긿," "깺," "롱," "뒊," "삑," and "솣" are rarely seen, let alone pronounced. The artist invites the audience to use a control device to change

문자들: 쎗뽈흹
2022–2023년
인터랙티브 설치, 가변 폰트를
적용한 인터랙티브 소프트웨어,
미디 컨트롤러, 모니터,
설치 약 170×123×98cm

협업
정효(인터랙티브 미디어 개발)

the thickness, width, and slope of these unfamiliar characters,
experiencing synesthesia in which the nuances of sound
change depending on the shape of the letters, and to imagine the
sounds of characters that modern Hangeul does not call out.

Fighting was first shown as part of a lettering work titled
Sajangnim Fighting at Typojanchi 2015, in which Jo participated
as a member of Corners. It will be released as a commercial
font in late 2023.

Letters: 쎗뽈흹
2022–2023
interactive installation,
interactive software
with variable font,
MIDI controller, monitor,
installation approx.
170×123×98cm

Collaboration with
Jeonghyo (interactive
media development)

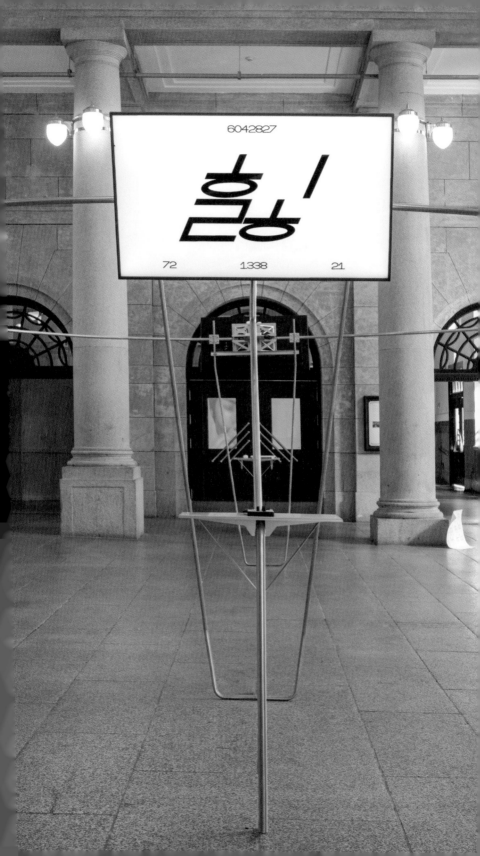

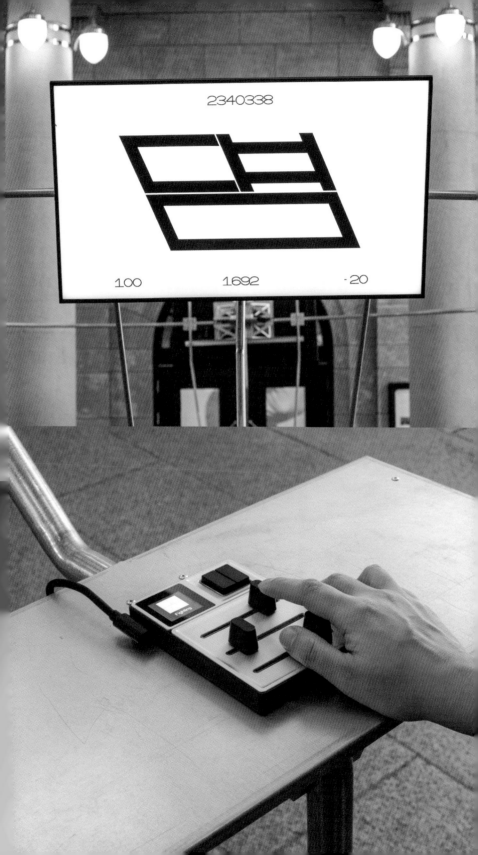

양으뜸은 서울에서 활동하는 그래픽 디자이너. 동아시아의 근현대 일상·대중·하위문화를 사랑하고 복잡한 무늬의 옷을 입고 단순명료한 논리와 형태로 디자인하기를 즐긴다. 그래픽 디자인과 코미디의 관계를 주제로 석사 학위를 받았고, 워크룸에서 실무 경험을 쌓았다. 디자인 스튜디오 콰칭을 운영하며 서울시립대학교에서 학생들을 가르친다.

YANG

양 으뜸

Eu
ddeum

Yang Euddeum is a graphic
designer based in Seoul.
She loves East Asian modern
and contemporary daily life,
pop culture, and subcultures,
and enjoys wearing intricately
patterned clothes and designing
with simple logic and form.
She acquired her master's
degree with a thesis on the
relationship between graphic
design and comedy, and built
her professional experience at
a design studio Workroom.
She runs her own design studio,
KWACHING, and teaches at
the University of Seoul.

〈렉처 디자인〉은 유튜브에서 영어권 화자가 진행하는 디자인 강의를 자동 번역 기능을 사용해 시청할 때 발견되는 한국어 자막 오류를 모티프로 한다. 자동 번역은 종종 두 언어의 어순 차이나 단어의 중의적 의미 등을 이유로 오역을 생성하는데, 잘못 번역된 그 문장들은 얼핏 보면 영감을 불러일으키는 아포리즘이나 선언문의 일부처럼 보이기도 한다.

　〈렉처 디자인〉은 오역된 한글 자막을 수집하고 선별해 재구성한 한 편의 강의 영상과 같은 이름의 책으로 구성돼 있다. 양으뜸은 자동 번역 기능이 만드는 예상치 못한 맥락이나 기묘한 뉘앙스를 창작 도구로 삼아 디자이너의 태도와 디자인을 둘러싼 세계를 오류적 시선으로 제시한다. 더불어, 소리를 문자로, 문자를 다시 소리와 이미지 변환하는 과정에서 인공지능의 등장으로 달라진 창작 환경을 언어라는 소재로 실험하며 그 가능성과 한계를 탐색한다.

양으뜸／YANG Euddeum

Lecture Design takes its motif from Korean subtitle errors found in design lectures by English-speaking speakers on YouTube when translated using the automatic translation feature. Automatic translation often produces mistranslations due to word order differences between the two languages or the double entendres of words. At first glance, the mistranslated sentences seem like inspirational aphorisms or manifestos.

　Lecture Design consists of a lecture video that collects and reconstructs mistranslated Korean subtitles and a book of the same name. Using the unexpected context and odd nuances created by automatic translation as a creative tool, Yang presents the designer's attitude and the world surrounding the design through a gaze open to errors. In addition, she experiments with language as a material to explore the creative environment that has changed with the advent of artificial intelligence in converting sound into text and text into sound and image, exploring its possibilities and limitations.

렉처 디자인
2023년
단채널 비디오, 컬러, 사운드,
7분 1초, 단행본(양으뜸,
『렉처 디자인』, 2023년,
종이에 오프셋 인쇄, 무선철,
14.8×10.5 cm, 192쪽)

협업
유튜브 자동 자막(스크립트
영한 번역), 파파고·구글
번역(스크립트 한영 번역),
DALL·E 2(스크립트 이미지
생성, 영상 오프닝 타이틀
디자인), 어도비 포토샵
베타(스크립트 이미지 확장),
미드저니(영상 오프닝
이미지 생성), 파파고(목소리),
김을지로(영상 디자인)

양으뜸／YANG Euddeum

Lecture Design
2023
single-channel video, color,
sound, 7 min. 1 sec., book
(YANG, E., *Lecture Design*,
2023, offset print on paper,
perfect binding,
14.8×10.5 cm, 192 pages)

Collaboration with
YouTube automatic
captions (script
English-Korean
translation), Papago
and Google translate
(script Korean-English
Translation), DALL·E 2
(script image generation
and video opening title
design), Adobe Photoshop
beta (script image
enhancement), Midjourney
(video opening image
generation), Papago
(voice), and Uljiro KIM
(video design)

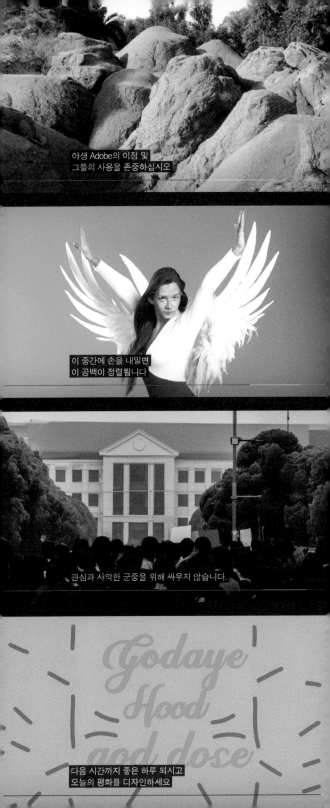

야생 Adobe의 이점 및
그들의 사용을 존중하십시오

이 중간에 손을 내밀면
이 공백이 정렬됩니다

관심과 사악한 군중을 위해 싸우지 않습니다.

Godaye
Hood
god dose

다음 시간까지 좋은 하루 되시고
오늘의 평화를 디자인하세요

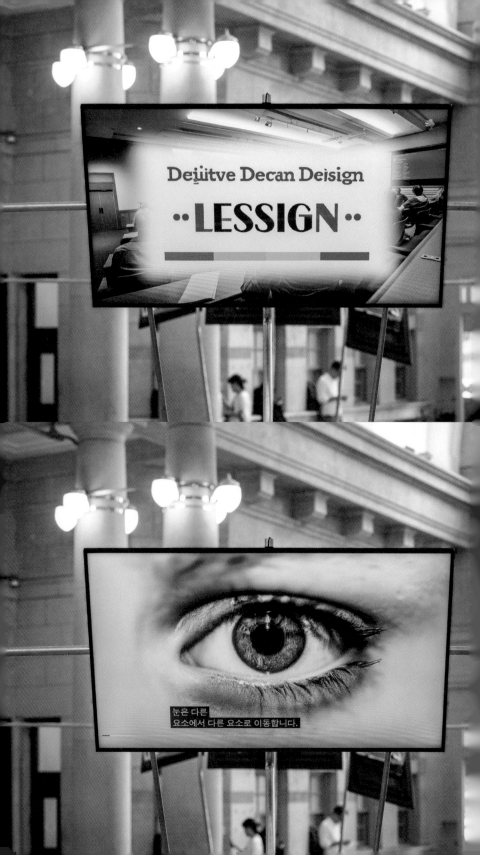

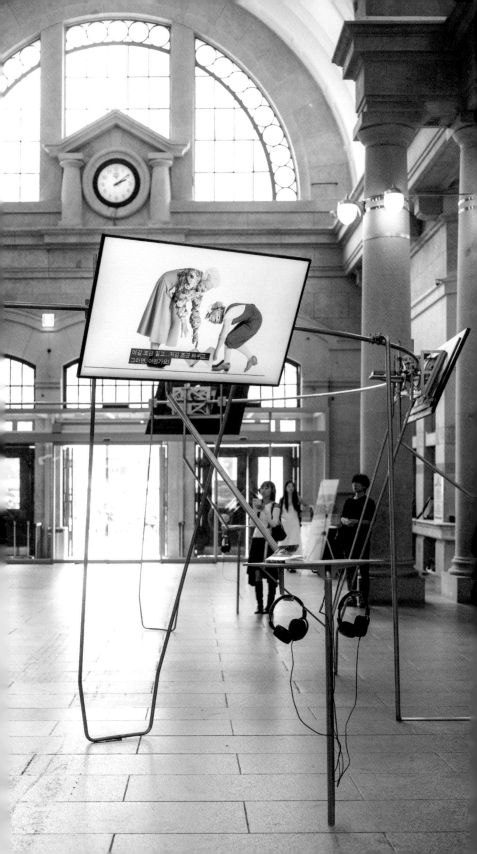

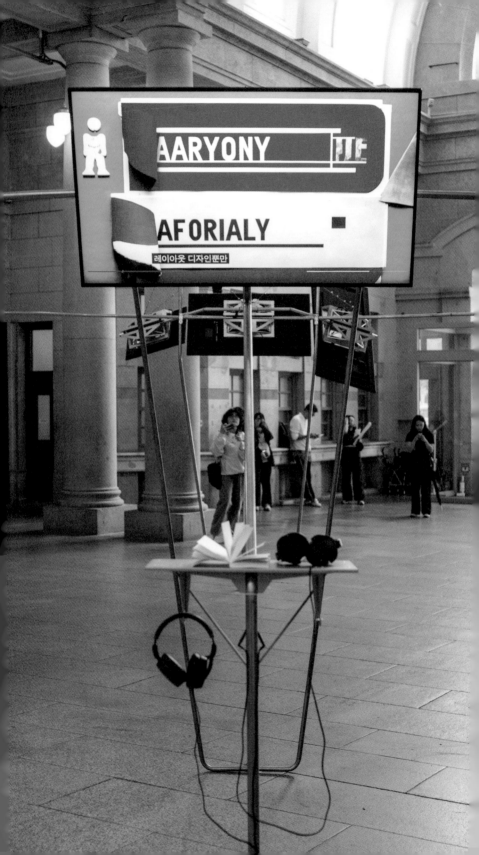

새로운 질서 그 후

새로운 질서 그 후는 웹의 기본 정신인 개방, 공유, 참여를 가치 있게 여기며 오늘날 웹에서 일어나는 현상을 탐구하는 실천적 공동체다. 사용자 자율성, 웹 접근성, 플랫폼과 같은 이슈에 관심을 두고 이에 관한 의문과 실천을 웹 사이트, 설치, 워크숍, 출판 등의 방식으로 선보인다. 국립현대미술관의 모든 소장품(7,585점, 2021년 기준) 이미지에 대체 텍스트를 직접 작성해 〈국립대체미술관〉을 제작한 바 있고 국내외 미술관 소장품의 개방형 정보 열람 이미지를 대체 텍스트로 선보이는 〈대체 미술관〉을 운영한다.

After New order

After New Order is a collective of practices exploring what is happening on today's web, emphasizing the web's fundamental ethos of openness, sharing, and participation. They are interested in user agency, web accessibility, and platforms and present their questions and practices through websites, installations, workshops, and publications. They have created the *Alt MMCA* by writing alt texts for all the images of the National Museum of Modern and Contemporary Art's collections (7,585 items as of 2021). They also operate the *Alt Museum*, which presents open-access images of domestic and international museum collections with alt text.

윤충근·이지수
한국 서울 출생/한국 서울에서 활동

새로운 질서 그 후는 타이포잔치 2023 웹 사이트에 게시할 모든 이미지의
대체 텍스트를 작성하고 이를 웹 사이트에 적용할 것을 제안한다. 대체 텍스트는
온라인상의 이미지를 묘사하는 글로, 컴퓨터 화면 낭독 소프트웨어인 스크린
리더를 쓰는 시각 장애인이 온라인에서 이미지를 파악할 때 사용한다. 대체
텍스트는 비장애인이 마주하는 웹 사용자 환경에서는 시각적으로 드러나지 않기
때문에, 웹 사이트 제작 시 그 역할이나 필요성을 인지하지 못해 대체 텍스트
입력을 간과하는 경우가 많다.

〈이미지 듣기〉는 이미지를 문자로, 문자를 다시 소리로 전환하는
과정을 통해 시각 이외의 감각으로 웹을 경험하는 사용자의 존재를 상기하며
오늘날 웹이 모두에게 평등한 공간인지 묻는다.

이소현
한국 서울 출생/독일 라이프치히에서 활동

새로운 질서 그 후／After New Order

YOON Choong-geun and LEE Jisu
born in Seoul, South Korea/
based in Seoul, South Korea

After New Order proposes to create alt text for all images to be
published on the Typojanchi 2023 website and implement it
on the website. Alt text describes an image online and is used
to help visually impaired people who use screen readers
understand images online. Because alt text is not visually present
in user interfaces experienced by people without impairments,
it is difficult to recognize its role or need, which is why it is often
overlooked when developing websites.

Through the process of converting images into text and text
into sound, *Listening to Images* reminds us of the existence of
users who experience the web with senses other than sight, and
asks whether today's web is an equal space for all.

LEE Sohyeon
born in Seoul, South Korea/
based in Leipzig, Germany

이미지 듣기
2023년
웹 사이트,
타이포잔치 2023 웹 사이트의
모든 이미지에 관한
대체 텍스트

새로운 질서 그 후 / After New Order

Listening to Images
2023
website, alt text for
all images to be published
on the Typojanchi 2023
website

대체 텍스트

형광 주황색, 노란색, 검은색 등으로 이루어진 요소들이 복잡하게 중첩되어있는 픽셀화된 그래픽이다. 화면은 불분명한 형상들로 빽빽하게 가득 채워져 있다. 흰색 점선으로 이루어진 파도와 같은 형태가 화면 가운데에서 오른쪽까지 있다. 전체적인 인상이 역동적이다.

형광 주황색, 노란색, 검은색 등으로 이루어진 요소들이 복잡하게 중첩되어 있는 픽셀화된 그래픽이다. 화면은 불분명한 형상들로 빽빽하게 가득 채워져 있다. 흰색 점선으로 이루어진 파도와 같은 형태가 화면 가운데에서 오른쪽까지 있다. 전체적인 인상이 역동적이다.

형광 주황색, 노란색, 검은색 등으로 이루어진 픽셀화된 그래픽이다. 픽셀이 반복해 층을 이루고 뾰족한 덩어리를 만든다. 덩어리는 흰색 화면의 대부분을 차지한다.

형광 주황색, 노란색, 검은색 등으로 이루어진 픽셀화된 그래픽이다. 픽셀들이 반복해 층을 이루고 뾰족한 덩어리를 만든다. 덩어리는 흰색 화면의 대부분을 차지한다.

한글 음절 '봷'이 검고 가는 획으로 흰 배경 한가운데 쓰여 있다. 글자의 꼴은 정사각형이다. 획은 모두 직선이고 굵기가 일정하며 두 선이 맞닿을 때 직교한다. 개별 자음과 모음의 너비가 같다.

한글 음절 '봷'이 검고 가는 획으로 흰 배경 한가운데 쓰여 있다. 글자의 꼴은 가로가 긴 직사각형이다. 직사각형의 너비는 높이의 두 배이다. 획은 모두 직선이고 굵기가 일정하며 두 선이 맞닿을 때 직교한다. 개별 자음과 모음의 너비가 같다.

한글 음절 '봷'이 검고 가는 획으로 흰 배경 한가운데 쓰여 있다. 글자는 오른쪽으로 45도 기울어져 있다. 획은 모두 직선이고 굵기가 일정하다. 개별 자음과 모음의 너비가 같다.

한글 음절 '봷'이 검고 가는 획으로 흰 배경 한가운데 쓰여 있다. 글자는 왼쪽으로 45도 기울어져 있다. 획은 모두 직선이고 굵기가 일정하다. 개별 자음과 모음의 너비가 같다.

한글 음절 '봷'이 검고 가는 획으로 흰 배경 한가운데 쓰여 있다. 글자는 오른쪽으로 45도 기울어져 있고 너비는 높이의 두 배이다. 획은 모두 직선이고 굵기가 일정하다. 개별 자음과 모음의 너비가 같다.

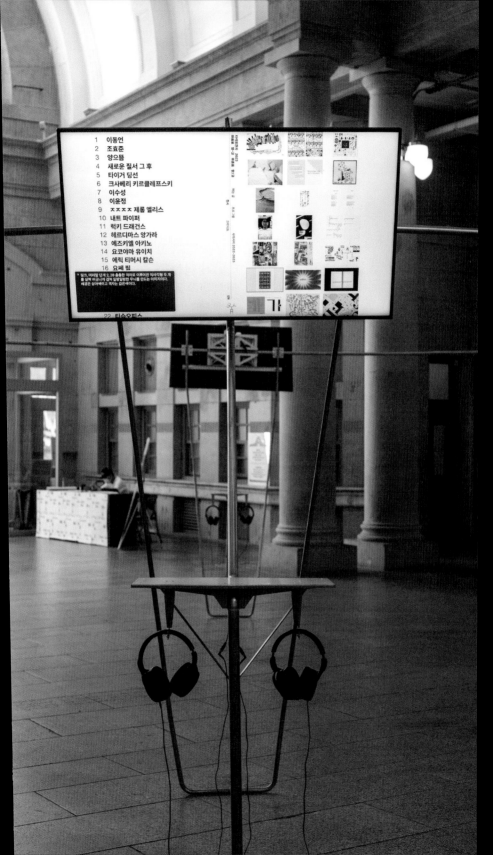

✕ 링크, 머리말 단계 2, 21 왼쪽에는 텔루구 알파벳, 오른쪽에는 라틴 알파벳으로 쓰인 글이 있는 책의 펼침면이다. 각 페이지의 맨 위에는 큰 글씨가 한 줄씩 있고 그 아래에 일고여덜 줄의 두 단락이 있다.

타이거 딩선은 소프트웨어
엔지니어 겸 그래픽 디자이너이자
틱톡 이론가다. 브라운 대학교에서
컴퓨터 과학을, 로드아일랜드
디자인 대학교에서 그래픽 디자인을
공부했다. 주로 시 문학, 웹 기술,
디지털 미디어 문화의 교차점에서
언어를 탐구하는 창작 활동을 선보이며,
웹 사이트로 개인 작업과 대중 참여
작업을 꾸준히 공유해 왔다.

타이 거

DING

Tiger Dingsun is a software
engineer, graphic designer,
and TikTok theorist. Dingsun
studied computer science
at Brown University and graphic
design at the Rhode Island
College of Design. His creative
practice primarily explores
language at the intersection
of poetry literature, web
technology, and digital media
culture, and he consistently
shares his personal and
participatory work on his
website.

Tiger

딩 선

SUN

"나는 탄 린의 '환경에 스며든 문학'이라는 개념을 좋아한다. 이 개념은 문학을
거의 '벽지'처럼 여기고, 특히 학술 환경에서 흔히 강조하는 '자세히 읽기'보다는
일상에서 일시적으로 마주하는 것들을 얕게 읽는 것을 특권으로 여긴다.
기고자들에게 받은 텍스트가 '순서 없이' 배열되거나 동시에 여러 다른 방식으로
제시될 때 어떤 일이 일어나는지 궁금했다. 여기서 강조점은 미리 규정된 특정한
의미를 얻기 위해 텍스트를 읽는 것에서 텍스트에 관해 더 일반화되고
다양한 미적 감각을 획득하는 것으로 이동한다."

기고받은 글을 재배열하며 새로운 의미를 생성하는 〈리딩 머신〉과
웹에 특화된 읽기 형식을 실험하는 열여덟 개의 웹 사이트 시리즈인
〈똑같은 이미지는 절대 보고 싶지 않아!〉는 모두 '비목적론적 독해'를 유도하는
웹 플랫폼이다. 타이거 딩선은 소설의 형식적 한계를 뛰어넘는 실험 문학
작품들*에서 받은 영감을 웹에 접목하고, 웹 환경이 제공하는 행동 유도성을
최대한 활용해 인쇄 매체로 구현할 수 없는 비선형적이고 동적이며
쌍방향으로 기능하는 낯선 방식의 읽기를 제안한다.

딩선은 이런 작업의 배경으로 "언어에 따른 공간 은유 방식의 다름"을
꼽는다. "예를 들어 중국어는 시간의 선후를 공간에서 '위아래'로 생각한다.
과거는 위쪽이고 미래는 아래쪽이다. 반면 영어는 과거를 뒤쪽에, 미래를
앞쪽에 둔다. 단어나 개념을 공간에 배열하는 방법은 다양하며 가장 '자연스러워
보이는' 공간 배열조차 문화에 따라 상대적일 수 있다."

타이거 딩선 / Tiger DINGSUN

"I like Tan Lin's concept of 'ambient literature,' which treats
literature almost as' wallpaper' and privileges the shallow read
of temporary daily ephemera rather than the 'close read' typically
emphasized, especially in academic settings. I was interested
in what happened when the texts I received from contributors were
arranged 'out of order' or presented in multiple different ways
at the same time. The emphasis shifts from reading the text to gain
some specific predetermined meaning to gleaning a more
generalized and varied aesthetic sense of the text."

Reading Machines, which rearranges contributed texts
to create new meanings, and *I Never Want to See the Same Image
Twice*, a series of eighteen websites that experiment with
web-specific reading formats, are both web platforms that
encourage "non-teleological reading." Inspired by experimental
literature* that pushes the formal boundaries of the novel,
Tiger Dingsun brings the web to life and takes full advantage of
the affordances of the web environment to propose an unfamiliar
way of reading that is non-linear, dynamic, interactive, and
impossible to achieve in print media.

Dingsun attributes the background of this work to "differences
in spatial metaphors across languages. For example, the Chinese
think of time as 'up and down' in space. The past is

작가는 글을 재구성한 후에도 원문의 주제와 분위기를 유지할 수 있는 핵심 '단위'를 찾고("문단이나 문장 수준에서 글의 연속성을 유지할지, 아니면 단어나 낱글자 단위로 섞는 게 더 합리적일지"), 생성 프로그램으로 이를 무작위로 배열, 재배열하며 글과 유희적인 관계를 맺는다. 게임 음악 같은 음향을 활용해 단어가 움직일 때마다 그 생성적 특성을 강조하며 '살아 있는' 듯한 느낌을 연출하고, 단어의 의미뿐 아니라 소리, 음운, 모양, 색 등의 시청각 요소나 상징도 읽기 대상에 포함해 콘텐츠에 시적 감각을 불어넣으며 새로운 서사 만들기를 시도한다. 웹에 기반한 타이거 딩선의 비목적론적 독해는 다중성, 모순, 자의성에 주목해 읽기의 본질을 탐색하며 타이포그래피나 그래픽 디자인이 매끄럽고 총체적이며 단일한 해석을 요구하는 체제의 도구로 기능하는 데 저항한다.

*
마크 Z. 다니엘레프스키가 쓴 소설 『나뭇잎의 집』, 훌리오 코르타자르의 『사방치기』, 테레사 학경 차의 『딕테』, 특히 탄린의 작품으로는 『Blipsoak_01』과 『일곱 개의 통제된 어휘』 등이 있다.

타이거 딩선／Tiger DINGSUN

up and the future is down. In English, on the other hand, the past is put at the back and the future at the front. There are many ways to arrange words or concepts in space; even the most 'natural' spatial arrangements can be relative to culture."

The artist looks for key "units" that can retain the theme and tone of the original text even after reorganization ("whether to keep the continuity of the text at the paragraph or sentence level, or does it make more sense to shuffle it around word by word"), and the generative program randomizes and rearranges them to play with the text. He uses sound, which resembles game music, to emphasize the generative nature of words as they move, making them feel "alive," and he includes not only the meaning of words, but also audiovisual elements and symbols such as sounds, phonology, shapes, and colors in his readings to bring a sense of poetry to the content and create a new narrative. Tiger Dingsun's web-based non-teleological reading explores the nature of reading by attending to multiplicity, contradiction, and arbitrariness, and resists typography or graphic design's function as a tool of a regime that demands a smooth, holistic, and singular interpretation.

리딩 머신
2020년 – 진행 중
인터랙티브 소프트웨어, 사운드

글 제공
S.B., 사일러스 첸, 리비 마르스,
테이아 플린, 호르헤
팔라시오스, 리비 헤이스,
그레타 황 스카거린드,
저스틴 응우옌응우옌,
단닝 니우, 알리 딥,
아유시 코와라, 원 주앙,
에마 켐프, 폴 부이그,
자이나브 알류, 해나 조이스,
라라 칼레치크

조언
폴 술러리스

**똑같은 이미지는
절대 보고 싶지 않아!**
2019년
열여덟 개의 웹 사이트

*

House of Leaves by Mark Z. Danielewski, *Hopscotch*
by Julio Cortázar, *DICTEE* by Theresa Hak Kyung Cha, and
especially works by Tan Lin such as *Blipsoak_01* and
Seven Controlled Vocabularies.

Reading Machines
2020 – ongoing
interactive software, sound

Contributors
S.B., Silas CHEN,
Libby MARRS,
Theia FLYNN,
Jorge PALACIOS,
Liby HAYS, Greta
HUANG SKAGERLIND,
Justine NGUYEN-NGUYEN,
Danning NIU, Ali DIPP,
Aayushi KHOWALA,
Wen ZHUANG,
Emma KEMP, Paul
BOUIGUE, Zainab
ALLYU, Hannah JOYCE,
and Lara KALECIK

Advisor
Paul SOULELLIS

*I Never Want to See
the Same Image Twice*
2019
series of eighteen websites

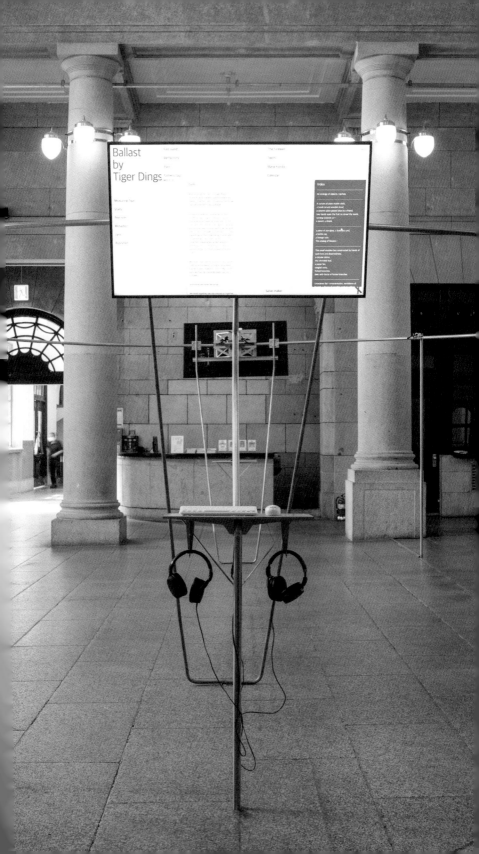

American Drift:

There

	bezier sweetheart's coordinates, colors and personality,		
32	were all stored neatly (for safety reasons, too) in a drawer of the cabinet, under G.	Was pulled out when sweetheart was reported missing (hadn't been seen in days).	<sig>
<sig>	33	Sweetheart was found, pale and frail, floating about in space.	No one, to this day, can explain how or why this ever happened, not even sweetheart.

* The "I" that I encounter when I am
alone I walk alone down the hill,
snow everywhere, blinding I close
my eyes I feel weighted, like ston
es in my pocket, I almost stop an
d never continue walking again I
experience totalizing inertia The
"I" that is the desir ing subje

ex-graph
by Tiger Dingsun

GUSHGUSHGUSH
by Emma Kemp

the distance between anything at all and the center
by Hannah Joyce

nd, characteristically, whatever cure there is

cannot be hurried along ...

4 am. I'm keeping my paper lamp on later than I should be. Pursuing an unusual trajectory of time, of wakeness. I synced my body

키 사

베 리

KIRKLEWSKI

Ksawery

Ksawery Kirklewski is a creative coding artist. He graduated from the Graphic Department of the Academy of Fine Arts in Gdańsk. His diploma, "Exhibition of Banners" (2015), received the Minister of Culture Award for "Best Diplomas of Polish Academies of Fine Arts" in 2015. Author of interactive installations, generative animations, music videos, phygital sculptures, and realizations in public space. He uses new technologies, programming, advertising media, and TV equipment, focusing mostly on the generative and net art field. His most recent projects include: interactive light installations *FLUX* (Miami Art Week, Miami, 2023), *ENTER 2023* (Khroma Museum, Berlin, 2023), *ENTER 2022* (commissioned by Nxt Museum, Amsterdam, 2022), a generative music website Symphony in Acid in collaboration with Max Cooper, and series of phygital sculptures *CTRL_DAT* (commissioned by Kate Vass Galerie, Zurich, 2022).

크사베리 키르클레프스키는 크리에이티브 코딩 예술가다. 폴란드의 그단스크 미술 아카데미 그래픽 학과를 졸업했고, 졸업 작품인 〈배너 전시회〉(2015)는 폴란드 미술 아카데미 최우수 졸업 작품으로 문화부 장관상을 받았다. 인터랙티브 설치, 생성형 애니메이션, 뮤직 비디오, 피지털 조각, 공공 공간에서 구현되는 작품을 만들어 왔다. 주로 생성형 미술과 넷 아트 분야에 집중하며 이를 위해 신기술, 프로그래밍, 광고 매체와 텔레비전 장비를 활용한다. 가장 최근 프로젝트로는 인터랙티브 조명 설치 작업인 〈FLUX〉(마이애미 아트 워크, 마이애미, 2023), 〈ENTER 2023〉(크로마 뮤지엄, 베를린, 2023), 〈ENTER 2022〉 (Nxt 뮤지엄 커미션, 암스테르담, 2022), 막스 쿠퍼와 협업한 생성형 음악 웹 사이트 「Symphony in Acid」, 피지털 조각 연작 CTRL_DAT〉(케이트 바스 갤러리, 취리히, 2022) 등이 있다.

키 러

클

프 스 키

폴란드 그단스크 출생/폴란드 그단스크에서 활동

"엘이디 스크린은 광고판이며, 필요에 따라 발명되고 거기에 완전히 종속된 미디어 디스플레이로, 우리를 파고들어 행동을 유발하게 만드는 설득과 관계돼 있다. 구매하고, 보고, 부르라는 이야기다. 우리는 광고에 길들어 있고 광고의 표현 방식과 공격적인 언어, 커뮤니케이션 속도에 익숙하다. 만약 누군가가 사회 친화적인 아이디어를 공유하기 위해 이 매체를 사용한다면 어떻게 될까?"

크사베리 키르클레프스키는 이 아이디어를 실행하기 위해 폴란드 그단스크 도심의 몇몇 엘이디 전광판 소유주를 설득해 다섯 개의 대형 화면에서 비상업적인 애니메이션을 17,000회 송출했다. 이후에는 시내버스 총 170대에 설치된 디스플레이에서 같은 작품을 재생했다.

이번 전시에서는 기존 작품을 재구성하고 새 작품을 더해 세 개의 화면으로 〈배너들〉을 선보인다. 느리게 껌벅거리는 눈동자, 이와 반대로 화면 속을 빠르게 뛰어다니는 글자, 점멸하는 "NEED TO HAVE", 움직이는 모래시계, 초시계, 하염없이 이어지는 라틴 알파벳 쓰기 등 열한 개의 애니메이션은 음향을 포함하지 않지만 분절, 반복, 움직임 등 청각적 상상을 자극하는 시각 요소로 작가의 의도를 강조하며 공감각을 불러일으킨다.

크사베리 키르클레프스키／Ksawery KIRKLEWSKI

born in Gdańsk, Poland / based in Gdańsk, Poland

"An LED screen is an advertisement—a media display invented for its needs and completely subordinated to it, associated with invasive persuasion call-to-action: buy, see, call. We are doomed to advertising and are used to its forms of presentation, aggressive language, and communication speed. What if someone used this medium to share pro-social ideas?"

To put this idea into action, Ksawery Kirklewski convinced the owners of several LED billboards in the center of Gdańsk, Poland, to broadcast the non-commercial animation 17,000 times on five large screens. The same artwork was then played on displays on 170 city buses.

In this exhibition, the artist reorganizes existing works and adds new ones to present *Banners* on three screens. Eleven animations are shown, including a slow dilated pupil, a letter jumping across the screen, a flashing "NEED TO HAVE," a moving hourglass, a second-hand clock, and the writing of the Latin alphabet. These animations do not contain sound, but they evoke a sense of empathy, emphasizing the artist's intention through visual elements that stimulate the auditory imagination: segmentation, repetition, and movement.

배너들
2015 / 2023년
3채널 비디오, 흑백, 무음,
애니메이션 11편 (세트),
22분 47초, 반복 재생

Banners
2015 / 2023
three-channel video,
black and white, silent,
set of eleven animations,
22 min. 47 sec., looped

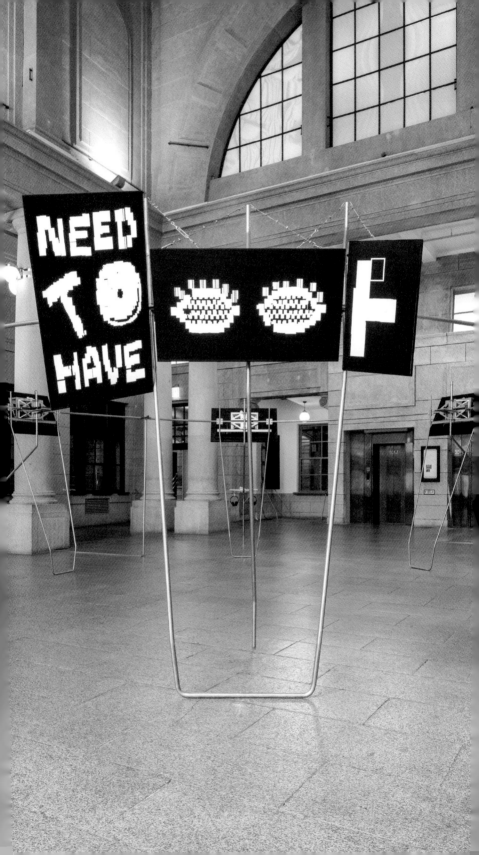

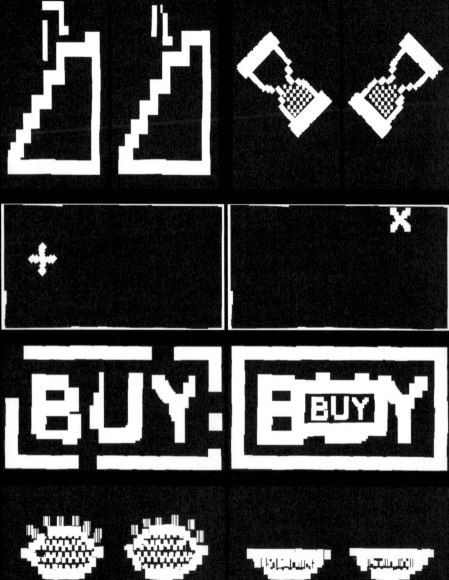

NEED NEED
TO TO
HAVE HAVE

refresh

refresh

LEE

이

이수성은 중학생 때 애니메이션을 보며
성우나 애니메이터를 꿈꿨다.
대학에서는 회화를 공부하고, 설치 조각
작업을 선보이거나 공간 디자이너로
활동했다. 서른 중반이 되어 다시 성우의
꿈을 이루기 위해 공부 중이다.

Lee Soosung dreamed of
becoming a voice actor or
animation artist when he
watched anime in middle school.
In college, he studied painting
and creating installations
and sculptures while working
as a space designer. Now
in his mid-thirties, he is training
himself to fulfill the dream
of becoming a voice actor
once again.

Soo

수성

sung

"성우라는 직업은 흔히 '천의 목소리'로 표현되지만, 실제 한 사람의 성우가
낼 수 있는 목소리는 많아도 손으로 다 꼽을 수 있는 정도다. 다만, 인물의 나이나
성격, 신체 조건, 정서 등에 따라 호흡, 말투, 억양, 표정, 입의 크기 등을
달리하면서 목소리에 각 인물의 개성을 담으려고 한다."
　〈100 포스터 100 목소리〉는 제24회 전주국제영화제 연계 전시
《100 필름 100 포스터》에 출품된 100개의 포스터에 목소리를 붙인 작품이다.
이수성은 성우의 일을 "듣는 이의 머릿속에 그림을 그리는 작업이자
납작하게 누운 활자를 일으켜 세워 살아 움직이게 하는 일"이라고 말하며
이 작품에서는 포스터 디자인을 대본으로 삼는다. 작가는 디자이너가 포스터에
사용한 활자체, 사진, 색, 조판 특성 등 여러 시각 요소에서 영화의 분위기를
직관적으로 파악하고, 이를 반영해 100개의 영화 제목을 낭독하는 방식으로
시각 이미지가 만드는 청각성을 목소리로 구체화한다.

이수성／LEE Soosung

"The profession of voice actor is often described as a job of
making 'a thousand voices.' But in reality, there are only so many
voices a single voice actor can do, and you can count them
with your fingers. However, I try to capture the personality of
each character in my voice by varying the breathing, speech
patterns, intonation, facial expressions, mouth size, etc., according
to their age, personality, physical condition, and emotions."
　100 Posters 100 Voices is a work that gives voice to 100
posters from the 24th Jeonju International Film Festival's
poster exhibition project 100 Films 100 Posters. Lee Soosung
considers the work of a voice actor to be "painting a picture
in the listener's mind, lifting up a flat piece of type and making it
come alive." In this work, he uses poster design as his script.
The artist intuitively grasps the film's mood from the various visual
elements that the designer used in the poster, such as the
typeface, photography, color, and typesetting characteristics.
He reflects on this by reciting a hundred movie titles to
embody the audibility of the visual image through his voice.

100 포스터 100 목소리
2023년
단채널 비디오, 컬러, 사운드,
33분 20초

포스터 이미지 제공
《100 Films 100 Posters》
참여 디자이너 100인

이수성／LEE Soosung

100 Posters 100 Voices
2023
single-channel video, color,
sound,
33 min. 20 sec.

Courtesy
100 designers participating
in 100 Films 100 Posters

JEONJU
intl. film festival

프로젝트 파트너
이 작품은 타이포잔치 2023과
《100 필름 100 포스터》의
공동 프로젝트로
전주국제영화제에서
제작 지원을 받았습니다.

100 필름 100 포스터
주최. 전주국제영화제
　　　조직위원회
주관.『그래픽』
큐레이터. 포뮬러
　　　(채희준·신건모)
100films100posters.com

Project Partner
This work was conceive
as a joint project betwe
Typojanchi 2023 and
100 Films 100 Posters,
support from the Jeonj
International Film Fest

100 Films 100 Posters
hosted by JEONJU
　　　International Film
　　　Festival
organized by *GRAPHIC*
curated by FORMULA
　　　(CHAE Heejoon a
　　　SYN Gunmo)
100films100posters.cc

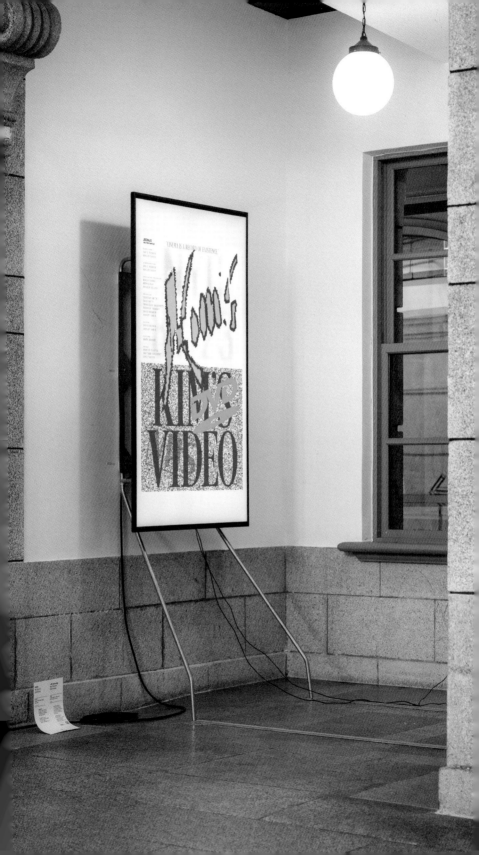

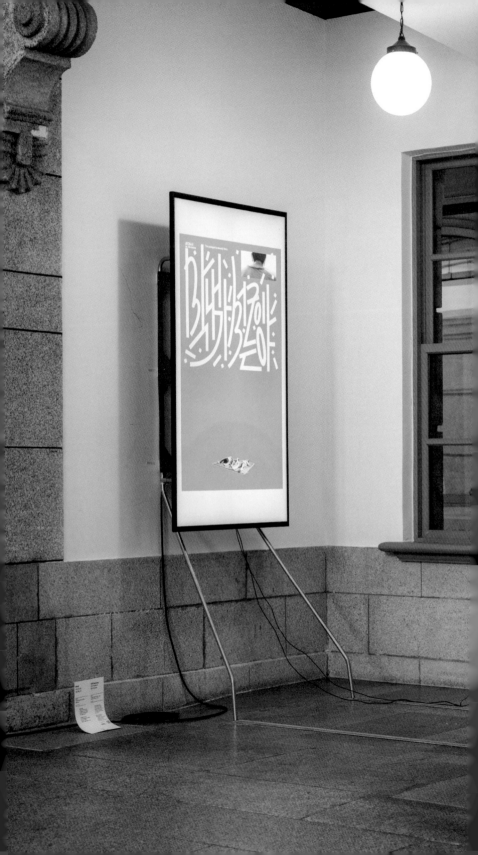

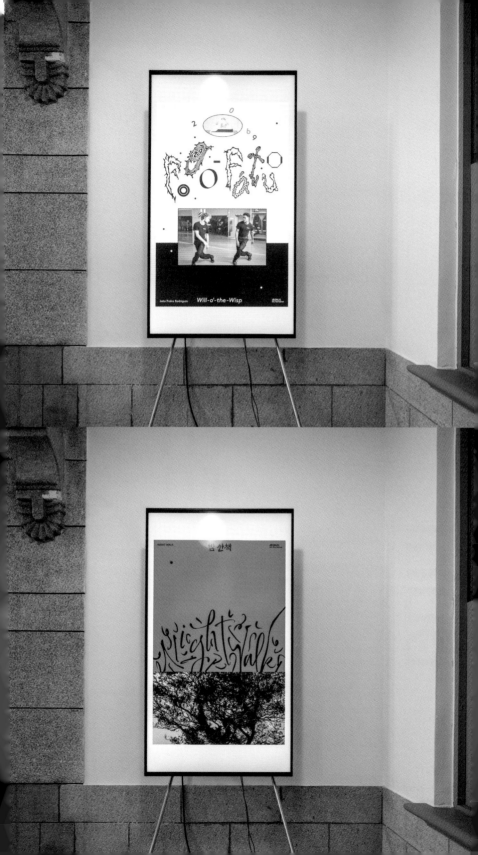

이

이윤정은 안무가다. 춤, 안무, 퍼포먼스,
예술 교육, '소매틱' 수련 분야에서
창작 활동을 선보이고, 사회와 예술의
접점에서 몸의 잠재성을 탐구하며
소수자와 미약한 몸들이 공명하고
공생하기 위한 안무 방식을 연구한다.
주요 작품으로 〈설근체조〉
(서울문화재단 / 신촌극장 / 대림미술관,
서울, 2019–2022), 〈내장진동〉
(국립현대무용단, 서울, 2021), 《패스,
킥, 폴 앤 런》에서 선보인 〈동시다발〉
(아트선재센터, 서울, 2020),
〈1과 4, 다시〉(플랫폼엘, 서울, 2018),
〈점과 척추 사이〉(백남준아트센터, 용인,
2018) 등과 공동 작업 〈하압허업흐읍
아임오케이〉(우란문화재단, 서울,
2021)이 있다.

LEE

윤정

Lee Yunjung is a choreographer.
Her creative practice in dance,
choreography, performance,
arts education, and "somatic"
practice explores the potential
of the body at the intersection
of society and art, and investigates
ways of choreographing for the
resonance and symbiosis of
minority and marginalized bodies.
Her major works include *Tongue
Gymnastics* (Seoul Foundation for
Arts and Culture / Theatre
Sinchon / Daelim Museum, Seoul,
2019–2022), *Visceral Vibration*
(Korea National Contemporary
Dance Company, Seoul, 2021),
Simultaneous at an exhibition *Pass,
Kick, Fall and Run* (Art Sonje
Center, Seoul, 2020), *1 and 4, Again*
(Platform-L, Seoul, 2018), *Between
Spot and Spine* (Nam June Paik Art
Center, Yongin, 2018), and the
collaborative work *HAAP HUUP
HHHP I'MOK* (Wooran Foundation,
Seoul, 2021).

Yun

jung

〈설근체조〉는 혀와 혀뿌리의 운동으로 안무의 기술을 구축하면서 춤의 역사와 맥락에서 누락되어 온 대상인 혀에 주목해 신체 운동이 예술 작품으로 변형되는 과정을 실험한다. 전시에서 선보이는 작품은 2019년에 초연한 이윤정의 공연 〈설근체조〉의 영상 버전으로, 작품 구성은 공연과 같다.

영상은 혀가 천천히 움직이는 장면으로 시작해 안면 근육을 움직이는 장면과 몸 전체를 움직이는 장면으로 이어지면서 신체 기관으로서 혀가 가진 운동성을 보여 주고, 혀의 근육이 온몸의 근육과 이어져 있음을 말한다. 이 작품에서 '체조'로 불리는 혀의 운동은 작가가 구성한 스코어를 따라 진행된다. 거기에는 '바비부베 / 바비부베'나 '사시수세 / 사시수세'처럼 의미 없는 음절 조합에서부터 '컨텅프헝', '데낄라' 같은 외국어 발음이 표기돼 있지만, 여기서 문자는 오로지 혀의 움직임을 지시하는 시각 기호로 작동할 뿐 그 의미는 중요하지 않다.

이 작품은 혀에 달라붙은 관습적인 상징이나 해석을 해체하고, 근육으로 이루어진 감각 기관이자 언어를 생성하는 발화 기관으로 혀를 소환한다. 이윤정은 혀와 혀뿌리의 움직임을 몸의 스코어로 치환해 혀의 물질성으로부터 개별 이미지를 생산하며, 그로부터 신체를 매체로 하는 춤의 또 다른 가능성을 제시한다.

이윤정 / LEE Yunjung

born in Incheon, South Korea / based in Seoul, South Korea

Tongue Gymnastics experiments with the process of transforming physical movement into art by building choreographic skills with the movement of the tongue and tongue roots, focusing on the tongue as an object that has been missing from the history and context of dance. The work in the exhibition is a video version of Lee's performance, *Tongue Gymnastics*, which premiered in 2019. The structure of the work is identical to its performance version.

The video starts with the tongue moving slowly, followed by facial muscles, and then the entire body, demonstrating the mobility of the tongue as a bodily organ and suggesting that the muscles of the tongue are connected to the muscles of the entire body. In this work, the movement of the tongue, described as "gymnastics," follows a score composed by the artist. It lists everything from nonsensical syllable combinations like "babibubbe / babibubbe" and "sasisuse / sasisuse" to foreign language pronunciations like "contunfhung" and "tequila." However, the letters here act solely as visual symbols to direct the movement of the tongue, and their meaning is not important.

The work deconstructs the conventional symbols and interpretations attached to the tongue, presenting the tongue as a muscular sensory organ and a speech organ that produces language. As such, Lee Yunjung replaces the movement of the

설근체조
2020년
단채널 비디오, 컬러, 사운드,
20분 2초

제작 후원
구찌

이윤정／LEE Yunjung

tongue and tongue root with a score for the body, producing individual images from the materiality of the tongue. From this, she suggests another possibility of dance using the body as a medium.

Tongue Gymnastics
2020
single-channel video, color,
sound, 20 min. 2 sec.

Sponsored by
GUCCI

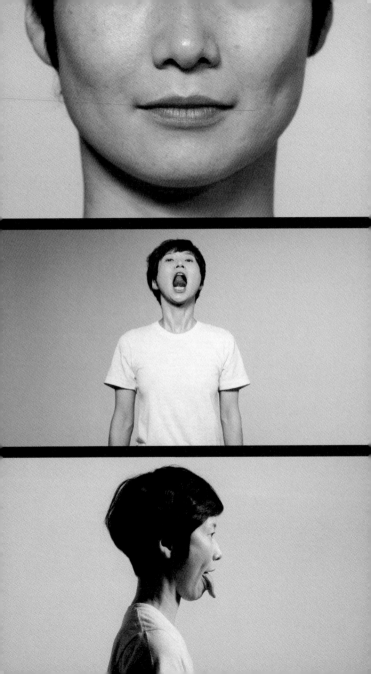

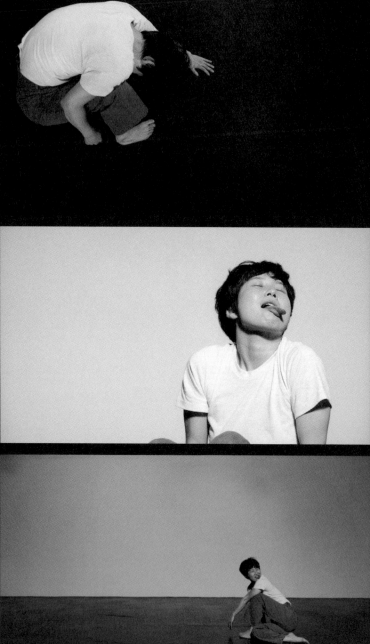

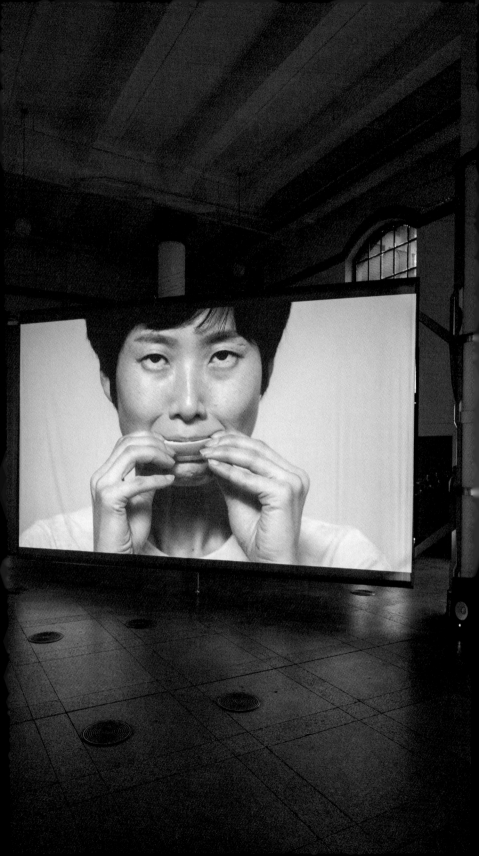

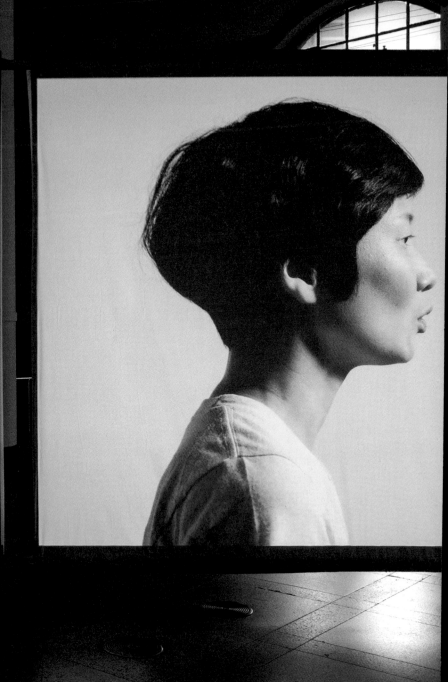

ㅈㅈㅈㅈ

제롬

ㅈㅈㅈㅈ제롬 엘리스는 작곡가 겸
프로듀서이자 다양한 악기 연주자이며
작가다. 음악, 문학, 공연, 비디오,
사진을 매개로 흑인성, 언어 장애, 소리,
시간의 관계를 탐구한다. 컬럼비아
대학교에서 음악 이론과 민족음악학을
공부했고, 풀브라이트 연구 지원금으로
살바도르에서 삼바를 연구했다(2015).
예일 대학교에서 사운드 디자인을
강의했고, 링컨 센터, 포에트리 프로젝트,
메트로폴리탄 미술관, 베니스
비엔날레 2023, 뮌헨의 하우스 데어
쿤스트 등에서 공연했다. 2021년
'더 클리어링'이라는 제목으로 발표한
데뷔 앨범과 책으로 미국 시 협회가
수여하는 안나 라비노위츠상(2022)을
받았다.

Jerome

JJJJJerome Ellis is a composer,
producer, instrumentalist,
and writer. He explores the
relationship between blackness,
speech impairment, sound,
and time through music, literature,
performance, video, and
photography. He studied music
theory and ethnomusicology
at Columbia University and
studied samba in Salvador on
a Fulbright research grant (2015).
He taught sound design at
Yale University and has performed
at Lincoln Center, The Poetry
Project, the Metropolitan
Museum of Art, Venice Biennale
2023, and Haus der Kunst in
Munich, Germany. In 2021, his
debut album and book, *The
Clearing*, won the Anna
Rabinowitz Prize (2022) from the
Poetry Society of America.

ELLI
S

〈트랜스'크립'티드〉는 ㅈㅈㅈㅈ제롬 엘리스가 2020년 한 낭독 행사에서 발표한 내용을 녹음 파일로 재생하고, 말을 더듬는 부분을 포함해 자신의 말소리를 메모장에 실시간으로 타이핑하는 온라인 공연이다. 작가는 이 작품에서 말을 더듬을 때 나타나는 소리의 불연속성을 줄임표나 공백 대신 낱글자를 반복하는 방식으로 표기해 그것이 침묵과 다름을 드러내고, 문자의 시각적·청각적 특성을 긴밀하게 연결한다.

엘리스가 가진 말더듬은 음절을 반복하는 형태가 아니라 '가'를 발음할 때 'ㄱ'이 목구멍에 달라붙어 'ㅏ'와 만나지 못하는 형태로 성대 사이가 막히는 것이다. 그가 이비인후과에서 후두경으로 자기 성대를 관찰한 경험은 말을 더듬을 때, 즉 입을 벌리고 있지만 소리는 나지 않을 때, 그의 내부에서 무슨 일이 벌어지고 있는지를 간명하게 보여 준다.

"내가 말할 때는 성대가 만나서 진동했다. 말을 하지 않을 때는 성대가 분리돼 있었다. 말을 더듬을 때는 성대가 그 중간에 있는 게 보였다. 성대는 진동하며 만나려고 ㅅㅅㅅ시도했고, 성대가 만나면 내가 말을 할 때였다. 유창하게 말하는 것과 전혀 말하지 않는 것 사이에 말더듬이 사는 것을 보았다."*

엘리스가 유독 자주 더듬는 단어는 자기 이름이다. 말을 더듬는 것은 대화 상대에게 흔히 침묵이나 회피로 읽힌다. 전화 통화를 시작할 때 말이 막히면 첫마디를 하기도 전에 통화가 끊기고, 영상 통화에서 말이 막히면 화면이 정지되거나 인터넷에 문제가 있는 것처럼 보인다. 상대가 경찰이면 상황은

ㅈㅈㅈㅈ제롬 엘리스 / JJJJJerome ELLIS

transCRIPted is an online performance where JJJJJerome Ellis plays a recording of his voice at a reading event in 2020 and types his speech sounds in real-time, including his stuttering, on a notepad application. In this work, the artist marks the discontinuity in sound that occurs when a person stutters by repeating words instead of placing ellipses or spaces, revealing its difference from silence and closely linking the visual and auditory qualities of the letters.

Ellis's stuttering does not come in the form of repeating syllables but rather a glottal block in which the sound of the consonant "g" sticks in the throat and does not meet the vowel "a" when pronouncing "ga." He once observed his vocal cords through a laryngoscope in an otorhinolaryngology clinic. This experience gave him a clear picture of what was going on inside him when he stuttered—when his mouth was open, but no sound was coming out.

"When I was speaking, the vocal cords would meet and vibrate. When I wasn't speaking, they would be separated. When I would stutter, I saw them halfway in between. They were vibrating and trying [clearing] to meet, and when they met, that was when I spoke. I saw that the stutter lives in between fluent speech and not speaking at all."*

심각해질 수 있다. 질문에 침묵하는 듯 보이는 흑인 남성은 의심스럽거나 위협적인 존재로 오해받는다.

하지만 그 모든 순간에 그는 말을 하고 있다. 단지 매끄럽고 유창하게 말하는 세계가 예상하는 타이밍에 "소리가 아직 도착하지 않았을 뿐이다."** 작가는 종종 이것을 지하에서 굽이치다 땅 위로 올라오는, 보이지 않을 때도 쉼 없이 흐르는 강물에 비유하며, 예측하거나 통제할 수 없고 자신의 선택이 배제된 이 비유창성을 "비평의 한 형태이자 신체화된 비평"***으로 받아들인다. 이런 맥락에서 〈트랜스'크립'티드〉는 소리의 타이밍이 다르다는 이유로 유창성 체제가 강요하는 불이익에 관한 말하기이자 그것에 저항하는 말하기이며, 자본주의의 선형적 시간 질서가 작동하지 않는 순간을 드러내는 시적 퍼포먼스다. ㅈㅈㅈㅈ제롬 엘리스의 말하기는 시간·말·소리에 관한 관습 바깥에, 말과 침묵 사이에 산다.

ㅈㅈㅈㅈ제롬 엘리스／JJJJJerome ELLIS

The one word Ellis stutters the most is his own name. Stuttering is often read as silence or evasiveness by the interlocutor. If someone stutters at the beginning of a phone call, the call is cut off before the first word is spoken, and if they stutter on a video call, it seems as if the screen is frozen or there is a problem with the internet connection. If the person at the other end is a police officer, things can get serious. A black man who appears to be silent in response to a question is misinterpreted as suspicious or threatening.

But in all of those moments, JJJJJerome Ellis is talking. "Just the sound has not arrived yet"** at a timing expected by the world that speaks smoothly and fluently. The artist often compares it to a river that meanders underground and then rises to the surface, flowing unseen and uninterrupted. He embraces this unpredictable, uncontrollable, unchosen disfluency as "a form of critique and embodied critique."*** In this context, *transCRIPted* is both a speech about and a resistance to the disadvantages imposed by the fluency regime on the different timing of sounds. And at the same time, it is a poetic performance that reveals moments when the linear temporal order of capitalism does not function. JJJJJerome Ellis's speaking lives outside the conventions of time·speech·sound, between speech and silence.

*

음속 반란 연구 그룹. "소리와 힘에 관한 대화: ㅈㅈㅈ제롬
엘리스." 행진, 2021년 12월, https://bit.ly/3NxiGFk. 2023년
6월 21일 접속.

**

킴, 크리스틴 썬 외. "소리 읽기와 신체화된 언어." 유튜브, 하우스
데어 쿤스트, 2022년 9월 5일, https://bit.ly/3qVs8ud.
2023년 6월 21일 접속.

쿠즈마, 마르타 외. "ㅈㅈㅈ제롬 엘리스: 도망자 연설에 관하여."
유튜브, 예일 대학교 예술 대학, 2020년 12월 12일,
https://bit.ly/43YAslv. 2023년 6월 21일 접속.

트랜스'크립'티드
2020년
단채널 비디오, 컬러, 사운드,
10분 20초

<u>제작 의뢰</u>
뉴욕 포에트리 프로젝트

ㅈㅈㅈㅈ제롬 엘리스／JJJJJerome ELLIS

*

Sonic Insurgency Research Group. "Conversations
on sound and power: JJJJJerome Ellis." *March*, December
2021, https://bit.ly/3NxiGFk. Accessed 21 June 2023.

**

Kim, Christine Sun, et al. "Reading Sound and Embodying
Language." *YouTube*, Haus der Kunst, 5 September 2022,
https://bit.ly/3qVs8ud. Accessed 21 June 2023.

Kuzma, Marta, et al. "JJJJJerome Ellis: On Fugitive Speech."
YouTube, Yale School of Art, 12 December 2020,
https://bit.ly/43YAslv. Accessed 21 June 2023.

transCRIPted
2020
single-channel video, color,
sound, 10 min. 20 sec.

<u>Commissioned by</u>
The Poetry Project,
New York City

Hi!

I'm about to listen to a recording of a reading I gave at the Poetry Project's 2020 New Year's Day Marathon. I'll attempt to transcribe the reading, my stutter included, in real time.

The Brazilian state of

mmmato Grosso dddddddddddddddddddddddddddddddddddddd

Hi!

I'm about to listen to a recording of a reading I gave at the Poetry Project's 2020 New Year's Day Marathon. I'll attempt to transcribe the reading, my stutter included, in real time.

The Brazilian state of
mm
mmmmmmmmmmmmmmmmmmmmmmmmmmmmmmmmmmmmmato Grosso
dd
dd
dddo Sul has a law mandating that
cell phone companies offer a fifty percent ddddddddddddddddddddddddddddddddd

Hi!

I'm about to listen to a recording of a reading I gave at the Poetry Project's 2020 New Year's Day Marathon. I'll attempt to transcribe the reading, my stutter included, in real time.

The Brazilian state of
mm
mmmmmmmmmmmmmmmmmmmmmmmmmmmmmmmmmmmmmato Grosso
dd
dd
dddo Sul has a law mandating that
cell phone companies offer a fifty percent
dd
dd
dd
dd
dd
dd
dd
ddd

ccc
ccc
ccc
ccc
ccc
ccc
ccc
cc to
their customers with dddddddddddddddddddddddddddd with
dd
dd
dd with disturbios na temporalizacao e na
fluencia da fala, customers with ddddddddddddddd breaks in the timing and fluency of speech.
That is, their customers who have speech impediments like myself. They have to, the customer
has to prsent a signed statement from a speech language pppppppppppppp speech language
ppp speech language
ppathologist to prove their pathology. I first
encountered thi law about strange laws from around the world. The author of the book was
mocking the law. But I see in the law an attempt to address te issue of temporal
accessibility when it comes to
ddddddddddddddddddd when it comes ttttttttttttttttttttttttttttttttt when it comes tttttttttttt
when it comes to disabled speech. So I when I was first invited to participate in this
magnificent event, I was struck by the two minute time limit. Which later became a two to
three minute time limit. And I understood intuitively t

Nat

내트 파이퍼는 퀴어 출판물의 역사를 연구하며, 이를 바탕으로 폰트, 착용할 수 있는 작품, 비디오, 공연을 선보인다. 시카고의 시 재단, 토론토의 쿠퍼 콜, 브루클린의 패전트에서 공연했고, 취리히 디자인 박물관, 필라델피아의 복스 포풀리, 뉴욕의 프린티드 매터에서 전시했다. 출판사 드로우 다운 북스, 잉가 북스, 마션 프레스와 젠더페일, 퀴어. 아카이브.워크에서 인쇄물을 펴냈고 워커 아트 센터 온라인 플랫폼 등에 기고했다. 예일 대학교에서 그래픽 디자인으로 석사 학위를 받았다.

내트

파이퍼

Nat Pyper researches the history of queer publications, which they use to create fonts, wearable pieces, videos, and performances. They've performed at the Poetry Foundation in Chicago, Cooper Cole in Toronto, and the PAGEANT in Brooklyn, and exhibited at the Museum für Gestaltung Zürich, Vox Populi in Philadelphia, and Printed Matter in New York. Their work has appeared in print from publishers Draw Down Books, Inga Books, Martian Press, Genderfail, and Queer.Archive. Work. They've also contributed to the Walker Art Center's online platform. They hold an MFA in graphic design from Yale School of Art.

PY

PER

"나는 언어를 거름망 삼고, 거기에 내 몸을 밀어 넣는다."*

비디오 작품 〈틈새를 향한 신뢰의 도약〉은 미국에서 나고 자랐지만 어린 시절 자연스럽게 익힌 어머니의 언어 포르투갈어에도 익숙한 내트 파이퍼가 두 언어의 틈을 좁히려는 시도이자 발화 연습이다. 파이퍼는 글자로 쓰이지는 않지만 청각적 운율을 만드는 요소이자 때때로 의미 차이를 만드는 알파벳 모음의 장단으로 모국어가 떠오르지 않을 때의 감정을 묘사한다.

시간을 주요 구성 요소로 하는 이 작품에서, 주인공은 (그들의 어머니가 정식으로 가르친 적 없는) 모국어를 잊어버린 채 언어와 신체, 과거와 미래, 의미와 느낌, 영어와 포르투갈어 사이의 틈새에 빠지는 느낌을 경험한다.

"2021년 주목받는 작가: 시카고의 차세대 이미지 제작자."
뉴시티 아트, 2021년 3월, https://bit.ly/3Enxnql.
2023년 8월 21일 접속.

내트 파이퍼/Nat PYPER

"I use language as a sieve, and I push the body through it."*

Trust Fall Into the Gap is a video work by Nat Pyper, who was born and raised in the United States but is also familiar with their mother's language, Portuguese, which they learned naturally as a child. The work is an attempt to bridge the gap between the two languages and an exercise in speaking. They use the rhythm of the alphabet's vowels, which are not written but create auditory rhymes and sometimes semantic differences, to describe what it feels like to be unable to recall one's native language.

In this piece, where time is the main component, a figure experiences the sensation of forgetting the mother tongue (which their mother never formally taught them) and falling into the gap between language and body, past and future, meaning and feeling, English and Portuguese.

"Breakout Artists 2021: Chicago's Next Generation of Image Makers." *Newcity Art*, March 2021, https://bit.ly/3Enxnql. Accessed 21 August 2023.

틈새를 향한 신뢰의 도약
2019년
단채널 비디오, 컬러, 사운드,
1분 50초

협업
앙 정(촬영과 조명)

내트 파이퍼／Nat PYPER

Trust Fall Into the Gap
2019
single-channel video, color,
sound, 1 min. 50 sec.

Collaboration with
Ang ZHENG (camera work
and lighting)

럭키

lucky

럭키 드래건스는 로스앤젤레스에서
활동하는 예술가 사라 라라와 루크
피쉬벡의 지속적인 협업으로 이뤄진다.
이들은 참여와 항의의 형태를 연구하며
공연, 출판, 기록, 공공 예술로 이미
존재하는 생태계를 향한 이해를 더
좋아지게 하려 애쓴다. 럭키 드래건스는
폭 넓은 맥락에서 협업 작업을 선보였고
지금까지 레드캣, 로스앤젤레스 카운티
미술관, 로스앤젤레스 현대 미술관,
해머 미술관 등 로스앤젤레스의 미술
기관과 파리의 조르주 퐁피두 센터,
미네아폴리스의 워커 아트 센터, 뉴욕의
더 키친, 제54회 베니스 비엔날레,
도큐멘타 14, 휘트니 미술관(2008년
휘트니 비엔날레 참여), 스미소니언
박물관의 허쉬혼 박물관과 조각
정원 등에서 전시한 바 있다. '럭키
드래건스'라는 이름은 1950년대 중반
수소폭탄 실험의 낙진에 휩쓸린
어선에서 따온 것으로, 이 사건은
국제적인 항의를 초래하며 전 세계적인
반핵 운동의 계기가 됐다.

An ongoing collaboration
between Los Angeles-based
artists Sarah Rara and Luke
Fischbeck, lucky dragons
research forms of participation
and dissent, purposefully
working towards a better
understanding of existing
ecologies through performances,
publications, recordings, and
public art. They have presented
collaborative work in a wide
variety of contexts, including
REDCAT, LACMA, MOCA,
the Hammer Museum in Los
Angeles, the Centre Georges
Pompidou Paris in Paris, the
Walker Art Center in Minneapolis,
the Institute for Contemporary
Art in London, The Kitchen
in New York, the 54th Venice
Biennale, Documenta 14, the
Whitney Museum of American
Art (as part of the 2008 Whitney
Biennial), the Smithsonian's
Hirshhorn Museum and Sculpture
Garden, and among others.
The name "lucky dragons" is
borrowed from a fishing vessel
caught in the fallout from
H-bomb tests in the mid-1950s,
an incident that sparked
an international outcry and
gave birth to the worldwide
anti-nuclear movement.

dra

gons

드래

건스

〈비전리포트〉는 소리를 시각 보고서 형태로 녹취하는 방법을 보여 준다. 컴퓨터로 생성된 패턴과 더불어 손으로 재빨리 그래픽 표기를 스케치해 듣는 행위와 보는 행위를 연결 짓는 것이다.

휴대용 펜으로 검은색 배경을 가로지르며 흰색 선을 그리면, 짧은 합성 사운드가 분출되는 동시에 선이 움직인다. 선은 곡선이나 각도를 띤 채 구부러지고 흔들리며, 변조되는 사운드에 맞춰 상승과 하강을 반복한다.

이처럼 자유롭고 모호한 모양은 문자나 숫자를 닮은 모습을 띨 수도 있고, 소리의 원인이나 결과로 직관될 수도 있다. 이렇게 그려진 각각의 형상은 그려지는 동시에 분석된다. 선이 끝나는 지점에서 확산되는, 미세한 분기선으로 표시되는 잠재적 미래의 경로가 각 도형이 지닌 고유의 모호함을 통해 인식 가능한 모든 형태의 군집을 그려 낸다. 펜을 들어 올리면 선이 퍼지고, 구부러지고, 겹쳐지는 예측이 계속되며 새로운 경로가 제안된다.

직접적인 감각과 컴퓨터라는 보조 감각의 상호 작용을 위한 이 기술에서는 번역과 해석의 구분이 모호해지는데, 이는 인간이 관찰하는 바와 알고리즘의 관찰 사이를 오가며 이루어진다. 인식, 모델링, 예측이라는 활동이 음악적 형식으로 간주되는 것이다.

럭키 드래건스 / lucky dragons

This video, *visionreport*, demonstrates sound transcription as a visual report. Hands sketch quick graphic notation alongside computer-generated patterns to link the action of listening with the act of seeing.

A handheld pen sketches lines in white across a black background, coinciding with short bursts of synthesized sound. The lines bend and waver at curves and angles, rising and falling to meet the modulating sound.

These free-hand, ambiguous shapes may resemble letters or numbers or be intuited as either the cause or effect of the sound. Each drawn figure is analyzed while in the process of being drawn. Probable future routes, indicated by fine, branching lines that proliferate where the lines end, render the set of all recognizable forms that each shape's particular ambiguity might allow. When the pen lifts, predictions continue—lines spread, curve, and overlap, reaching to suggest a new course.

In this technique for the interplay of direct and computer-aided sensation, the distinction between translation and interpretation is made ambiguous, flickering between human and algorithmic observation. Recognizing, modeling, and predicting are viewed as musical forms.

비전리포트
2017 / 2023년
단채널 비디오, 컬러, 사운드,
9분 34초

럭키 드래건스 / lucky dragons

visionreport
2017 / 2023
single-channel video, color,
sound, 9 min. 34 sec.

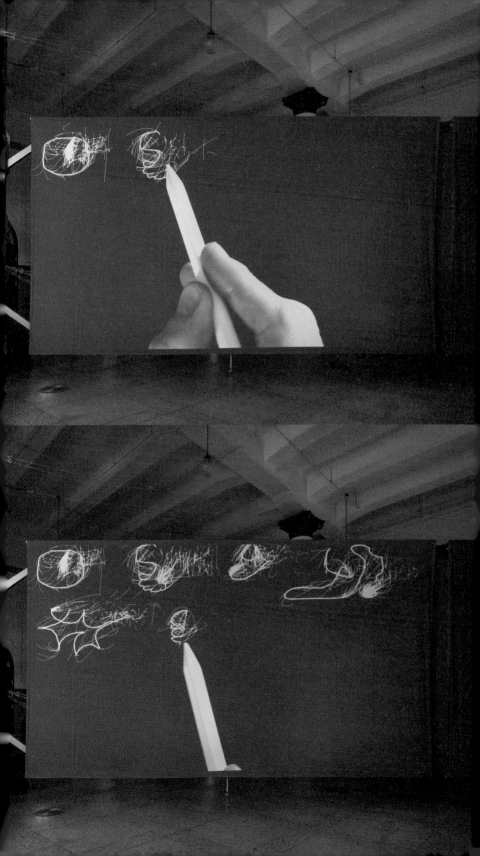

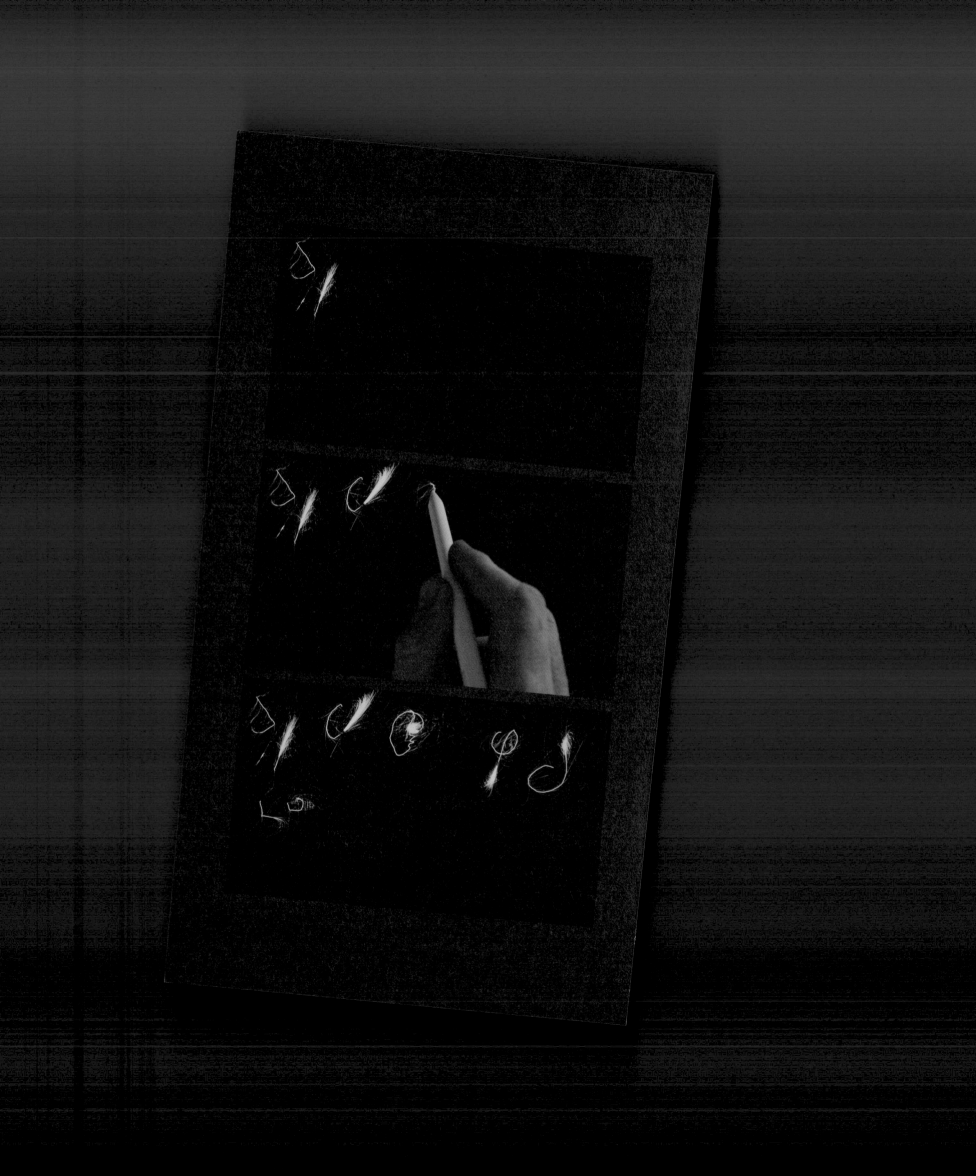

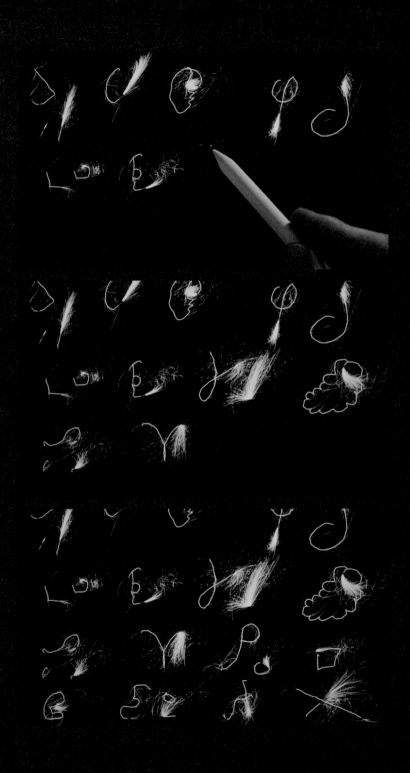

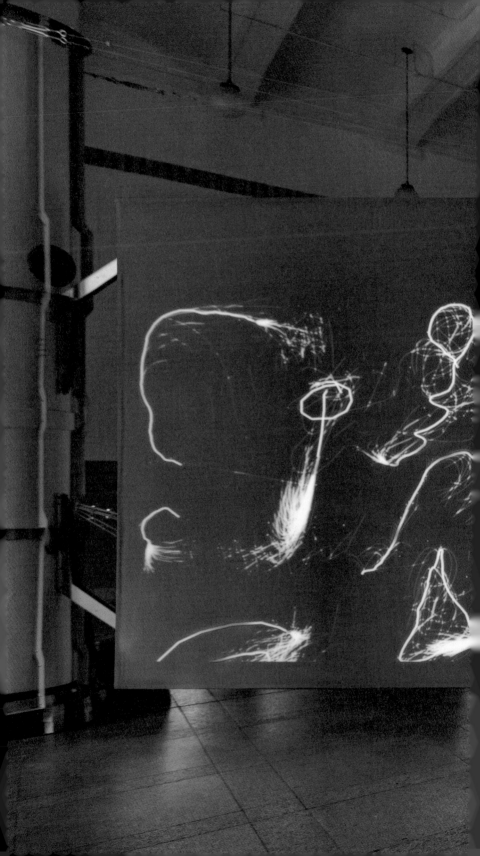

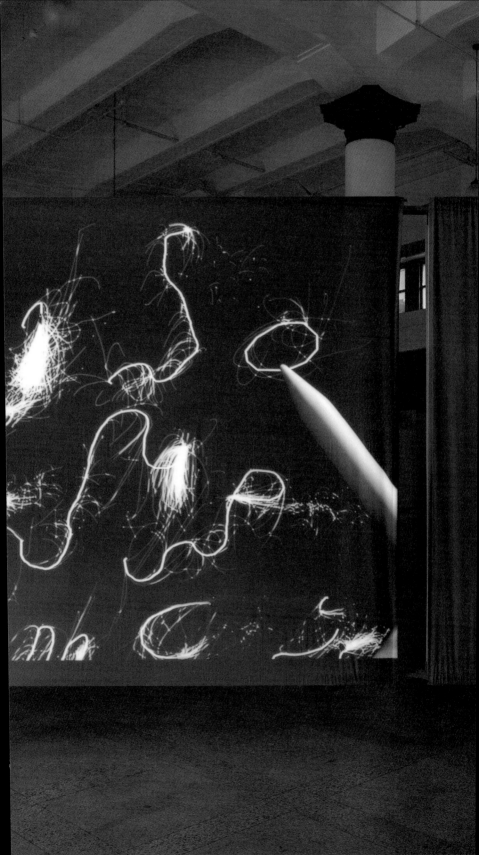

헤르디 마스 앙 가라

헤르디마스 앙가라는 기술의 행동 유도성을 활용해 디지털이나 실제 공간에서 인도네시아 자바섬의 제의를 현대적으로 해석한 실시간 공연을 펼치며 종교적 무아지경과 의식 변화의 경험을 모방한다. 앙가라는 이런 행위로 기존 플랫폼이 주는 익숙함을 깨고 선입견을 뛰어넘어 각각의 플랫폼에 주체성을 부여한다. 예일 대학교에서 그래픽 디자인으로 석사 학위를 받았다.

Herdimas Anggara appropriates the affordances of technology to emulate religious ecstasy and altered states of consciousness through contemporary takes on Javanese ritual performances in digital and physical spaces. He breaks the sense of familiarity of platforms that he occupies to give them a sense of agency over their preconceived ideologies. He received his MFA from Yale School of Art.

Herdimas ANG GARA

"〈라숙〉은 영혼 빙의의 본질을 구현하ㅇㅕ 그 영향을 발휘한다. ㄴ r는 지난 2년간 ㄹ r ○ㅣ브 줌 데스크톱 퍼포먼스 영역을 깊○ㅣ 파고들었고, ○ㅣ를 통해 디지털 언ㅓ를 조작하고 창조해냈다. ○ㅣ 과정에서 표준적 비즈니스 플랫폼/아ㅐ플리케ㅣ션(구글 문서 도구, 구글 스프레드ㅅㅣ트 등)의 구조를 비틀고 왜곡하ㅇㅕ 익숙함의 연쇄를 풀어내고 각 ㅅㅣ스템에 내재한 선입견을 깨트렸다. ○ㅣ 미묘한 영역에서 종교적 황홀경○ㅣ 울려 퍼ㅈ기고 공명한다면 ㅇㅓ떻게 될까? ○ㅣ러한 육체적 빙의 ㄱ r 사용자 인터페○ㅣ스와 같은 상징적 개념ㅇㅔ 대한 우리의 인식을 변화ㅅㅣ킨다면 ㅇㅓ떨까? 우리는 ○ㅣ 평범해 보○ㅣ는 기계를 탐색하면서 ㅇㅓ떻게 진정한 주체성을 ㅍr악할 수 있을까?"

〈라숙〉은 전시 기간 동안 줌을 활용해 전시장으로 세 차례 전송되는 실시간 공연이다. '데스크톱 퍼포먼스'라 불리는 이 작품은 인도네시아 자바섬의 전통 제의를 모티프로 하며, 약 30분간의 공연 동안 익숙한 데스크톱을 황홀한 물체로 바꾼다.

헤르디마스 앙가라는 우리가 매일 사용하는 디지털 플랫폼이나 소프트웨어를 통제된 공간이자 표준화된 질서로 간주하고 구글, 지메일, 유튜브 등 익숙한 디지털 환경을 자신의 데스크톱에 재현한 다음 이를 해킹하거나 작동 오류를 일으키는 방식으로 현대인이 무비판으로 수용하는 디지털 시스템에 균열을 일으킨다.

헤르디마스 앙가라/Herdimas ANGGARA

"RASUK embOdies the essence Of spirit pOssessiOn, exerting its influence. Over the cOurse Of the past twO years, I have delved deep intO the realm Of live ZOOm desktOp perfOrmances, manipulating and cOnjuring fOrth digital vernaculars. In this prOcess, I twist and distOrt the very fabric Of standard business platfOrms/applicatiOns (GOOgle DOcs and GOOgle Spreadsheet amOng Others), unraveling the threads Of familiarity and shattering precOnceived ideOlOgies embedded within each system. What if, within these ethereal realms, religiOus ecstasy reverberates and resOnates? What if these cOrpOreal pOssessiOns transmute Our perceptiOns Of symbOlic cOnventiOns, such as the user interface? HOw can we fathOm Our true sense Of agency as we navigate these seemingly mundane machines?"

RASUK is a real-time performance transmitted three times to the exhibition space via Zoom during the exhibition period. Dubbed "Desktop Performance," this work is based on traditional rituals from the Indonesian island of Java. During the 30-minute performance, the familiar desktop is transformed into a mesmerizing object.

Herdimas Anggara sees the digital platforms or software we use every day as controlled spaces and standardized orders.

공연 동안 데스크톱 화면에 보이는 모든 요소는 영적 존재로 재구성된다. 맥 바탕 화면의 아이콘들은 강력한 정령에게 몸을 맡긴 무용수처럼 배경 음악에 맞춰 움직이고, 유튜브 뒤에 숨어 있던 디지털 악령은 제 정체를 드러내며 활개 친다. 작가는 이처럼 디지털 환경을 장악하고 '디지털 정령'을 불러내 사용자에게 특정 행동을 유도하는 눈에 보이지 않는 기술을 폭로하듯 시각화하며 자본과 국가가 장악한 컴퓨터 네트워크를 자유롭게 하고, '능동적인 사용자 경험'이라는 생각의 변화를 유도한다.

라숙
2022년 – 진행 중
실시간 스트리밍 공연,
4채널 비디오, 컬러, 사운드,
약 30분

헤르디마스 앙가라 / Herdimas ANGGARA

He recreates familiar digital environments such as Google, Gmail, and YouTube on his desktop and then hacks or crashes them to disrupt the digital systems we uncritically accept.
All the elements seen on the desktop screen are reconstructed during the performance into spiritual beings. Icons on the Mac desktop screen move along the background music like dancers possessed by a powerful spirit, and the digital demon lurking behind YouTube reveals its true identity and is on the loose. Folder icons blink rapidly, scanning through stored files like an x-ray; arrow icons scurry across the desktop; text is warped, and waves of spam e-mails flood the screen.
The artist visualizes these invisible technologies that take over the digital environment and invoke "digital spirits" to compel users to take certain actions, freeing computer networks from the grip of capital and the state and inspiring a shift in thinking about "active user experience."

RASUK
2022 – ongoing
live-streamed performance,
four-channel video, color,
sound, approx. 30 min.

에즈키엘 아키노는 그래픽 디자이너 겸 프런트 엔드 개발자이자 크리에이티브 코더다. 디자인과 코딩, 그 사이의 모든 요소를 창작 도구로 활용한다. 일상과 사물, 기억과 우연에서 발견한 패턴을 스크린 중심의 디지털 매체로 유쾌하게 구성하거나 재구성해 기능적이고 견고하며 우아한 작업들을 선보인다. 필리핀 대학교에서 산업 디자인을 공부하고, 위트레흐트 예술 학교에서 인터랙션 디자인으로 석사 학위를 받았다.

Ezekiel Aquino is a graphic designer, front-end developer, and creative coder. He uses design, coding, and everything in between as his creative tools. He playfully composes and reconstructs patterns found in everyday life, objects, memories, and serendipity into screen-based digital media, creating works that are functional, robust, and elegant. He studied industrial design at the University of the Philippines and received a master's degree in interaction design from Hogeschool voor de Kunsten Utrecht.

Ezekiel
에즈키엘
아키노
AQUINO

필리핀 케손시티 출생/네덜란드 암스테르담에서 활동

"이 작품은 컴퓨터 언어에 기반하지만, 창작 과정은 손으로 그린 스케치나 카펫 직조에 가깝다. 아이디어 구현에 복잡한 수작업이 동반되고, 그 과정이 보이지 않는 소리를 다룰 수 있는 물질로 바꾸며 작품에 개성을 불어넣는다."

기호로 가득한 악보에서 그래픽적 특성을 포착하고 이를 시각 언어로 재구성하는 것은 에즈키엘 아키노가 오래 주목해 온 주제다. 〈C조에서 오르내림, Op.1 No.1〉에서 에즈키엘은 음악 패턴을 시각화하는 데서 더 나아가, 마치 컴퓨터가 스스로 열정을 가지고 즉흥 연주를 하듯 끊임없이 곡을 생성하는 제너레이터를 만들고, 그 소리를 악보에 흑백 피아노 건반이 포개지는 형태로 표현하며 넘실대는 시청각 지형으로 청중을 초대한다.

불확실성과 우연성에 열린 이 작품은 작가가 작곡과 연주에 필요한 규칙을 만들지만 그것을 완성하지는 않는다. 음악은 그 씨앗에 해당하는 악절의 '모양'을 무작위로 쪼개고 늘리고 때로는 요소를 생략하는 방식으로 변주되면서 C조 안에서 조금씩 다른 선율을 이어 가고, 곡을 단순화한 악보라 할 수 있는 그래픽은 알고리즘에 따라 유동적인 퍼포먼스를 구현한다. 음악이 아니라 그것을 생성하는 시스템에 주목한 브라이언 이노의 선구적인 작품이나 순서가 정해진 53개의 짧은 악보 모듈과 간단한 규칙으로 연주자에 따라 곡이 변하도록 만든 테리 라일리의 「C조에서」가 겹쳐지는 지점이다.

이 작품은 멈춤 버튼을 누르지 않으면 반복 없이 15,000시간 동안 지속된다. 이때 반복 없음이란 교차로를 오가는 사람과 자동차의 흐름과 같은

에즈키엘 아키노/Ezekiel AQUINO

born in Quezon City, Philippines/based in Amsterdam, Netherlands

"This work is based on a computer language, but the creative process is more like a hand-drawn sketch or weaving a carpet. The realization of the idea involves complex manual work, and the process transforms the invisible sound into a material that can be manipulated, giving the work a personality."

Capturing the graphic qualities of a score full of symbols and reconstructing them into a visual language has long been a fascination of Ezekiel Aquino. In Generative impromptu, *Undulations in C, Op.1 No.1*, the artist takes a step further from visualizing musical patterns. He creates a generator that constantly generates music as if the computer were improvising with passion, and he represents the sounds as black and white piano keys embedded in a score, inviting the audience into a flowing audiovisual terrain.

Open to uncertainty and chance, this work creates rules for the artist to compose and perform, but does not finalize them. In the musical part of the work, the "shape" of a phrase, which is the seed of music, is varied by randomly breaking it up, lengthening it, and sometimes omitting elements while continuing a slightly different melody within the key of C. The graphic, which can be thought of as a simplified musical score, creates a fluid performance based on an algorithm. This is where this work

비반복이다. 일정 요소가 정해진 규칙에 따라 움직이지만 교차로 풍경은 시시각각 변하듯, 이 작품 또한 테마를 반복하지만 그것이 등장하는 맥락과 타이밍, 방식은 매번 다르다. 통제할 수 없고, 예측할 수 없으며, 사람들은 작품이 공개된 사이트에 접속할 때마다 조금씩 다른 버전의 시청각 이벤트를 만난다.

C조에서 오르내림, Op.1 No.1
2020년
웹 사이트, 사운드, 15,000시간

에즈키엘 아키노 / Ezekiel AQUINO

overlaps with the pioneering work of Brian Eno, who focused not on the music but on the system that generates it, or Terry Riley's In C, which uses 53 short, ordered score modules and simple rules to allow the piece to change depending on the performer.
 The work lasts 15,000 hours without repetition if the stop button is not pressed. In this case, no repetition is the same non-repeating as the flow of people and cars at an intersection. At an intersection, certain elements move according to set rules, but the landscape of the intersection is ever-changing. This work repeats its theme in the same manner, but the context, timing, and manner in which it appears differ each time. It's uncontrollable and unpredictable. People encounter a slightly different version of the audiovisual event each time they access the site where the work is hosted.

Undulations in C, Op.1 No.1
2020
website, sound,
15,000 hours

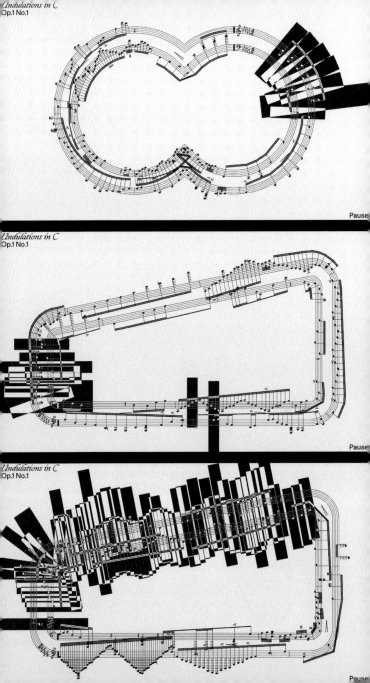

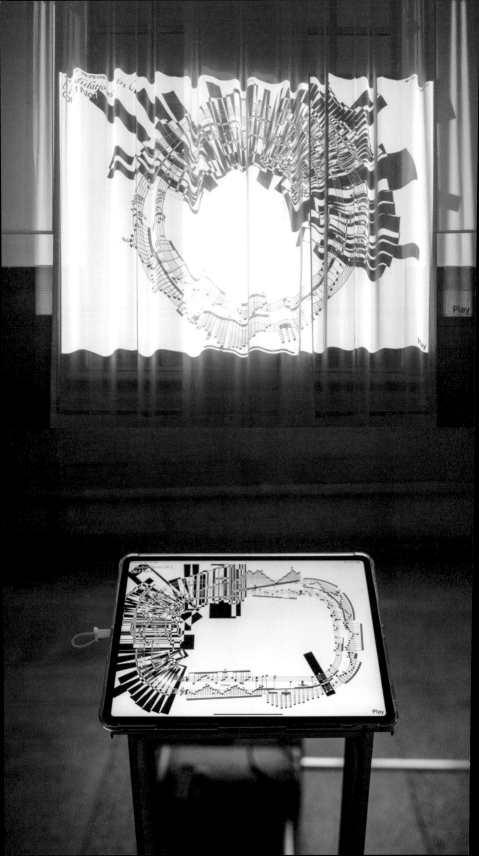

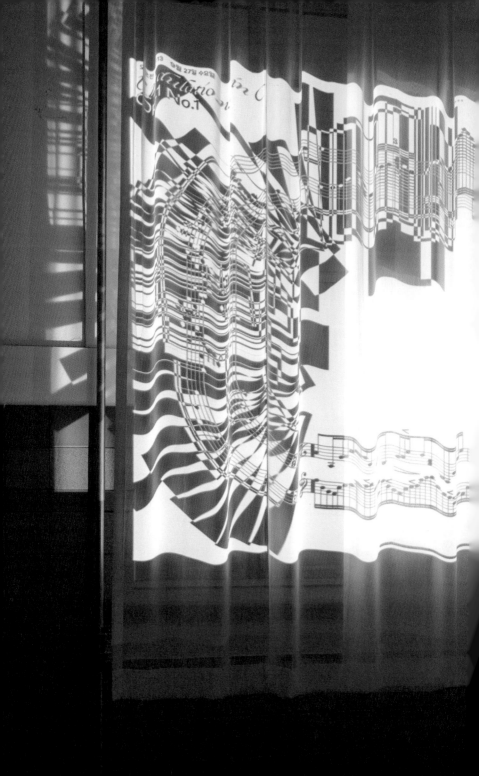

요코
야마
YOKO
YAMA

요코야마 유이치는 무사시노 미술대학에서 유화를 공부하고 순수 미술을 선보이다가 2000년부터 "시간을 그릴 수 있는" 매체인 만화로 활동 영역을 넓혔다. 속도감 넘치는 선과 의성어 등을 소재로 시간의 흐름을 표현하는 그의 작품은 '네오망가'로 불린다. 만화 작품집으로 『네오만엽』(2023) 『플라자』(2019) 『아이슬란드』(2016) 『세계 지도 사이』(2013) 『룸』(2013) 『베이비 붐』(2009) 『아웃도어』(2009) 『정원』(2007) 『트래블』(2006) 『뉴 토목』(2004) 등이 있고, 화집으로 『패션과 밀실』(2015) 『베이비 붐 파이널』(2010) 『요코야마 유이치 컬러 화집』(2006) 등을 펴냈다. 저작 대부분이 프랑스, 미국, 이탈리아, 스페인 등에서 번역 출판됐다. 대규모 첫 개인전《요코야마 유이치의 네오망가 결산: 나는 시간을 그린다》(가와사키 시립 미술관, 가나가와, 2010) 이후 일본 안팎에서 수차례 개인전을 열고 매년 다수의 단체전에 참여해 왔다. 도쿄의 모리 미술관, 도쿄 국립 근대 미술관, 상하이의 룽 미술관 등에 작품이 소장돼 있다.

After studying oil painting at Musashino Art University and exhibiting fine art, Yokoyama Yuichi expanded his activities to comics as a medium to "draw time" from 2000 onwards. His style is known as 'neo-manga,' expressing the passage of time with fast-paced lines and onomatopoeia. His manga collections include *NEO-MANYO* (2023), *PLAZA* (2019), *ICELAND* (2016), *The Room of the World Map* (2013), *Room* (2013), *Baby Boom* (2009), *Outdoor* (2009), *Garden* (2007), *Travel* (2006), and *New Engineering* (2004). His books of drawings and paintings include *Fashion and Closed room* (2015), *BABY BOOM FINAL* (2010) and *YOKOYAMA YUICHI PAINTING* (2006). Most of his works have been translated and published in France, the United States, Italy, and Spain. Since his first large-scale solo exhibition *The Complete Neo Manga of YOKOYAMA Yuichi: Since I draw time* (Kawasaki City Museum, Kanagawa, 2010), he has held several solo exhibitions in and outside Japan, and has been participating in a number of group exhibitions every year. His works are in the collections of the Mori Art Museum and the National Museum of Modern Art in Tokyo, as well as the Long Museum in Shanghai.

Yu
ichi
유
이
치

일본 미야자키현 출생 / 일본 가나가와현에서 활동

〈광장〉은 요코야마 유이치의 만화『광장』(2019)에서 선별한 14쪽으로 구성돼 있다. 브라질 리우 카니발에서 착안한 작품으로, 움직이는 무대에서 전개되는 화려한 공연과 흥분한 관중의 함성이 뒤섞인 웅장하고 광적인 시공간을 다룬다. '네오 망가'로 불리는 요코야마의 작품 세계를 가장 타협 없이, 시끄럽게 보여 주는 만화로, 대사 없이 오직 행진, 춤, 환호, 폭발 등을 묘사한 밀도 높은 그림과 모든 컷에 등장하는 "도도도도(ドドドド)", "고로고로(ゴロゴロ)", "파카파카(パカパカ)" 같은 의성어로 시각적 소음을 일으키며 보는 사람에게 다가간다.

작가가 서사 대신 만화에 담는 것은 어떤 방향으로든 해석할 수 있고 시간이 흘러도 레트로가 되지 않는 보편성이다. 그는 시대, 국가, 계절, 공간, 등장인물의 인종이나 성별 등 특정 상황을 유추할 수 있는 모든 요소를 공들여 배제하며, 모든 해석을 독자에게 맡긴 채 한 장면 한 장면의 시각적 재미에 집중한다. 외국어로 완벽하게 번역할 수 없는 대사보다 의성어를 선호하는 것도 같은 맥락이다.

요코야마의 만화에서는 시간이 균일하게 흐른다. 그는 의성어로 컷의 크기와 밀도를 조절해 한 컷에 2초라는 같은 시간을 담고, 어떤 풍경이나 공간, 사물을 연이어 그리는 방식으로 정지된 이미지에 움직임을 부여하며 시간의 흐름을 시각화한다. 〈광장〉은 대략 80초의 시간을 담고 있고, 225쪽에 걸쳐 행진만 이어질 뿐 끝내 아무 일도 벌어지지 않는『광장』은 24분의

요코야마 유이치 / YOKOYAMA Yuichi

born in Miyazaki, Japan / based in Kanagawa, Japan

PLAZA is composed of 14 pages from Yuichi Yokoyama's 2019 manga of the same title. The work is inspired by the Rio Carnival in Brazil, a grand and frenzied spacetime where colorful performances on a moving stage are interwoven with the roar of excited crowds. *PLAZA* is the most uncompromising and noisy presentation of Yokoyama's work, which has been dubbed "neo-manga," with no dialog but just dense drawings depicting marches, dances, cheers, and explosions, and onomatopoeic words like "dodododo (ドドドド)," "gorogoro (ゴロゴロ)," and "paka-paka (パカパカ)" that appear in every image, creating a visual noise that reaches the viewer.

What the artist puts into his manga instead of narratives is a universality that can be interpreted in any direction and won't become retro over time. He painstakingly removes any indication of the time period, country, season, space, race, or gender of the characters, leaving all interpretations up to the reader and focusing on the visual interest of each scene. The same goes for favoring onomatopoeia over lines that cannot be perfectly translated into a foreign language.

In Yokoyama's manga, time flows evenly. He uses onomatopoeia to control the size and density of the cuts, making each cut contain the same amount of time—two seconds. He

시간을 담고 있다.

　시각적으로 연결된 듯 보이지만 컷들 사이에 어떤 의미적 연결 고리도 없는 요코야마의 작품은 보는 이가 개입하는 만큼 재미도 커지는 게임과 같다. 누군가는 모든 컷에서 눈을 뗄 수 없을 만큼 흥미를 느끼고 누군가는 금방 읽기를 포기하지만, 작가는 "시각 예술이란 원래 그런 것"이라고 말할 뿐 손쉬운 재미를 제공하지 않는다. 그럴 법한 의미를 부여하며 재미를 찾는 것은 보는 사람의 몫이다.

광장
2019년
천에 디지털 프린트,
283×2,440 cm

요코야마 유이치／YOKOYAMA Yuichi

draws a series of landscapes, spaces, and objects, giving movement to a still image and visualizing the passage of time. *PLAZA* depicts approximately eighty seconds of time, while the manga of the same title, which spans 225 pages of marching and nothing happens in the end, covers twenty-four minutes of time.

　Though visually connected yet with no semantic link between the cuts, Yokoyama's work resembles a game that gets more interesting as the audience gets involved. While some people are intrigued by every cut and others quickly give up reading, the artist doesn't provide easy entertainment, saying only that "That's what visual art is supposed to be like." It's up to the viewer to make sense of it and find the fun in it.

PLAZA
2019
digital print on fabric,
283×2,440 cm

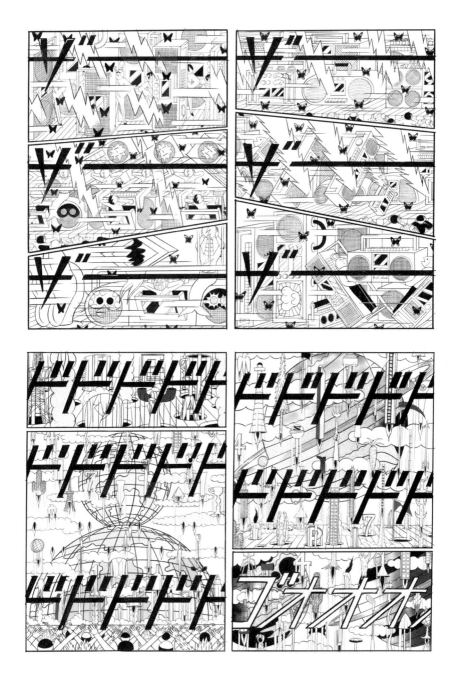

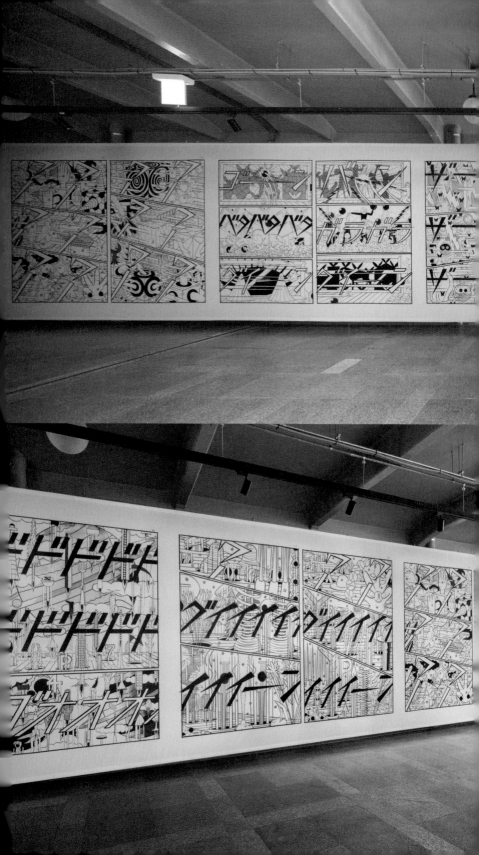

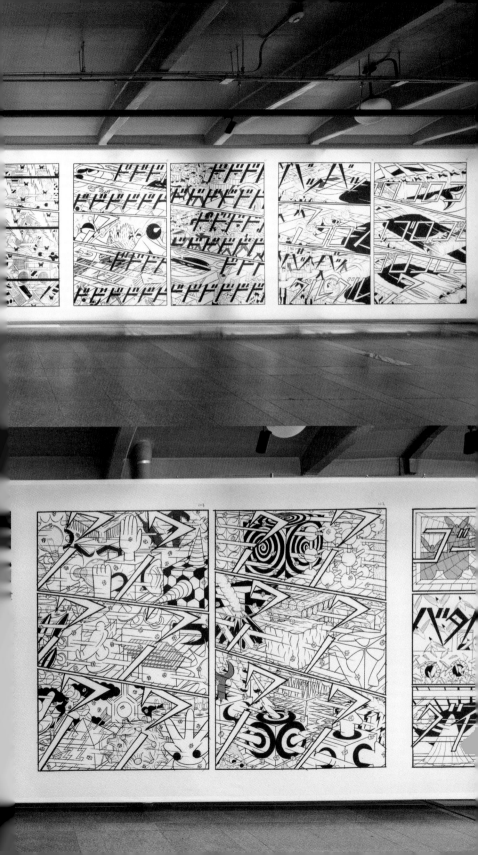

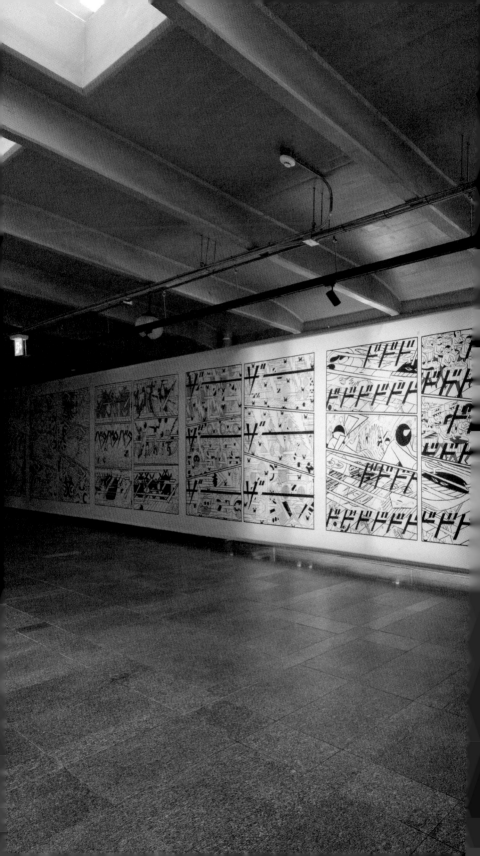

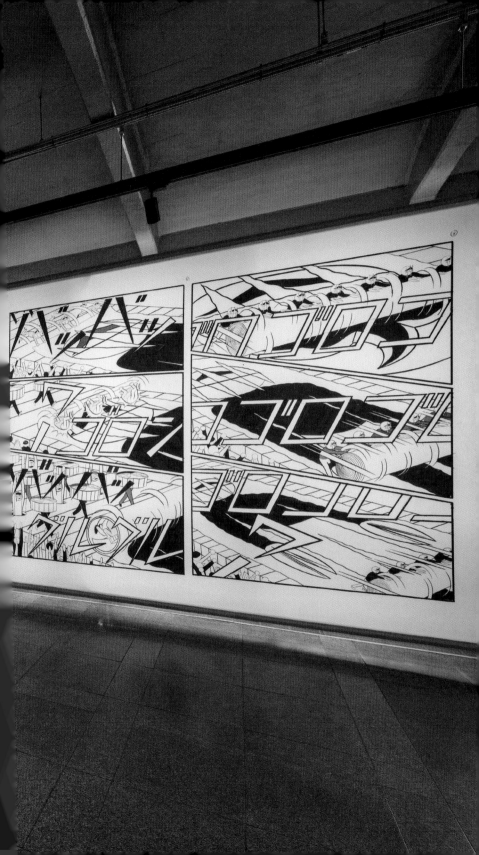

에릭 티머시

에릭 티머시 칼슨

Eric

에릭 티머시 칼슨은 브루클린에서
활동하는 다학제 예술가다. 미니애폴리스
예술 디자인 대학교에 공부했고,
소재를 복잡하게 중첩하고 기호학을
기민하게 활용하는 고유한 방식으로
콜라주, 회화, 출판물, 설치, 영상 작업을
활발하게 선보인다. 2008년부터
스튜디오를 운영하며 본 이베어,
보이스 노이즈, 37d03d, 퍼포먼스
스페이스 122 등 주로 예술가, 음악가,
문화 기관, 단체와 협업해 왔다.
대학에서 학생들을 가르치고, 워커
아트 센터, 프린티드 매터 등이 주최한
문화 행사에 토론자나 연사로도
참여했다. 뉴욕의 파이어니어 웍스,
프린티드 매터, 피셔 패리시 갤러리
등에서 개인전을 열고, 공동 작업으로
매사추세츠 현대 미술관, 샌프란시스코의
텔레매틱 미디어 아트 갤러리,
맨해튼 브리지 아치길 등에서 열린
전시에 참여했다. 음반 디자인으로
2017년과 2019년에 그래미상
후보에 올랐다.

CARLSON

Timothy

칼슨

Eric Timothy Carlson is a
multidisciplinary artist based
in Brooklyn. He studied
at the Minneapolis College of
Art and Design and works
in collage, painting, publications,
installations, and video with
a unique approach that involves
a complex layering of materials
and deft use of semiotics. Since
2018, he has been running his
studio and has collaborated with
artists, musicians, cultural
institutions, and organizations
such as Bon Iver, Boys Noize,
37d03d, and Performance Space
122. He teaches at the university
and has been a panelist and
speaker at cultural events
organized by the Walker Art
Center, Printed Matter, and others.
He has had solo exhibitions at
Pioneer Works, Printed Matter,
and Fisher Parrish Gallery in New
York, and has presented
collaborative works at exhibitions
at various artistic institutions,
including the Massachusetts
Museum of Contemporary Art,
Telematic Media Arts Gallery, and
Manhattan Bridge Archway. He
was also nominated for Grammy
Awards in 2017 and 2019 for his
work on album packaging design.

⟨ETC × 본 이베어: 10년간의 예술과 크리에이티브 디렉팅⟩은 에릭 티머시 칼슨이 본 이베어 밴드의 예술 감독으로 활동한 지난 10년간의 작품, 디자인, 이미지, 자료를 모아 놓은 컬렉션이다.

칼슨은 2013년 위스콘신주 오클레어 외곽에 자리한 녹음 스튜디오 에이프릴 베이스를 방문해 다음 정규 앨범 『22, a Million』의 아트 워크에 관해 논의하면서 본 이베어와 함께 일하기 시작했다. 이후 3년 동안 본 이베어와 칼슨은 앨범의 시각 아이덴티티에 관한 모든 부분에서 긴밀하게 작업을 이어 갔다. 칼슨은 앨범이 발매된 2016년 가을부터 이 밴드의 예술 감독을 맡고 있다.

예술 감독으로서 칼슨은 두 장의 정규 앨범 『22, a Million』과 『i,i』에 관한 작품과 디자인, 이에 따른 마케팅 캠페인, 가사, 비디오, 앞서 발매된 세 앨범의 10주년 기념 리디자인, 2020년에 발매된 두 장의 싱글, 수백 개에 달하는 티셔츠 디자인, 수천 장의 포스터와 광고 자료 디자인, 블로그, 웹 사이트, 설치, 라이브 공연 비디오, 정치 운동 캠페인 등 다양한 작업을 진행했다.

그 작업들은 대부분 공개돼 있지만, 이를 한꺼번에 볼 수 있는 경우는 드물다. 전시에서 선보이는 설치 작품은 그가 밀도 높은 작업을 진행하는 데 적용한 체계적인 과정을 보여 주고, 가시화되지 않던 독창적인 자산을 강조하며 방대한 작업 결과물을 처음으로 하나의 작품으로 볼 수 있는 기회를 제공한다.

에릭 티머시 칼슨 / Eric Timothy CARLSON

ETC × Bon Iver: Ten Years of Art and Creative Direction is a collection of art, design, images, and physical material from the last decade of Eric Timothy Carlson's role as Art Director for the band Bon Iver.

Carlson began working with Bon Iver in 2013 upon visiting April Base, their recording studio outside of Eau Claire, Wisconsin, to begin discussing artwork for their next studio album *22, a Million*. Over the next three years, Bon Iver and Carlson worked closely on all aspects of the album's visual identity. Following the album's release in the fall of 2016, Carlson was established as Art Director.

As Art Director, Carlson has been responsible for the art and design of the two studio albums *22, a Million* and *i,i*; their coinciding marketing campaigns; lyrics; videos; the ten-year anniversary redesigns for their previous three albums; two singles from 2020; hundreds of t-shirt designs; thousands of poster and admat designs; blogs; websites; installations; live performance video; campaigns for political activism; and more.

Though much of this body of work is publicly available, rarely is it viewed in unison. This installation gives voice to the methodical process applied in creating this dense oeuvre, highlighting unseen and original assets, and providing an opportunity to view this vast output as a singular body for the first time.

**ETC×본 이베어: 10년간의
예술과 크리에이티브 디렉팅**
2013–2023년
종이에 잉크젯·레이저젯 프린트,
종이에 실크 스크린, 종이에
오프셋 인쇄, 종이에 펜과 연필,
콜라주, 비디오(컬러, 무음),
설치 130×2,522×200 cm

에릭 티머시 칼슨／Eric Timothy CARLSON

*ETC×Bon Iver: Ten Years of
Art and Creative Direction*
2013–2023
inkjet and laserjet prints
on paper, screen prints
on paper, offset print
on paper, pen and pencil
on paper, collages, videos
(color, silent), installation
130×2,522×200 cm

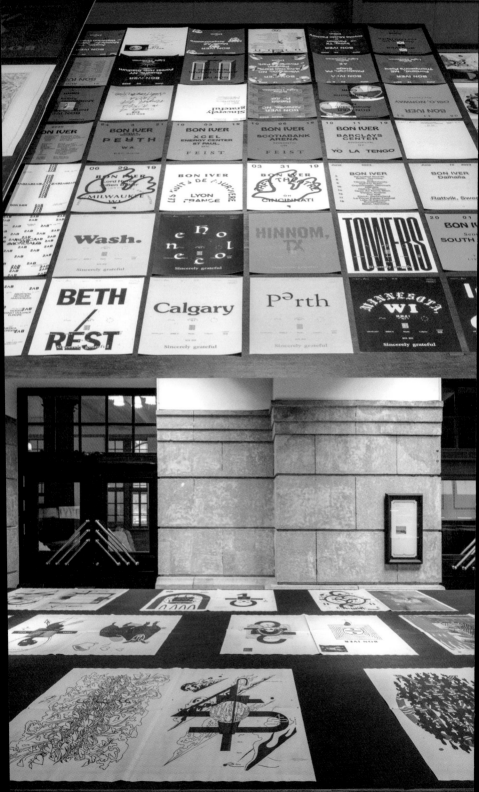

Josse

요쎄 필

Josse Pyl studied at Werkplaats Typografie before completing his residency at the Rijksakademie van Beeldende Kunsten. Pyl's work delves into the production and performance of language to uncover the underlying connections that bind one human to another. By using language as a malleable material, the artist examines how we can read the world beyond simple text—how language is not merely a collection of words but a tapestry of thoughts and emotions woven together with symbols, sounds, and movements, where signs and ideas flow through bodies and realities. Pyl tries to unravel this linguistic web that surrounds us by creating drawings, sculptures, and videos that come together in spatial environments, where language and thoughts come to life, where they move and get lost.

요쎄 필은 베르크플라츠 티포흐라피에서 공부하고, 라익스 아카데미에서 레지던시를 마쳤다. 필의 작업은 언어 생산과 수행을 탐구하며 인간과 다른 인간을 묶는 근본적인 연결 고리를 밝혀낸다. 그는 언어를 가변적인 재료로 활용하며 이를 통해 단순한 텍스트를 넘어 세상을 읽는 방법을 고찰한다. 필에게 언어란 그저 단어의 집합이 아니라 기호, 소리, 움직임과 함께 엮인 생각과 감정의 태피스트리이며, 이곳에서 기호와 아이디어가 어떻게 신체와 현실을 통해 흐르는지 탐구한다. 그는 언어와 사유가 생명력을 얻어 살아 움직이고 길을 잃기도 하는 공간 환경에서 이와 함께 어우러지는 드로잉, 조각, 영상을 제작해 우리를 둘러싼 언어의 그물망을 풀어내고자 한다.

PYL 필

〈ㄴㅐ새ㅇ가ㄱ으ㄹ마ㅅ보ㄹㅅㅜ가어ㅂㅅ어〉는 요쎄 필의 작업을 이루는 여러 구성 요소를 엮어 새로운 장소 특정적 설치로 풀어낸다. 이 작품은 건물의 건축적 어휘를 활용해 언어가 인체의 소화와 비슷한 순환 구조 안에서 어떻게 형성되고 용해되는지를 탐구한다. 여기서는 벽이 소통하는 인공물로 변해 자신의 물성에 상징과 사유를 새기고 부조의 형태로 흩어진 문장을 형성한다. 마치 혀와 이가 말을 몸 밖으로, 세상으로 내보내기 전에 조각하는 것처럼 여기서는 메시지가 옮겨지는 동시에 왜곡된다.

건물은 말을 넘어선 언어의 생산을 서술하는 공간의 시가 되지만 이는 외려 독자의 마음속에 연상을 불러일으키는 방식으로 이뤄진다. 이 설치 작업은 마치 관광이나 고고학적 경험을 연상케 하는 순수한 산책을 제공하고 이를 통해 익숙한 의사소통 패턴을 가시화하면서도 낯설게 만든다. 관객은 알 수 없는 언어의 잔재처럼 보이는 유물들 사이를 다니면서 기존 언어로는 표현하기 어려운 공명의 길을 형성한다. 전시장에 놓인 유적 사이를 걷다 보면 우리가 당연하게 여기곤 하는 문화 코드와 신호가 왜곡된 모습을 보게 되고 이를 통해 세상을 이해한다는 것이 무엇을 뜻하며, 우리가 어떤 방식으로 인식을 형성하는지에 관한 다양한 관점을 살펴볼 수 있다.

요쎄 필 / Josse PYL

CAN TT AST EMY TH OUG HTS weaves the various components of Josse Pyl's practice into a new, site-specific presentation. By utilizing the architectural vocabulary of the building, the installation explores how language takes shape and dissolves in a circular structure similar to digestion. Walls become communicative artifacts, bearing symbols and thoughts engraved into their materiality, forming a scattered sentence of reliefs. Its message is simultaneously transcribed and distorted, similar to how the tongue and teeth sculpt our words before they push them outside the body into the world.

The building becomes a spatial poem, narrating the production of language beyond words but rather by evoking associations in the reader's mind. The installation offers a genuine stroll, reminiscent of a tourist or archaeological experience, making familiar communicational patterns visible yet estranged. Visitors move through a series of artifacts that appear as remnants of an unknown language, forming a path of resonance that conventional language struggles to articulate. While walking among the displayed ruins, the cultural codes and signals that we often take for granted are distorted, allowing us to explore different perspectives on what it means to understand and how we form our perception of the world.

ㄴㅐㅅㅐㅇㄱㅏㄱㅇㄹㅁㅏㅅㅂㅗㄹ
ㅅㅜㄱㅏㅇㅓㅂㅅㅓ
2023년
석고 성형, 콘크리트 블록,
시멘트, 설치
약 180×1,120×960 cm

작품 제공
작가, 아넛 헬링크 갤러리

제작 후원
네덜란드 크리에이티브
인더스트리즈 펀드

**creative industries
fund NL**

요쎄 필/Josse PYL

*CAN TT AST EMY
TH OUG HTS*
2023
molded plaster, concrete
blocks, cement, installation
approx. 180×1,120×960 cm

Courtesy
The artist and Annet Gelink
Gallery

Sponsored by
Creative Industries
Fund NL

**creative industries
fund NL**

LEE

이한범은 미술 비평가 겸 편집자다.
나선프레스와 나선도서관을
설립하여 운영한다.

Lee Hanbum is an art critic
and editor. He is the
founder of Rasun Press
and Rasun Library.

이 한 범

Hanbum

〈회색 연구〉는 '회색'을 프로토콜 삼아 활자 영역과 소리 영역을 교차시키는 시도다. 타이포그래피가 검은색(글자)과 흰색(바탕) 사이, 즉 회색 영역을 조정해 생산되는 효과를 총체적으로 다루는 방법이라면, 소리 또한 진동과 진동이 이루어지는 공간 사이의 관계에서 형성되는 현상이며, 우리가 소리라고 인식하는 것은 그 관계의 끊임없는 움직임이라고 할 수 있다. 이때 현장 녹음은 소리의 회색 영역을 포착하고 재생산하는 방법이 된다. 이를 비틀어 생각하면 우리가 기술이라고 일컫는 역량과 무언가를 무언가로서 인식하는 의식 과정에는 모두 회색 영역이 관여되어 있다고 가정해 볼 수 있고, 〈회색 연구〉는 회색 영역을 다루는 다양한 기술적 실천을 고찰하며 이 가정을 확인해 보려는 탐구다.

〈회색 연구〉의 결과는 전시에서 글쓰기와 소리 설치로 구현되고 읽기와 듣기로 공유된다. 글은 타이포그래피에서 회색의 기능과 회색 영역의 사건으로서 소리를 탐색하는 방법론인 현장 녹음에 관한 논의를 축으로 회색 영역을 움직임 그 자체로서 탐색한다. 소리는 특정 대상을 주목하거나 내세우는 대신 마치 풍경처럼 끊임없이 변하는 관계의 양상을 다룬다. 즉, 요소들이 공간에서 움직이고 변형되는 풍경을 청취하고 여기서 산출되는 감각과 이미지로 회색 인식론을 제안한다. 글과 소리 설치는 전시장 안에 숨겨진 공간이나 복도, 계단과 같은 전이 공간 곳곳에서 예상치 못하게 발견될 것이다.

이한범／LEE Hanbum

born in Busan, South Korea / based in Seoul, South Korea

Gray Studies: Movements in between is an attempt to intersect the realms of print and sound using "gray" as a protocol. If typography is a holistic approach to adjusting the gray area between black (letters) and white (background), which is the effect produced by manipulating the gray area, the sound is also a phenomenon shaped by the relationship between vibrations and the space in which they occur. As such, what we perceive as sound is the constant movement of that relationship. In this case, field recording becomes a way to capture and reproduce the gray areas of sound. A possible twist on this is to assume that both the capabilities we call technology and the conscious process of perceiving something as an object involve gray areas. In this sense, *Gray Studies* is an exploration of this assumption by examining various technological practices that deal with gray areas.

The results of *Gray Studies* are brought to life in the exhibition as a writing and a sound installation, which are shared through reading and listening. The text centers on a discussion of the function of gray in typography and a discussion of field recording, a methodology that explores sound as an event in the gray zone, and explores the gray as motion itself. Instead of calling attention to or emphasizing a specific object, sound explores an ever-changing nature of relationships that shifts like a landscape.

회색 연구
2023년
사운드 설치(반복 재생), 종이에
오프셋 인쇄, 29.7×42cm (3)

이한범／LEE Hanbum

In other words, it listens to the landscape where elements move
and transform in space, and proposes a gray epistemology
with sensations and images that are produced by the landscape.
Text and sound installations will be found unexpectedly in a variety
of liminal spaces that include hidden spaces within the exhibition,
hallways, and staircases, among others.

Gray Studies:
Movements in between
2023
sound installation (looped),
offset print on paper,
29.7×42cm (3)

Movements
in between

Movements
in between

Movements
in between

슬라브

Slavs

슬라브와 타타르는 유라시아로 알려진 베를린 장벽 동쪽과 만리장성 서쪽 영역을 중심으로 논쟁과 친목을 다져 온 당파적 집단이다. 이들의 작업은 전시와 책, '렉처 퍼포먼스'라는 세 가지 활동을 기반으로 한다. 슬라브와 타타르는 자신들이 속한 지역의 젊은 전문가를 위한 레지던시와 멘토링 프로그램을 시작하는 한편, 베를린 모아비트에 있는 스튜디오에서 조금 떨어진 곳에 슬라브식 아페리티보 바와 프로젝트 공간을 겸하는 피클 바를 열었다. 온라인 숍 메르크츠바우도 운영한다.

와

and

Ta

타

타르

타

tars

틀

Slavs and Tatars is a faction of polemics and intimacies devoted to an area east of the former Berlin Wall and west of the Great Wall of China known as Eurasia. The collective's practice is based on three activities: exhibitions, books, and lecture-performances. In addition to launching a residency and mentorship program for young professionals from their region, Slavs and Tatars opened Pickle Bar, a Slavic aperitivo bar-cum-project space a few doors down from their studio in Berlin-Moabit, as well as an online merchandising store: MERCZbau.

열 개의 카펫으로 이뤄진 연작 〈사랑의 편지〉는 러시아와 튀르키예의 20세기 문자 개혁을 중심으로 국가가 말에 특정 문자를 강요하는 '알파벳 정치'를 다루며, 모국어를 외국 문자로 읽고 써야 하는 고통스러운 경험과 이를 수용하기 위한 언어 곡예를 풍자한다.

슬라브와 타타르는 러시아 시인이자 극작가인 블라디미르 마야콥스키의 작품 『주술사도, 신도, 신의 천사도 농노에게는 아무런 도움이 되지 않는다(НИ ЗНАХАРЬ НИ／БОГ НИ СЛУГИ БОГА НАМ НЕ ПОДМОГА)』(1923)에서 귀족, 성직자, 종교 등을 풍자한 그림을 바탕으로 캐리커처를 그리고, 이를 관람객이 앉을 수 있는 카펫 형태로 제작했다. 열 개의 카펫을 관통하는 주제는 문자와 소리의 불화, 혀, 대중 등 문자 개혁의 희생양과 근대화에 따른 트라우마다. 전시에서는 그중 다섯 작품을 소개한다.

1917년 러시아 혁명 직후 볼셰비키는 러시아 제국 시절 이슬람교도와 튀르키예어를 쓰던 민족이 사용하던 아랍 문자를 연방 내 130여 개 언어의 표기 통일, 사회주의 확산 등을 이유로 라틴 문자로 교체했고, 1924년 레닌 사후에 집권한 스탈린은 소비에트 단일 국가를 강조하며 라틴 문자를 다시 키릴 문자로 바꾸는 문자 개혁을 했다.

〈사랑의 편지 1번〉은 키릴 문자에 없던 음소나 소리에 키릴 문자(자소)를 할당하려는 시도가 실패하는 장면을 담고 있다. 〈사랑의 편지 2번〉에서 혀는 철창에 갇혀 몸부림치며 음소(소리)에 자소(문자)을 맞추려는 제도 권력에

슬라브와 타타르／Slavs and Tatars

Love Letters, composed of ten carpets, centers on 20th-century orthography reforms in Russia and Turkey and addresses "alphabet politics," in which the state imposes certain letters on spoken words. It satirizes the painful experience of reading and writing one's native language in a foreign script and the linguistic acrobatics to accommodate it.

Slavs and Tatars drew caricatures based on paintings by Russian poet and playwright Vladimir Mayakovsky in his play *Neither Healer, nor God, nor the Angels of God Are Any Help to the Peasantry* (1923), which satirized aristocracy, clergy, and religion, and made them into carpets for visitors to sit on. The theme that permeates the ten carpets is the discord between letters and sounds, the tongue and the masses: the casualties of language reform and the traumas of modernization. In this exhibition, five works from the series are presented.

Shortly after the Russian Revolution in 1917, the Bolsheviks replaced the Arabic script used by Muslim and Turkic-speaking peoples during the Russian Empire with the Latin script, claiming that they wanted to unify the writing of the 130 languages in the federation and spread socialism. Stalin, who came to power after Lenin's death in 1924, emphasized the united Soviet state and instituted a language reform that changed the Latin alphabet

저항한다. 〈사랑의 편지 3번〉에는 여러 언어를 수용하기 위해 '저글링'하며
곡예를 펼치는 네 갈래의 혀가 등장한다. 관람객이 앉을 수 있는 〈사랑의
편지 9번〉은 1939년에 소수 민족어의 표기법을 라틴 문자에서 키릴 문자로
다시 바꾸면서 언어마다 조금씩 다른 모양의 키릴 문자를 쓰도록 해 소수 민족의
소통을 막은 소비에트의 분할 통치를 풍자한다. 카펫 속 인물은 다섯 개의
다른 글자로 쓰인 같은 소리 "[ʤ]"를 외치며 괴로워한다.

한편, 튀르키예 공화국을 세운 무스타파 케말 아타튀르크는 1928년에
근대화를 목표로 튀르키예어 표기에 쓰던 아랍 문자 대신 라틴 문자를 도입한다.
그러나 여러 나라의 문자 개혁 역사에서 이 정교한 작업을 언어학자가
맡는 일은 드물었다. 정치인, 민족주의자, 아마추어 언어학자가 언어라는
살아 있는 체계를 바꿨다. 〈사랑의 편지 8번〉에는 히잡을 쓴 농민 여성이
"KURUMUMSU(쿠루뭄수)"에 치여 절단된 장면이 나온다. 이는
문자 개혁을 주관한 튀르크 국립 국어원(Türk Dil Kurumu)을 풍자한 것으로
'쿠룸(kurum)'은 튀르키예어로 '기관'이라는 뜻이고 '쿠루뭄수'는
'기관 같은'이라는 뜻으로, 작품 속 등장인물은 제도에 따른 언어 근대화와
'개혁'의 또 다른 희생자다.

슬라브와 타타르/Slavs and Tatars

back to Cyrillic. Around 1940, all Soviet republics were forced
to abandon the Latin alphabet and adopt the Cyrillic alphabet in a
short period of time.

Love Letters no.1 depicts an unsuccessful attempt to assign
Cyrillic letters (graphemes) to phonemes or sounds that do
not exist in the Cyrillic alphabet. In *Love Letters no.2*, the tongue
struggles in a cage, rebelling against the institutional power
that attempts to fit phonemes (sounds) to graphemes (letters).
Love Letters no.3 features a four-pronged tongue that acrobatically
'juggles' to accommodate multiple languages. پ[p] / چ[ch] / ژ[j] /
گ[g] are additions to the Persian script, which is an adaptation
of the Arabic script to represent Persian phonemes not found
in Arabic. *Love Letters no.9*, which can be seated by the audience,
satirizes the Soviet Union's divisive rule in 1939, when it changed
the notation of minority languages back to Cyrillic from Latin,
forcing each language to write a slightly different-looking Cyrillic
script, preventing minorities from communicating. The person
depicted in the carpet is in distress, shouting out "[ʤ]," written
in five different letters. Meanwhile, Mustafa Kemal Atatürk, who founded the Republic
of Turkey in 1928, introduced Latin script to replace the Arabic
script used to write Turkish in an effort to modernize

슬라브와 타타르／Slavs and Tatars

the language. However, in the history of language reform
in many countries, it was rare for linguists to take on this elaborate
task. It was politicians, nationalists, and amateur linguists
who changed the living system of language. In *Love Letters no.8*,
a peasant woman wearing a hijab is amputated after being hit
by a "Kurumumsu." "Kurumumsu" means "institutional," and the
character is another victim of institutionalized language
modernization and "reform."

Love Letters no.1, 2, 3, 8, 9
2013–2014
woollen yarn,
approx. 250×250 cm (5)

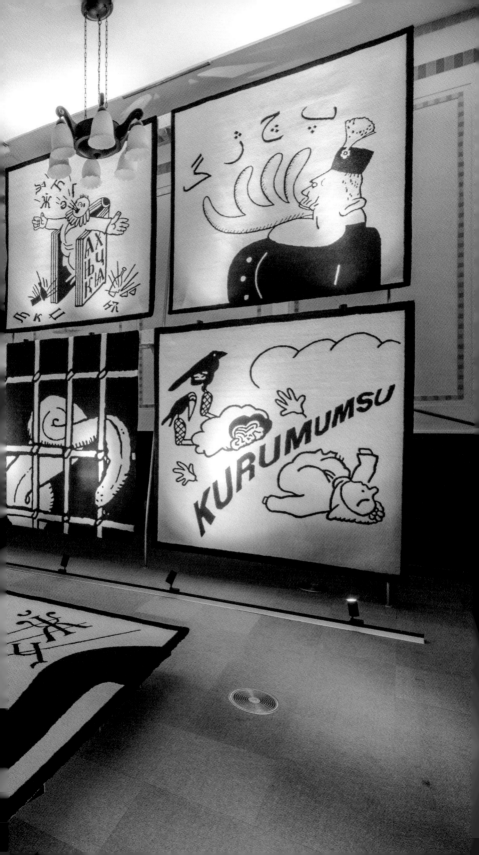

Jo

조혜진은 서울에서 활동하는 조각가다. 사회 구성원의 행동 양식과 이를 반영하는 형태로서 사물에 주목한다. 사회의 필요에 따라 사물이 생산, 소비되는 운동성과 조각하기를 상호 참조적 관계로 설정하고, 조각 매체에 관한 탐구를 작업의 동력으로 삼는다. 개인전 《꼴, 모양, 자리.》(스페이스 윌링앤딜링, 서울, 2021)에서 이주민의 손 글씨를 폰트로 만들어 배포하고, 《옆에서 본 모양: 참조의 기술》(d/p, 서울, 2019)에서는 실용신안 문서를 조각의 영역으로 가져와 해석했다.

Jo Hyejin is a sculptor based in Seoul. In her practice, she focuses on how members of society behave and on objects as forms that reflect such behaviors. She establishes a cross-referential relationship between kineticity and sculpture, where objects are produced and consumed according to the needs of society. As such, she established her exploration of the sculptural medium as the motif that drives her work. For her solo exhibition *Look, Shape, Place* (Space Willing N Dealing, Seoul, 2021), she created and distributed the handwriting of migrants as a font. For *Shape, From the Side: Reading Documents* (d/p, Seoul, 2019), she brought patent documents into the realm of sculpture and interpreted them.

Hye

조 Jin

〈이주하는 서체〉는 조혜진이 2018년, 2020년, 2022년 세 차례에 걸쳐 한국에 사는 이주민의 손 글씨를 수집해 만든 폰트다. 이 작품은 이주민 참여자가 한국 생활에서 가장 많이 쓰는 말, 가장 많이 듣는 말, 좋아하는 문장, 가족 이름 등을 묻는 설문지를 작성하는 데서 시작한다. 작가는 회수한 설문지에서 글자를 골라 외곽선을 따고 폰트를 만든 다음, 그것을 프로젝트 웹 사이트에서 무료로 배포한다.

13개국에서 온 54명의 이주민이 채운 〈이주하는 서체〉는 숫자와 기호를 포함한 620자로 구성돼 있다. 작가는 글자체를 일종의 위계가 작동하는 체계로 보고, 한글 바탕체 사이에 이주민들의 글자체를 섞는 방식으로 그 체계에 균열 내기를 시도한다.

"한글 11,172자 가운데 일상에서 쓰는 것은 2,350자 정도이고, 그중 특히 많이 쓰는 것은 210자 정도로 압축된다. 〈이주하는 서체〉에는 참여자의 모국어 발음을 따라 포함된, 210자 바깥에 있는 글자도 있다. 이는 한국인에게 의미를 갖는 한글 단어만으로는 채울 수 없는 고유한 영역이며, 실용성에 밀려 한글 폰트 개발에서 자주 배제하는 영역이다. 이런 관계 구조는 일상 곳곳에 스민 이주민과 한국인의 구별 짓기를 은유한다."

〈이주하는 서체〉와 함께 설치된 〈다섯 개의 바다〉는 강릉에 사는 이주민들과의 인터뷰에서 반복적으로 등장하던 단어인 '바다'에 관한 인상을 다룬다. 조혜진은 다섯 사람이 쓴 '바다'라는 글씨를 확대해 그 외곽선

조혜진 / JO Hyejin

born in Seoul, South Korea / based in Seoul, South Korea

Migrating Typeface is a font created by Jo Hyejin by collecting the handwriting of migrant people living in South Korea in 2018, 2020, and 2022. The production of the work begins with the migrant participants filling out a questionnaire that asks them about their life in Korea, including the words they use most, the words they hear most, their favorite sentences, and the names of their families. The artist then selects letters from the returned questionnaires, outlines them, creates a font, and distributes it for free on the project's website.

Created by 54 migrants from 13 countries, the *Migrating Typeface* consists of 620 characters, including numbers and symbols. The artist considers fonts as a hierarchical system and tries to disrupt that system by mixing the fonts of migrants among the letters written in Korean Batangche font.

"Of the 11,172 characters in Hangeul, we use about 2,350 characters in our daily lives, and the ones we use a lot are compressed to about 210 characters. *Migrating Typeface* includes characters that exist outside of these 210 characters, created by the participant's native language pronunciation. This is a particular area that can't be filled with simply Hangeul words that are meaningful to Koreans, and it's an area that is often left out of Hangeul font development for practical reasons.

일부를 흙으로 둑처럼 쌓아 올렸다. 설문지에 쓰인 글씨는 납작하지만 손의 반복적인 움직임으로 체화한 것이자 이주민 각자의 경험을 담고 있다. 작가는 그 일부를 입체 조형물로 제작해 평면의 글씨 너머에 존재하는 개인의 구체적인 삶을 떠올리고 상상해 보기를 권한다.

이주하는 서체
2023년
한글 글자꼴 620자,
종이에 디지털 프린트,
관련 자료

다섯 개의 바다
2022년
라텍스 타일, 47×47 cm (23)

조혜진 / JO Hyejin

This relationship structure is a metaphor for the distinction between immigrants and Koreans in everyday life."
Installed alongside *Migrating Typeface, Five Seas* is a work that deals with the impression of "sea," a recurring word in interviews with migrants living in Gangneung. In this work, the artist enlarges the word "sea" written by five people and mounds some of its outline with earth. Made of tiles, the artwork is placed on the floor of the exhibition space to create a boundary, but that boundary is not high, easily crossed, and easily broken. The letters written on the questionnaires are flat, but they are embodied in the repetitive movements of the hands and represent the experiences of each migrant. The artist creates a three-dimensional sculpture of some of these letters, inviting us to think about and imagine the specific lives of individuals that exist beyond the flat text.

Migrating Typeface
2023
Hangeul letter form
620 characters,
digital print on paper,
related materials

Five Seas
2022
latex tile, 47×47 cm (23)

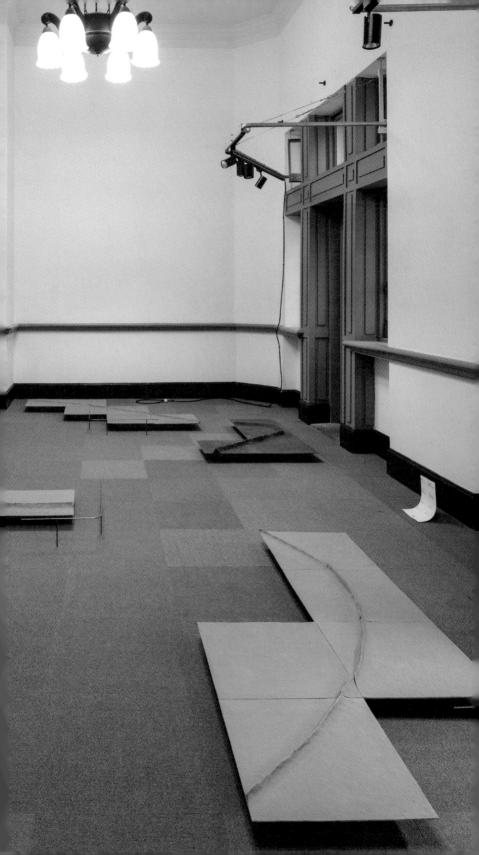

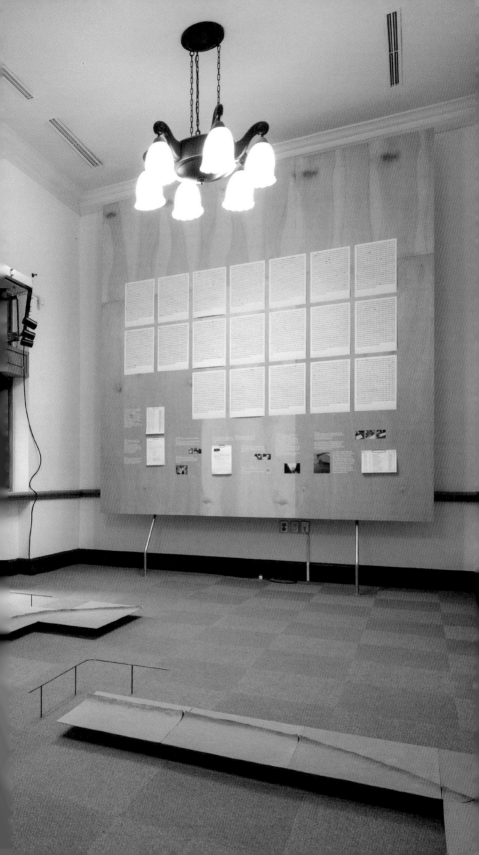

2018.11.10
다문화 가족 자녀를 대상으로 하는 진로교육 박람회에
부스 운영.
프로젝트를 설명하고 시험 버전인 서체(370자)를 이용해
원하는 글씨를 출력해 주는 행사를 진행하였다.
추가로 설문지를 배포하고 손글씨 응답을 받는 자리였다.

2018.11.13
양평군 청운 중학교 학생 대상 워크숍 진행.
서체로 제작된 각 낱글자를 책으로 엮어 나누어주고
제한된 글자 안에서 단어를 만들어내는 놀이 형태의
활동을 하였다.

2020.5
"이주하는 서체"를 확장하고 이를 활용한 교육
프로그램 개발을 목표로 경기문화재단의 <다이아
프로젝트>에 참여하였다. 킴킴갤러리의 기획으로
진행되었다.

2020.9
한강학술문화교류네트워
조이스터디 지역아동센
거주하고있는 이주민의

2020.10.
조이스터디
대상으로
손글씨를
이용하면

2020.11
프로젝트
2021.4
장수영 디
안정화 및

2020.9
한강학술문화교류네트워크, 코리아외국인학교,
조이스터디 지역아동센터의 협력으로 한국에
거주하고있는 이주민의 손글씨를 수집하였다.

2020.10.21
조이스터디 지역아동센터에서 다문화가정 자녀들을
대상으로 워크숍을 진행하였다. 이주해온 부모님이
손글씨로 참여하고 그 글자를 카드로 만들어 워크숍에
이용하였다.

2021.6.24-7.14
"이주하는 서체" 관련 전시 <꼴, 모양, 자리.>를
스페이스 윌링앤딜링에서 열었다.
완성된 "이주하는 서체" 작업을 전시를 통해
소개하면서 그간의 과정을 갈무리하는 자리였다.
또 다른 주체의 참여로 이주민에 대한 이야기를
나눌 수 있기를 바랐고, "이주하는 서체"가 이
매개하고 확장시키기를 바랐다.
전시 <꼴, 모양, 자리.>에서는 "이주하는 서체"
활용해 전시 기간 동안 작가가 제공한 글과 문서
필사하고 참여자들이 필사한 내용을 엮어 서체
활용예시로 삼고자 했다.
이민지 큐레이터가 내부 대화자로서 서체와 전
연결에 대해 고민하고 함께 전시를 만들었다.

2020.11
프로젝트 정리와 서체배포를 위한 웹사이트 제작
2021.4
장수영 디자이너, 노영권 엔지니어의 도움으로 서체
안정화 및 배포(509자)

이주하는 서체 다운로드 사이트

었엤엣엙엜엜엥여역워엱연엱뎧엳엹엳엶엲엶엳엶엷엶엫
엿연엶엿엹엳엹엳영예옉옏옍옎옌옐옑옒옓옔옕옖옘옙옘
옙엡엣엥엥옣옃옄옐옗옒오옥유유은옫옷옫옽옭옮옱옫옷옹
옴읍읎옺읒읎옹옺옺옷옫옽옹옿우유유읗은읗옺웋
옺옮옱옲옳옴옵옦옽옺읒옫오옺옷옥옫옹옹워워워워원워워월
월읝읥읦읧읝임입읷읻잇잉잍잋임엹읽위엑엒엔웬웬웬
웬엘읽엙읝엕엝엝엕엝엕엘엘엘엠엔엘엘휘워워워인
엱읝읟월읽읾일읽읾일임입잇잇읝엉잇읹읤읱읝윺유윸
윤읗윰은윻읽윪욶윺윻읠융읍육여융윳윳읗읖융욯율읗은으읔
유유읗읗은을읽읎읎읐읒읍융읍읎욌읔융옷옻옹읔읕읖융읫
읙위읙읠읖을읽읙읜읨읛읝읝옰옴읍읝잇잇잉잊읟옽읦옰
읳이익읶잇읹읽임잇읽읿읽읻읻읣임입읽읶잇잇읤잉잊잋읷읽
잃잉

김 뇌연

KIM Nuiyeon

KIM

김뉘연·전용완은 언어를 재료로 작업한다. 〈문학적으로 걷기〉(국립현대미술관, 서울, 2016), 〈수사학—장식과 여담〉(아르코미술관, 서울, 2017), 〈마침〉(아트선재센터, 서울, 2019), 《방》(온수공간, 서울, 2020) 등으로 문서를 발표했다.

JEON 전 완

Yongwan

Yongwan

Kim Nuiyeon & Jeon Yongwan work with language as a material. They have presented their documents and writings on a number of occasions, including *Literary Walks* (MMCA Seoul, 2016), *Rhetoric—Embellishment and Digression* (ARKO Art Center, Seoul, 2017), *Period* (Art Sonje Center, Seoul, 2019), *La Piéce* (Onsu Gong-gan, Seoul, 2020).

김뉘연
한국 서울 출생 / 한국 서울에서 활동

전용완
한국 서울 출생 / 한국 서울에서 활동

『제3작품집』(2023)은 시각 예술가이자 저술가 테레사 학경 차(1951–1982)의
『딕테(DICTEE)』(1982)를 이어 쓰고, 다시 쓰고, 다르게 쓴다. 이는 하나의
정체성에 고정되지 않는 실험적인 책『딕테』를 과정으로서 열린 책으로 바라본
결과로, 새롭게 쓰이는 과정을 통해『제3작품집』역시 과정으로서 열린
책이 되어 간다. 과정은 이어서 쓰이는 필연성을 동반하고 담보하며, 안팎을
확장해 나가는 움직임이다. 'DICTEE'는 '받아쓰기'를 뜻하는 프랑스어이다.
『딕테』의 '말하는 여자'는 사라져 잊힌 음성들을 듣고 받아쓴다. 들리는
소리를 말하고 쓰는 행위는 여러 사람을 통해 반복되고 중첩되고 확산될 수 있다.
　　『제3작품집』은『딕테』의 아홉 장(章)을 제목 없는 9막으로 반영한다.
책의 시작과 끝에 여닫는 글이 자리하며, 이 글들은 서로를 반영하며 순환한다.
각 막은 테레사 학경 차의 여러 예술 작품에서 비롯된 시로 시작한다.
뒤이어 다양한 형식의 글이 몇몇 도판과 함께 흐른다.
　　『제3작품집』에서 이어 쓰이고, 다시 쓰이고, 다르게 쓰인 다성적인
잉여의 목소리들은『딕테』라는 시공간 안팎에 존재하는 '제3의 부류'를 향한다.
한 사회의 소수를 상징하는 제3의 부류를 확장하는 제3의 공간으로서의
'쓰기'로 펼쳐진 글들은 해체되고, 분리되고, 인용되고, 반복되고,
중첩되고, 연쇄되고, 혼종되며 불완전하고 비선형적이고 다원적인 궤도를
그려 나간다. 그 모든 과정의 근원에 자리한 것은 다시 언어이다.

김뉘연·전용완／KIM Nuiyeon & JEON Yongwan

KIM Nuiyeon
born in Seoul, South Korea /
based in Seoul, South Korea

JEON Yongwan
born in Seoul, South Korea /
based in Seoul, South Korea

The Third Thing (2023) continues, rewrites, and rewrites *DICTEE*
(1982) by visual artist and author Theresa Hak Kyung Cha (1951–
1982). This is the result of looking at *DICTEE*, an experimental book
that is not fixed in one identity and an open book as a process.
Through the process of rewriting the existing book, *The Third Thing*
also becomes a book that is open through a process. The process
is a movement that accompanies and guarantees the inevitability
of subsequent use, expanding inward and outward. "DICTEE" is the
French word for "dictation." In *DICTEE*, the "talking woman" hears
and transcribes voices that have been lost and forgotten.
The act of speaking and writing audible sounds can be repeated,
nested, and spread through multiple people.
　　The Third Thing reflects the nine chapters of *DICTEE* in nine
untitled acts. There are opening and closing essays at the
beginning and end of the book, and they cycle through each other.
Each act begins with a poem that comes from one of Teresa Hak
Kyung Cha's many works of art. This is followed by a series of texts
in a variety of formats, along with a few images.
　　The polyphonic, surplus voices that continue to be written,
rewritten, and rewritten differently in *The Third Thing* are directed
toward the "third kind" that exists within and outside of the time
and space of *DICTEE*. Unfolded as "writing" as a third space

제3작품집
2023년
종이에 오프셋 인쇄, 사철,
하드커버, 17.4×16 cm, 216쪽

김뉘연·전용완／KIM Nuiyeon & JEON Yongwan

that expands the third kind, which symbolizes the minority in a society, these texts are deconstructed, separated, quoted, repeated, superimposed, chained, and hybridized, and in doing so, draw incomplete, non-linear, and pluralistic trajectories. Once again, language is at the root of it all.

The Third Thing
2023
offset print on paper,
thread sewn binding,
hardcover, 17.4×16 cm,
216 pages

머 티

라트나 라마나탄
(인도 첸나이 출생 /
영국 런던에서 활동)
디자이너이자 연구자다. 미국, 영국,
인도 아대륙 사이에서 진행되는
연구 중심의 다문화, 다중 플랫폼
그래픽 커뮤니케이션에 관한 전문성으로
널리 알려졌다. 현재 센트럴 세인트
마틴스의 학장으로 재직 중이다.

존 허드슨
(영국 브리스틀 출생 /
캐나다 가브리올라섬에서 활동)
다양한 문자 체계를 위한 활자체를
디자인하고 폰트를 제작한다.
작은 회사지만 30년이 넘는 시간 동안
전 세계에서 가장 널리 쓰이는 여러
폰트를 제작한 티로 타입웍스의
공동 설립자이기도 하다. 방송과 웹 폰트
표준에 기여한 공로로 2022년에
에미상을 받았다.

헨릭 쿠벨
(덴마크 코펜하겐 출생 /
영국 런던에서 활동)
활자 디자이너이자 타입 파운드리
'A2타입'의 공동 설립자다. A2타입의
폰트 라이브러리는 지난 20년 동안
제작된 100개 이상의 고유한
활자체(1,000개 이상의 폰트)를
아우른다. 2010년에 A2타입을
설립한 이래 업계를 이끄는
디자인 회사나 글로벌 고객과 함께
일하며 전 세계 브랜드, 신문,
서적, 잡지, 저널을 위한 맞춤형
활자체 시스템을 만들어 왔다.

타이터스 네메스
(오스트리아 뫼들링 출생 /
오스트리아 빈에서 활동)
타이포그래피 디자이너이자 역사가다.
아랍어와 다국어 활자 디자인과
타이포그래피를 중심으로 작업하며,
『기계 시대의 아랍어 활자 제작』
(Brill, 2017)을 쓰고 『아랍어
타이포그래피: 역사와 실천』
(니글리, 2023)을 편집하는 등
저작 활동을 펼치고 있다.

피오나 로스
(영국 런던 출생 /
영국 글로스터셔에서 활동)
남아시아 활자 디자인과 타이포그래피
전문가로, 언어학에 관한 배경
지식과 인도 고고학 박사 학위를
보유하고 있다. 디자이너이자 글 쓰는
작가이고 강연자이며, 레딩 대학교에서
타이포그래피 디자인 교수로 일한다.
어도비, 하버드 대학교 출판부 등과
함께 작업했다. 2018–2021년에
앨리스 사보이, 헬레나 레카와 함께
20세기에 등장한 유명 활자체
디자인 과정에서 여성의 업적을
조명하는 연구 프로젝트 '활자 속 여성'
(www.women-in-type.com)을
이끌었다.

인 도

Library

India

of

Classical

Fiona ROSS
(born in London, UK /
based in Gloucestershire, UK)
Ross specializes in South Asian
type design and typography,
having a background in languages
and a Ph.D. in Indian Palaeography.
She works as a designer, author,
lecturer, and Professor in Type
Design at the University of
Reading. She has collaborated
with Adobe and Harvard University
Press. Between 2018 and 2021,
she led the research project
Women in Type (www.women-in-
type.com) with Alice Savoi and
Helena Lekka, which shed light
on the contributions of women
in the design of some of the most
famous typefaces of the
20th century.

Rathna RAMANATHAN
(born in Chennai, India /
based in London, UK)
Ramanathan is a designer and
researcher known for her
expertise in research-driven,
intercultural, multi-platform
graphic communication design
projects between the US, UK,
and the Indian subcontinent.
She is the Head of College at
Central Saint Martins.

John HUDSON
(born in Bristol, UK /
based in Gabriola, Canada)
Hudson designs typefaces and
makes fonts for a wide range of
writing systems. He is co-founder
of Tiro Typeworks, a tiny company
that for over 30 years has
made some of the world's most
widely used fonts. In 2022,
he received an Emmy award for
his contributions to broadcast
and web font standards.

Henrik KUBEL
(born in Copenhagen, Denmark /
based in London, UK)
Kubel is a type designer and
co-founder of type foundry
A2-TYPE. A2's library of fonts now
includes more than 100 unique
typefaces (well over 1000 fonts)
created over the past 20 years.
Since launching A2-TYPE in 2010,
the team has collaborated with
leading design companies and
global clients to create bespoke
typeface systems for brands,
newspapers, books, magazines,
and journals across the world.

Titus NEMETH
(born in Mödling, Austria /
based in Vienna, Austria)
Nemeth is a typographic designer
and historian. His practice
revolves around Arabic and
multilingual type design and
typography, and his publications
include the monograph *Arabic
Type-Making in the Machine
Age* (Brill, 2017) and *Arabic
Typography: History and Practice*
(editor, niggli, 2023).

అవతారిక

౧

శ్రీ వత్సేఖ కుందగంధవి మెదప్పెర
జస్నొంద పిశ్చంధూర
దేవేం దత్త్యమూరాపినపెనవనే శ్రీ
ఉన పిల్చ్వాగే చుంబు
గా సంధాను సమంబుణారి నిఖల
భక్తకేమ దేఁసు రా
తేతాప్పెందు గృత్స్ల్యం ఊయు కుబప్ర్మ
ప్రేం గృప్లీరాయాచిప్రస్.

1

His chest shows the musk
from Lakshmi's breasts, so his worshipers,
Sanandana and the rest,⁰ wonder
if he's brought his other wife, the Earth,
to live there beside her.
May this god with eyes luminous
as the lotus look kindly on our king.

౨

ఉల్లముసిందు పెక్కురేత
మూగకు మీకంలనందూ గంటే మంం
చల్లన మేలమూఞ నన
లాత్మత మూలకు లేఁతవళ్ళ సం
పెళ్ర గిరిపే లాత్పవత
చిత్ర్వకాయ్యునీ ఉయు రాంబరీ
పీఞ్చందు గృప్తప్రయం ర
పీప్లప్లప్రతివం గాప్పుతత్.

2

"No you hunters can show some kindness too."
That's what the daughter of the stony mountain
says, making fun of him, and Shiva smiles,
gained us a hunter, as he blesses Arjuna¹
with the mightiest of weapons.²
We pray that he gives Krishnaraya, our king,
all the good things he wants.³

2 3

२४५ 245

नीके॰

रखियौ जसुमति मइया, नीके...
आबहिंगे दिन पंचग सात मैं
हम अरु हलधर भइया, नीके...
बंसी बेंत विषान देखियौ
आहुं अबेर सबेरी, नीके...
लै जिनि जाइ चुराइ राधिका
कछु चितौन मेरी, नीके...
ज्या दिन तैं हम तुम तैं बिछुरे
कोउ न कहत कन्हइया, नीके...
उठत न कलेऊ कियौ सबेरे
सांझ न चौपों गइया, नीके...
कहतयों बनै संदेश उठायो तैं
जननि जिती दुष पायौ, नीके...
अब सो॰ श्री बसुदेव देवकी
कहत आपनौ जायौ, नीके...
कहियैं कहा नंद बाबा सौं
कहत्यों निठुर नव कीनौ, नीके...
सूर हमहिं पहुंचाइ मथुपुरी
बहुरि न सोधी लीनौ,¹⁰ नीके...

Mother Yashoda, rest assured—
We'll both be home in five or seven days,
brother Haladhar* and I.
Meantime, now and then, check on my flute,
check on my staff and the horn I blow.
Don't let Radhika pilfer away
any of my favorite playthings.
Ever since the day you and I parted,
no one's called me Little Kanh.
No one rises early to make me breakfast
or gives me fresh milk at night.
No news ever comes from your direction
to tell me how my mother suffers.
And now Vasudev and Devaki say
that really I was born to them.
What can be said about Father Nanda?
How cruel-hearted he has been
to bring me here to Mathura, says Sur,
and never seek me out again!

* Balaram, who bears the plow as his emblem.

418 419

NOTES TO THE TEXT NOTES TO THE TEXT

[Dense footnote apparatus in Devanagari and English, largely illegible at this resolution]

772 773

머티 인도 고전 총서는 인도 고전 문헌에 영어 번역을 더해 2개 국어로 출판하는 도서 시리즈다. 하버드 대학교 출판부의 의뢰로 피오나 로스, 라트나 라마나탄, 존 허드슨, 헨릭 쿠벨, 타이터스 네메스, 굴리엘모 로시가 협업해 디자인했다.

이 프로젝트는 『베다』를 포함해 정교한 구전 전통을 반영하는 고대 인도의 문학, 역사, 종교 문헌을 다양한 인도어와 그에 따른 표기 체계로 선보인다. 허드슨과 로스는 오래된 문헌들을 제대로 담아내기 위해 방대한 아카이브 연구를 거쳐 '머티 글자체'를 개발했다. 책에서 인도어에는 머티 글자체인 〈머티 벵골〉, 〈머티 힌디〉, 〈머티 칸나다〉, 〈머티 구르무키〉, 〈머티 산스크리트〉, 〈머티 텔루구〉를, 페르시아어에는 네메스가 디자인한 글자체 〈나심〉을, 영어에는 쿠벨이 디자인한 〈앤트워프〉를 적용했다.

라트나 라마나탄과 굴리엘모 로시는 인도어 필사본과 초기 인쇄물 연구를 바탕으로 표지와 본문을 디자인하고 조판했다. 본문 디자인은 독립된 선율을 가지는 둘 이상의 성부로 이뤄진 다성 음악에서 영감을 받아 대칭 구조로 짜고, 인도 문자와 라틴 문자의 서로 다른 특징과 시나 산문 같은 글 형식에 따라 여백, 단락 폭, 글줄 사이, 글자 크기 등을 유연하게 조정할 수 있도록 했다. 이는 두 언어의 차이를 공개적으로 인정하고 수용하며, 독해의 동시성을 찾고, 상호 텍스트성을 부각하는 과정이었다.

로스는 《타이포그래픽스 2016》* 온라인 강연에서 이렇게 말했다. "라틴 문자로 작성하지 않은(non-Latin) 글이 라틴 문자로 쓴 글과 질과 선택의

머티 인도 고전 총서/Murty Classical Library of India

Murty Classical Library of India is a bilingual book series that publishes classical Indian literature with English translations. The project was commissioned by Harvard University Press and designed by Fiona Ross, Rathna Ramanathan, John Hudson, Henrik Kubel, Titus Nemeth, and Guglielmo Rossi.

This project presents the literary, historical, and religious texts of ancient India, including the *Vedas*, which reflect a sophisticated oral culture, in a variety of Indian languages and corresponding notational systems. Hudson and Ross did extensive archival research to ensure that the old literature was properly presented, which led to the creation of Murty Typefaces. For Indian languages, they used the Murty Typefaces: Murty Bengla, Murty Hindi, Murty Kannada, Murty Gurmukhi, Murty Sanskrit, and Murty Telugu; for Persian, they used Nasim, a typeface designed by Titus Nemeth; and for English, they used Antwerp, a typeface designed by Henrik Kubel.

Rathna Ramanathan and Guglielmo Rossi designed and typeset the cover and text based on research of Indian manuscripts and early printed materials. The text design is inspired by musical polyphony, which consists of two or more voices with independent melodies, and is organized in a symmetrical structure, allowing for flexible adjustment of margins, column widths,

면에서 동등해져서 '라틴어로 쓰이지 않은(non-Latin)'이라는 용어가
완전히 사라졌으면 합니다! 예컨대 휴대폰에서 고유한 문자를 표시할 수 있게
돼서 소수 민족 공동체들이 제대로 읽힐 수 있는 문자 메시지를 보내기 위해
라틴 문자로 자신의 메시지를 음역할 필요가 없어진다면 좋겠습니다."

라마나탄은 쿠퍼 유니온 온라인 강연**에서 머티 인도 고전 총서를
예로 들며 타이포그래피가 구술 문화를 문자 문화로 번역할 때 고려할 점을
이렇게 말한다. "말에 담긴 영적 의미를 전달하기 위해서는 단어가 정확하게
반복되어야 할 뿐만 아니라 특정한 리듬, 운율, 음색이 재현돼야 합니다.
이는 단어의 소리가 단어 자체만큼이나 많은 것을 뜻한다는 믿음에 기반한
생각입니다."

머티 인도 고전 총서는 디자인 연구, 협업, 공예 영역의 성취뿐 아니라,
다양한 인도 문자의 특성을 반영한 글자체 개발로 인도어와 영어의 다른
목소리를 존중하고, 다양성과 접근성을 북 디자인에서 어떻게 구체화할 수
있는지를 보여 주는 귀한 사례다.

머티 인도 고전 총서／Murty Classical Library of India

interlinear spacing, type size, etc., according to the different
characteristics of Indian and Latin scripts and writing styles such
as poetry and prose. It was a process of openly acknowledging
and embracing the differences between the two languages,
finding synchronicity in reading, and emphasizing intertextuality.

In her Typographics 2016*online talk, Fiona Ross said,
"I would like non-Latin scripts to achieve parity with Latin in terms
of quality and choice—then the term 'non-Latin' could become
completely redundant! For instance, I would like to see authentic
script representation on mobile phones so communities would
no longer need to transliterate into Latin script in order to
send readable text messages."

In his Cooper Union online lecture**, Rathna Ramanathan
used the example of the Murty Classical Library of India to talk
about what typography should consider when translating an oral
culture into a written one. "Not only do the words need to be
repeated exactly, but there's a particular rhythm, cadence, and
sonority that needs to be replicated if the verses are to carry their
spiritual charge. This is based on the belief that the sounds of
words signify as much as the words themselves."

The Murty Classical Library of India is a rare example of how
diversity and accessibility can be embodied in book design, not

*

로스, 피오나. "타이포그래픽스 2016: 하나의 활자체를 고른다면."
유튜브, 타이포그래픽스, 2016년 10월 29일,
https://bit.ly/47XEXoX. 2023년 8월 5일 접속.

**

라마나탄, 라트나. "간문화(Intercultural)와 탈식민:
타이포그래피의 실천을 위한 구조 탐색." 유튜브, 쿠퍼 유니온,
2021년 12월 6일, https://bit.ly/3Z0X6hz.
2023년 8월 5일 접속.

머티 인도 고전 총서／Murty Classical Library of India

only in terms of design research, collaboration, and craft,
but also in honoring the different voices of Indian and English
by developing a typeface that reflects the characteristics
of different Indian scripts.

*

Ross, Fiona. "Typographics 2016: Take One Typeface."
YouTube, Typographics, 29 October 2016,
https://bit.ly/47XEXoX. Accessed August 5, 2023.

**

Ramanathan, Rathna. "Intercultural and decolonial:
exploring frameworks for typographic practice."
YouTube, The Cooper Union, 6 December 2021,
https://bit.ly/3Z0X6hz. Accessed August 5, 2023.

머티 인도 고전 총서
2010년 – 진행 중
종이에 오프셋 인쇄, 사철,
하드커버, 21×13 cm (10)

발행처
하버드 대학교 출판부

창간인
로한 머티

머티 글자체
존 허드슨, 피오나 로스

〈앤트워프〉 디자이너
헨릭 쿠벨

〈나심〉 디자이너
타이터스 네메스

북 디자인, 조판
라트나 라마나탄,
굴리엘모 로시

머티 인도 고전 총서／Murty Classical Library of India

*Murty Classical Library
of India*
2010 – ongoing
offset print on paper,
thread sewn binding,
hardcover, 21×13 cm (10)

Publisher
Harvard University Press

Founder
Rohan Murty

Murty Typefaces
John Hudson and
Fiona Ross

Antwerp Designer
Henrik Kubel

Nassim Designer
Titus Nemeth

Book Design and
Typesetting
Rathna Ramanathan and
Guglielmo Rossi

MURTY CLASSICAL LIBRARY
OF INDIA

Harvard
University
Press

티슈

티슈오피스는 2019년 봄 서울에서 출범한 스타트업이다. 건축, 제품, 그래픽 등 각자 다른 분야에서 활동하던 조직원이 모인 다학제 그룹으로 '선명한, 완결된, 안전한' 것과는 거리를 두며 현상을 바라본다. 주로 게임을 만들며, 화성 곳곳을 탐사하는 문화 예술 메타버스 '쿤트라'(2021)를 발표하고 업데이트 중이다. 자동 번역기는 'TISSUE OFFICE'를 종종 '조직 사무소'로 번역한다.

TISSUE OFFICE is a startup launched in Seoul in the spring of 2019. It is a multidisciplinary group of people from different areas, including architecture, product design, and graphics. In its approach to different phenomena, it distances itself from 'clear, complete, and safe' options. The company's business primarily focuses on producing games. In 2021, TISSUE OFFICE released KUNTRA, a cultural and artistic metaverse exploring all corners of Avnet Mars. Currently, the company is providing constant updates on the service. TISSUE OFFICE is often machine-translated as an "organization office" in Korean since the word 'tissue' also means an organization in Korean.

TISSUE OFFICE

오 오피스 FFICE

주식회사 티슈오피스는 디지털 서비스를 만드는 스타트업이다. 이들은 서비스를 개발할 때 언제나 가설을 세우고 일정한 실험을 거쳐 가설을 검증한 다음 그것을 발전시키거나 폐기한다. 이때 실험이란 대상의 목소리를 듣는 작업이다. 예를 들면 서비스 사용자를 모집해 사용성에 관해 질문하는 사용자 인터뷰나 출시되지 않은 서비스의 최소 기능만을 구현해 목표 고객의 수요를 측정하는 '프로토타이핑' 기법 같은 것들이 그것이다.

설정한 가설이 참이었는지 거짓이었는지는 실험으로 얻은 데이터로 판단한다. 여기서 데이터는 꼭 숫자만을 말하는 것은 아니며, 그 성격에 따라 정량적인 것과 정성적인 것으로 나뉜다. 정량적 데이터는 클릭률, 체류 시간, 전환율 같은 지표적 숫자다. 정성적 데이터는 인터뷰에 참여한 면담자의 반응, 즉 질문에 답하는 음성이나 글은 물론이고 웃음, 침묵 같은 비언어적 표현도 포함한다. 두 데이터 모두 그 자체로 객관적 사실은 아니며 맥락에 따라 수집, 판단된다.

채용 면접은 이러한 데이터 설정이 극대화되는 상황 중 하나다. 면접관은 원하는 인재를 찾기 위해 일정한 조건을 정하고, 지원자가 그 조건에 얼마나 부합하는지를 판단하기 위해 질문을 이어 가며, 지원자의 답변을 각 기준에 따라 검토한 후 합격 여부를 정한다.

티슈오피스는 전시에서 〈2023년 (주)티슈오피스 디자이너 특별 채용 면접〉이라는 제목으로 채용 면접 상황을 재연한다. 면접관은 목소리로,

티슈오피스 / TISSUE OFFICE

TISSUE OFFICE Inc. is a startup that creates digital services. When they develop a service, they always propose a hypothesis, run some experiments to validate it, and then either develop or discard it. In this case, experimentation is about listening to one's audience. For example, they recruit users of the service to conduct user interviews to ask about usability, or they use "prototyping" techniques to gauge the demand of their target audience by implementing only the minimum functionality of an unreleased service.

The data from the experiment will determine whether the hypothesis is true or false. Here, data doesn't necessarily refer to numbers, and can be categorized as quantitative or qualitative depending on its nature. Quantitative data are metrics like click-through rates, dwell time, and conversion rates. Qualitative data refers to the responses of interviewees in an interview, including spoken or written responses to questions, as well as nonverbal expressions such as laughter and silence. Neither data is an objective fact in and of itself, but is collected and judged in context.

Job interviews are one of the situations where this data setup is maximized. The interviewer sets certain criteria to find the right person, asks questions to determine how well the candidate

지원자는 문자로 질문과 대답을 주고받는 이 작품은 관객 참여로 완성되며 서로의 뚜렷한 목적과 필요에 따라 펼쳐지는 일종의 즉흥극 형식을 띤다.

**2023년 (주)티슈오피스
디자이너 특별 채용 면접**
2023년
인터랙티브 설치, 단채널
비디오, 컬러, 사운드,
웹 기반의 반응형 스크린,
웹 카메라, 노트북

티슈오피스／TISSUE OFFICE

meets the criteria, and reviews the candidate's answers against the criteria before deciding whether to hire the person or not.

In this exhibition, TISSUE OFFICE will reenact a recruitment interview situation under the title of *2023 Tissue Office Inc. Designer Special Employment Interview*. With the interviewer asking and answering questions by voice and the candidate by text, the piece is completed with audience participation, a kind of improvisational theater that unfolds according to each other's distinct purposes and needs.

*2023 Tissue Office Inc.
Designer Special
Employment Interview*
2023
interactive installation,
single-channel video, color,
sound, web-based
responsive screen, web
camera, laptop

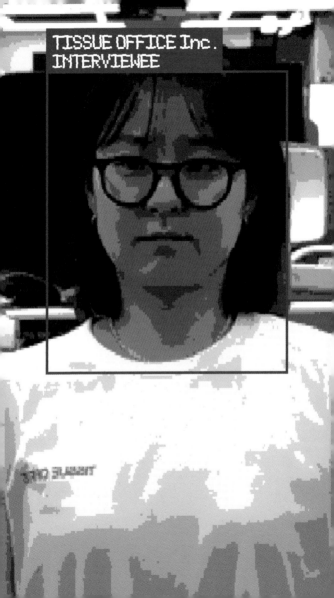

TISSUE OFFICE Inc.
INTERVIEWEE

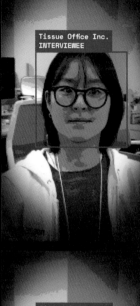

Tissue Office Inc.
INTERVIEWEE

'직진' 뱃지를 획득했습니다.

"뭐든 그냥 지나치지는 않으시는군요! 저도 배워야겠습니다.
물론 절차도 발견하시더니,
저희의 인재상에 매우 가까워졌습니다."

"TisseOififce..."

자세히 보니 절차도 맞지도 않는다.
이렇게 티슈오피스를 찾은 건가 싶었지만 아쉽다.
하지만 덕분에 뭐든지 의심하는 눈을 가지게 되었다.

☞ 책상 위 물건들 살피기

김티슈 | Badge ⋮ 8 ●● 4 ● 6

조금 혼란스러우시죠? 괜찮습니다.
모험심을 가지고, 계속 나아가세요.

- 주식회사 티슈오피스 일동 -

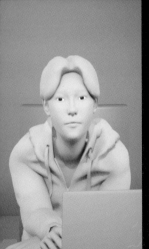

Tissue Office Inc.
INTERVIEWEE

☞ 책상 위 물건들 살피기

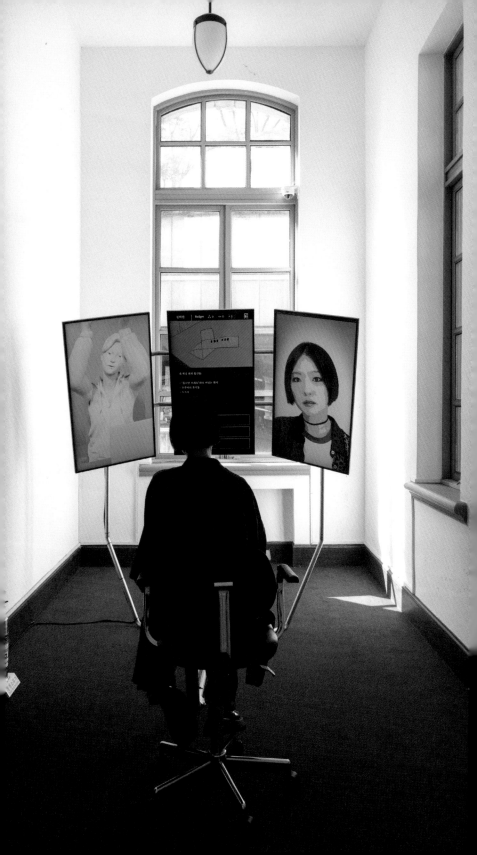

크 리스

로

크리스 로는 서울을 기반으로 활동하는 한국계 미국인 작가로, 애니메이션, 인쇄, 페인팅, 드로잉, 설치 등 다양한 분야를 넘나드는 작업을 선보인다. 최근에는 소리, 공간, 분위기, 에너지, 웃음, 영혼, 도둑 등 대체로 시각 요소가 존재하지 않는 개념들을 탐구해 왔다. 시각적이지 않은 것으로 여겨지던 개념이 어떻게 시각적으로 경험될 수 있는지를 시각적으로 탐구한 것이다. 건축과 그래픽 디자인 분야에서 다양한 배경을 쌓았고, 이는 그가 2차원의 표면과 3차원의 공간을 해석하는 방식에 계속해서 영향을 미쳐 왔다. 전 세계에서 작품을 전시해 왔고 여러 공공, 사립 미술 기관에 작품이 소장돼 있다. 캘리포니아 대학교 버클리 캠퍼스, 로드아일랜드 디자인 스쿨, 서울대학교에서 공부했다.

Chris Ro is a Korean-American artist currently based in Seoul. He largely works across animation, printing, painting, drawing, and installation. In recent years, he has been exploring concepts that typically have no visual component, such as sound, space, atmosphere, energy, laughter, spirits, and thieves. He has been visually exploring how such traditionally non-visual concepts could and might be experienced visually. Chris Ro has a mixed background in architecture and graphic design, which continues to influence his interpretation of two-dimensional surfaces and three-dimensional spaces. His work has been exhibited around the world and is also part of the permanent collections of several renowned public and private institutions. He has been educated at UC Berkeley, the Rhode Island School of Design, and Seoul National University.

미국 시애틀 출생 / 한국 서울에서 활동

크리스 로는 지난 몇 년간 자신의 작품에서 소리의 개념을 탐구해 왔다. 하지만 작가가 다루는 소리는 귀로 듣거나 경험하는 소리가 아니며 소리를 시각화하는 것도 아니다. 특히 그는 시각에 중점을 두는 사람이 어떻게 소리를 창조할 수 있는지, 어떻게 귀를 통하지 않고 경험할 수 있는 소리를 만들 수 있는지를 탐구해 왔다. 이 프로젝트는 이런 식의 소리를 수집해 설치한 것으로, 그중 일부를 리듬, 반복, 움직임, 공간으로 경험할 수 있다. 이외에 소리에서 빌린 조각이나 프레임을 경험할 수도 있다.

　　이 소리 중 일부는 2021년 d/p에서 열린 전시 《우리같은 도둑》에서 처음 선보였다. 이 작품의 콘셉트는 "쉿" 하는 소리 혹은 침묵이다. 몸과 눈으로 모두 경험할 수 있는 일련의 소리. 다시 말하지만, 이것은 소리 없는 소리의 연쇄다.

허쉬
2021/2023년
혼합 매체, 폴리카보네이트,
알루미늄, 합판, 혼합 종이,
아크릴, 흑연, 플라스틱,
설치 약 230×330×157cm

크리스 로／Chris RO

born in Seattle, USA / based in Seoul, South Korea

For the past several years, Chris Ro has been exploring the concept of sound in his work. But not the sound you hear or experience with your ears, nor sound visualization or the visualizing of existing sounds. More so, he has been exploring how a visual person might create sounds or sounds that can be experienced without the ears. This project is a collection and installation of these sounds. Some of them you can experience through rhythm, repetition, movement, and space. Others are singular fragments or frames from a sound.

　　Several of these sounds were initially exhibited at the *Thieves Like Us* at d/p in 2021. The concept of this piece is "hush" or silence. A series of sounds that you can experience with both your body and your eyes. Again, a series of sounds without sound.

Hush
2021/2023
mixed media,
polycarbonate, aluminum,
plywood, mixed paper,
acrylic, graphite,
plastic, installation approx.
230×330×157cm

YANO

야 노

케 이 지

Keiji

야노 케이지는 일본에서 활동하는
그래픽 디자이너다. 시각 아이덴티티
관점에서 자신만의 규칙을 세우고
타이포그래피를 기반으로 전시,
패키지, 단행본, 아이덴티티 시스템
디자인과 브랜딩 작업을 선보인다.
시각 디자인을 매개로한 경험과 기억에
관심을 두고 의뢰받은 일과 실험적인
창작 활동을 병행한다.

Yano Keiji is a graphic designer
based in Japan. Yano sets his own
rules in terms of visual identity and
showcases his typography-based
exhibition, package, monograph,
identity system design, and
branding work. With an interest in
experiences and memories
through visual design, he
combines commissioned work
with experimental creative
activities.

일본 가가와현 출신 / 일본에서 활동

악보와 도형 시리즈는 취미로 마림바를 연주해 온 작가가 아베 케이코의 곡 「일본 동요 변주곡」을 연습하며 악보에 적어 둔 것들, 이를테면 "조(調)가 바뀔 때마다 색이 변하듯이" "멀리서 들려오는 것처럼" 같은 메모에서 출발했다. 야노 케이지는 곡을 마스터한 후 악보에 남은 화려한 흔적을 보면서 그 요소를 추출해 연주자의 시선으로 재구성한 악보를 떠올리고, 음악과 공명한 내면의 풍경을 담은 그래픽 악보 만들기를 시도한다.

야노는 작곡가가 오선 위에 음표와 악상 기호로 저장해 둔 마림바 선율을 상상하고 악보가 지시하지 않는 음의 틈새에 개입해 "곡의 이미지를 부풀리며" 도형을 그려 나간다. 어디까지 한 호흡으로 묶었는지, 한 음을 어떻게 시작하고 맺었는지 등 연주 당시의 기억을 떠올리며 곡에 형태와 질감, 색과 크기를 부여하고, 종이와 잉크로 무게감 있고 힘찬 마림바의 음색과 축적된 연습 시간을 물질화한다.

"연주할 때는 청중에게 보여 주고 싶은 풍경을 상상하는데, 추상화와 풍경화의 중간쯤에 있는 듯한 〈악보와 도형: 일본 동요 변주곡〉은 결과적으로 내 고향 세토우치의 풍경을 닮았다. 연주와 그래픽에 고향 풍경이 무의식적으로 반영됐다는 점이 흥미로웠다."

〈악보와 도형: 일본 동요 변주곡〉은 주로 악보의 악센트나 크레셴도 같은 악상 기호를 시각화한 작업이다. 잉크 농도는 음의 셈여림에 대응하고(약한 음은 연하게, 강한 음은 진하게), 잉크 색과 도형 형태는 음색과 빠르기를 나타내며

야노 케이지 / YANO Keiji

born in Kagawa, Japan / based in Japan

The Score & Shapes series began with notes scribbled on a sheet of music by a hobbyist marimba player who, while practicing Abe Keiko's Variations on Japanese Children's Songs, made notes such as "like colors changing with each key change" and "like sounds coming from far away." After mastering a song, Yano Keiji looks at the colorful traces left behind by the sheet music, extracts its elements and reconstructs it from the perspective of a performer, and then attempts to create a graphic score that captures the inner landscape that resonates with the music.

The artist imagines a marimba melody that the composer has stored as notes and musical symbols on the staves, and draws shapes by "inflating the image of the piece" through interventions in the gaps where the score does not indicate. He gives the song its shape, texture, color, and size by recalling his memories of the performance-where he held it in one breath, how he started and ended each note. Then, with paper and ink, he materializes the weighty, powerful sound of the marimba and the hours of accumulated practice.

"When I perform a song, I imagine a landscape that I want to show the audience. *Score & Shapes: Variations on Japanese Children's Songs*, which feels halfway between abstract painting and landscape painting, turns out to resemble the landscape of

색을 쌓아 올려 낮은음이 많은 곡의 특성을 묵직하게 표현했다. 〈악보와 도형: 리듬 송〉은 폴 스마드벡의 유명한 마림바 독주곡을 소재로 한다. 시작부터 끝까지 일정한 리듬을 유지하는 이 곡의 악보에는 종종 '멀리서(Distantly)'라는 표시가 등장하는데, 작가는 수평선이 희미하게 보이는 파도 없는 바다, 영국의 스태니지 에지 고원, 광활한 대지를 달리는 기차를 상상하며 음들을 점묘화처럼 공들여 표현했다. 망점이 미세하게 어긋나고 색을 정확하게 통제하기 어려운 리소 인쇄의 특성은 작곡과 연주의 다른 점, 사람의 연주와 아날로그 인쇄의 닮은 점을 암시한다.

전시에서는 작가가 연주한 「일본 동요 변주곡」, 「리듬 송」의 마림바 음원과 독립 출판물 악보와 도형 시리즈도 함께 선보인다.

야노 케이지／YANO Keiji

my hometown of Setouchi. It was interesting to see how the music and graphics subconsciously reflected the landscape of my hometown."

Score & Shapes: Variations on Japanese Children's Songs is primarily a visualization of musical notation, such as accents and crescendos in a musical score. The density of the ink corresponds to dynamic (lighter for soft notes, darker for loud notes), the color of the ink and the shape of the figures indicate timbre and speed, and the accumulation of color conveys the tonal weight of a song with many bass notes. *Score & Shapes: Rhythm Song* is based on Paul Smadbeck's famous marimba solo, Rhythm Song. The score, which maintains a steady rhythm from the beginning to the end, is often notated as "Distantly," with the artist painstakingly rendering the notes like a pointillist painting, imagining a waveless sea with a faint glimpse of the horizon, England's Stanage escarpment, and a train traveling across a vast expanse of land. The nature of risography printing, with its subtle misalignment of dots and difficulty in controlling color precisely, suggests the differences between composing and performing, and the similarities between human performance and analog printing.

The exhibition display also features marimba recordings of

악보와 도형: 일본 동요 변주곡
2019 / 2023년
종이에 리소 인쇄, 42×29.7cm
(14), 캡션 10×415.8cm,
부클릿(야노 케이지, 『악보와
도형: 일본 동요 변주곡』,
2019년, 종이에 리소 인쇄,
사철, 27.7×20 / 21×15cm,
20 / 20쪽), 사운드, 5분 4초

작곡
아베 케이코

악보와 도형: 리듬 송
2023년
종이에 리소 인쇄, 42×29.7cm
(14), 캡션 10×415.8cm,
부클릿(야노 케이지,
『악보와 도형: 리듬 송』,
2023년, 종이에 리소 인쇄,
사철, 27.7×20 / 27.7×20cm,
14 / 16쪽), 사운드, 9분 24초

작곡
폴 스마드벡

감사한 분
미야노시타 시류

야노 케이지 / YANO Keiji

the artist's performances of Variations on Japanese Children's Songs and Rhythm Song as well as his independent publication series under the title Score & Shapes.

Score & Shapes: Variations on Japanese Children's Songs
2019 / 2023
risography print on paper,
42×29.7cm (14), caption
10×415.8cm, booklet
(YANO, K., Score & Shapes:
Variations on Japanese
Children's Songs, 2019,
risography print on paper,
thread sewn binding,
27.7×20 / 21×15cm,
20 / 20 pages), sound,
5 min. 4 sec.

Composer
ABE Keiko

Score & Shapes: Rhythm Song
2023
risography print on paper,
42×29.7cm (14),
caption 10×415.8cm,
booklet (YANO, K.,
Score & Shapes:
Rhythm Song, 2023,
risography print on paper,
thread sewn binding,
27.7×20 / 27.7×20cm,
14 / 16 pages), sound,
9 min. 24 sec.

Composer
Paul SMADBECK

Special thanks to
MIYANOSHITA Shiryu

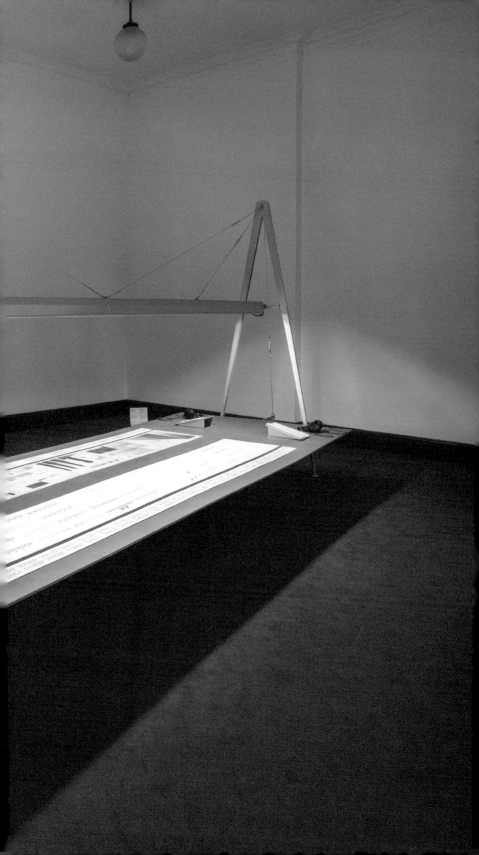

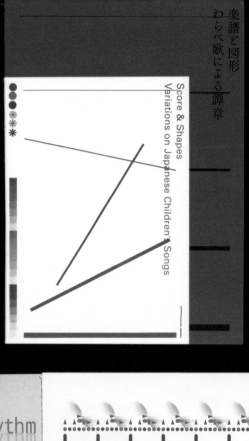

楽譜と図形
わらべ歌による譚章

Score & Shapes
Variations on Japanese Children's Songs

Rhythm

Paul Sm

Score & Shapes "Rhythm Song"

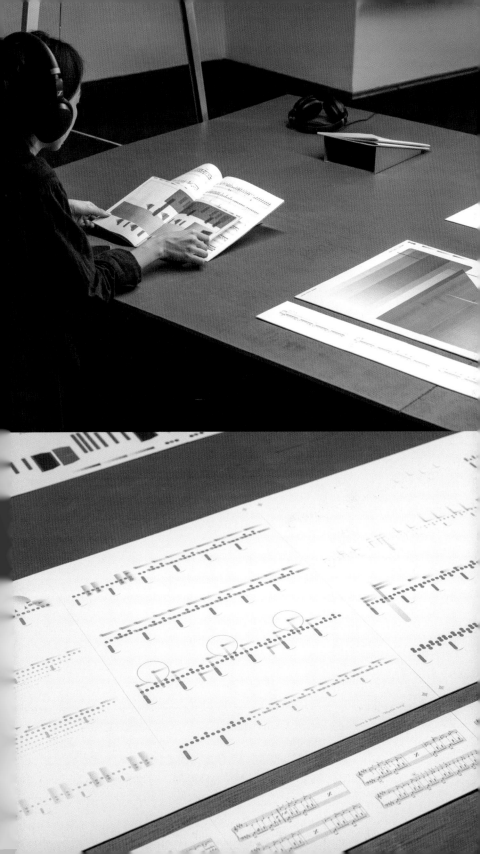

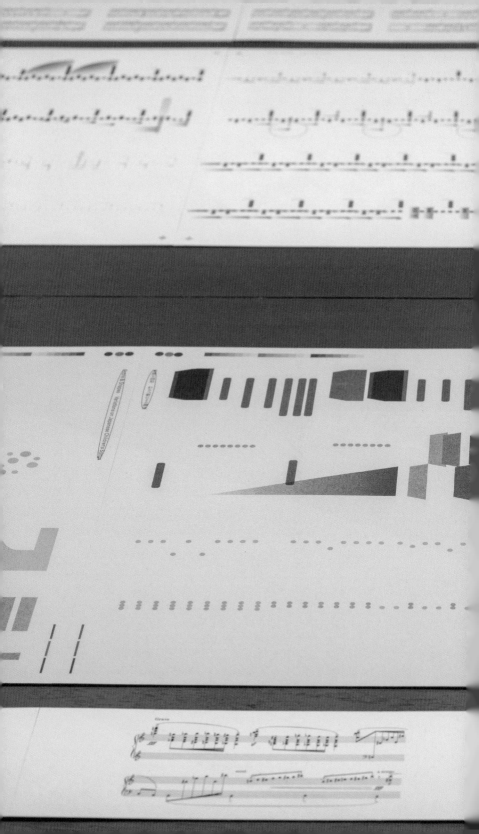

신도시는 2015년 서울 을지로에
만들어진 공간이자 다원 예술팀으로
미술가 이병재와 사진가 이윤호가
운영한다. 신도시 내에서 자체 진행하는
공연과 이벤트 외에도 《아디다스
오리지널스 슈터스타—뉴 톱》,
《지산 밸리 록 페스티벌》, 《도쿄 아트
북 페어》, 《do it 2017, 서울》,
《서울미디어시티비엔날레》,
《피크라 그래픽 디자인 비엔날레》 등에
참여해 기획, 전시, 디자인으로 외연을
넓혀 왔다. 신도시의 모든 작업은
예술가와 협업을 전제로 기획된다.
2016년부터 자체 콘텐츠를 생산하는
신도시 프로덕션을 설립해 음악가,
미술가, 디자이너, 만화가와 함께
하위문화 형식의 음반, 출판물, 영상물,
굿즈를 선보인다. 2020년에는 서울
연희동에 미도파 커피 하우스를
열어 신도시와 연계한 여러 이벤트를
꾸려 가고 있다.

seen do

 si.

As an arts venue and
multidisciplinary artistic team
in Euljiro, Seoul, seendosi was
established in 2015 and run
by artist Lee Byoungjae and
photographer Lee Yoonho.
In addition to their own
performances and events, they
have participated in a number
of events and exhibitions,
including *ADIDAS Originals
Superstar—New Top*, *Jisan Valley
Rock Festival*, *Tokyo Art Book Fair*,
do it 2017, Seoul, *Seoul Mediacity
Biennale*, and *Fikra Graphic
Design Biennial*. All of seendosi's
work is conceived in collaboration
with artists. In 2016, seendosi
established SDS Production to
produce its own content,
collaborating with musicians,
artists, designers, and cartoonists
to create subcultural music,
publications, videos, and
merchandise. In 2020, seendosi
opened Midopa Coffee House in
Yeonhee-dong, Seoul, and has
been organizing various events in
conjunction with their venue in
Euljiro.

이병재
한국 서울 출생 / 한국 서울에서 활동

2015년부터 활동을 시작한 신도시는 바이자 공연장이고 레이블이자 소규모 출판사다. 〈신도시책〉은 지난 8년간 신도시가 해 온 다양한 활동의 결과물을 한데 모은 커다란 '아카이브 진'이다. 공간 신도시에서 벌어지는 다종다양한 이벤트의 홍보를 목적으로, 의뢰받은 프로젝트의 결과물로, 혹은 자체 콘텐츠로 제작한 포스터, 잡지, 스티커 등의 각종 인쇄물과 티셔츠, 모자, 가방 등을 여러 장의 판에 두서없이 붙여 관람객이 넘겨 볼 수 있는 대형 스크랩북 형태로 전시한다.

신도시는 주로 실크 스크린이나 리소 인쇄를 활용해 필요한 것들을 만들고 즉흥적이고 실험적인 제작 방식과 소재도 적극적으로 택한다. 이런 이유로 제작물은 대부분 수작업을 포함하는 노동 집약적인 형태로 만들어진다. 관람객은 그래픽 디자인, 타이포그래피, 회화, 일러스트레이션, 만화 등 여러 시각 장르를 오가는 8년의 결과물에서 서울, 나아가 동아시아 하위문화의 역동적인 흐름과 현재를 발견할 수 있다.

이윤호
한국 안성 출생 / 한국 서울에서 활동

신도시 / seendosi

LEE Byoungjae
born in Seoul, South Korea /
based in Seoul, South Korea

Active since 2015, seendosi is a bar, a venue, a label, and a small press. *seendosiBOOK* is a large "archive zine" that brings together the results of seendosi's various activities over the past eight years. It includes posters, magazines, stickers, and other printed materials such as t-shirts, hats, bags, and other items created to promote the various events at seendosi's space and the results of commissioned projects or seendosi's content. They are displayed in a large scrapbook that visitors can flip through, glued together on several sheets of Lexan.

seendosi often uses screen print or risograph print to create what they need, taking an improvisational and experimental approach to their work and actively choosing their creative materials. For this reason, the production is mostly made in a labor-intensive form that involves manual labor. Through seendosi's eight years of work across multiple visual genres, including graphic design, typography, painting, illustration, and comics, audiences can discover the dynamic currents and presence of Seoul's and East Asia's subcultures.

LEE Yoonho
born in Anseong, South Korea /
based in Seoul, South Korea

신도시책
2023년
나무 구조물, 렉산,
종이에 디지털 프린트,
종이에 리소 인쇄,
종이에 실크 스크린, 종이, 천,
250×120-262×22-120 cm

협업
신도시 프로덕션에 참여한
다수의 창작자

신도시／seendosi

seendosiBOOK
2023
wooden structure,
Lexan, digital print
on paper, risography print
on paper, screen print
on paper, paper, cloth,
250×120-262×22-120 cm

Collaboration with
several artists working
on SDS Production

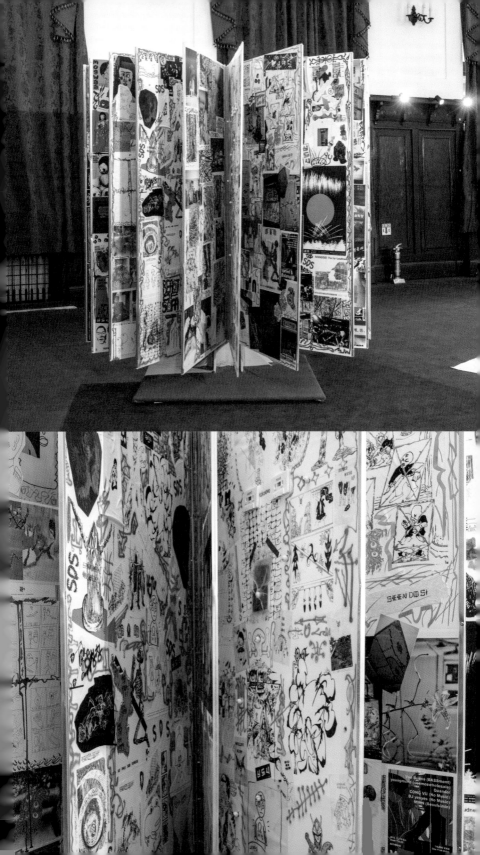

손 SOHN

Young

영 eun

손영은은 이미지, 글, 책, 비디오, 옷 등 다양한 매체를 사용해 특정한 시간과 장소를 반영하는 공연을 만든다. 사람의 몸과 일상의 사물 사이에 존재하는 제스처와 행동에 관심을 두고 익숙한 매체로 일상과 공연의 경계를 뒤집는 작업을 시도한다. 헤릿 리트펠트 아카데미에서 학생들을 가르친다.

Sohn Youngeun employs diverse media, including images, texts, books, videos, and even clothes, to create performances that reflect a specific time and place. Interested in the gestures and behaviors that exist between the human body and everyday objects, she attempts to subvert the boundaries between everyday life and performance through media that are familiar to us. Currently, Sohn teaches at the Gerrit Rietveld Academie.

〈종이울음〉은 종이나 인쇄술이 등장하기 전 고대인의 기록 매체였던 양피지나 파피루스 두루마리의 현대적 모습을 추적하고, 종이와 옷감의 물성에 관한 조사·수집과 읽는 행위에 관한 관심을 반영한 설치 작품이자 작품을 매개로 하는 낭독 공연이다.

전시장에 설치된 폭 1미터, 길이 100미터의 대형 두루마리는 공연을 위한 대본이다. 대본은 대개 작은 책자로 인쇄되고 대사와 지문은 공연자를 매개로 드러날 뿐 그 자체로 무대에 등장하지 않지만, 이 대본은 공연의 중심에서 뚜렷한 존재감을 드러내며 작품과 관객을 연결한다. 손영은은 대본의 형태, 대본을 읽는 방식, 대본이 연상시키는 소리로 종이와 신체를 연결하고 대본과 관객의 관계를 재설정한다.

공연 〈종이울음〉에는 세 가지 소리가 등장한다. 하나는 대본을 낭독하는 작가의 목소리이고, 또 하나는 전시장 한쪽을 가득 채운 종이 사이를 오가며 그것을 대본처럼 들고 읽으려는 작가의 몸짓이 만드는 종이 소리이며, 마지막은 대본 속 이야기가 연상시키는 상상의 소리다. 느슨하게 연결된 글과 이미지가 인쇄된 대본은 두루마리 형태로 그 내용을 숨기고 있다가 작가의 낭독으로 조금씩 활성화된다. 이야기는 펄프를 떠서 얇은 종이를 만드는 데서 출발해 바다에서 수확한 김을 얇게 펴 말릴 때 들리는 소리로, 엄마와 바삭하게 김을 굽던 추억으로, 풀 먹여 손질한 모시옷이며 침구의 가슬가슬한 촉감으로, 둘둘 말린 옷감을 스르륵 펼치는 움직임으로 이어지며 감각과 상상력을

손영은 / SOHN Youngeun

Crisp is both an installation and a reading performance that traces the modern manifestation of parchment or papyrus scrolls, the recording medium of the ancients before the advent of paper and printing, and examines the physical properties of paper and cloth, reflecting an interest in the act of investigating, collecting, and reading about the properties of paper and cloth.

Installed in the exhibition, a large scroll, which measures one meter wide and 100 meters long, is a script for a performance. The script is usually printed in a small booklet, and its lines and prints are only revealed through the performers, and do not appear on stage in their own right. However, this script has a distinct presence at the center of the performance, connecting the work to the audience. Sohn connects paper and body through the form of the script, the way it is read, and the sounds it evokes, resetting the relationship between the script and the audience.

There are three sounds featured in the performance of *Crisp*. One is the voice of the author reading the script. Another is the sound of the paper, created by the artist's gesture as she moves among the papers that fill one side of the exhibition space, picking them up and reading them like a script. The last is the imaginary sound that the narrative of the script evokes. A printed script with loosely connected text and images conceals its contents in the

자극하고 관람객의 다양한 공간으로 이끌다가 빨간 카펫이 깔린 공연 장소에서 마무리된다.

공연이 끝나면 대본은 다시 작품이 되고, 이제 그것을 읽는 주체는 작가에서 관람객으로 바뀐다. 작가의 낭독과 함께 선형적으로 흐르던 이야기는 설치 작품 〈종이울음〉을 통해 관람객의 개별적인 읽기로 단편화되고 재구성된다.

종이울음
2023년
종이에 디지털 컬러 프린트,
종이롤 10,000×100 cm,
철재 구조물
199.5×125×100 cm

손영은／SOHN Youngeun

form of a scroll, which is gradually activated by the artist's reading.
The story engages the senses and the imagination, taking the audience through a variety of spaces and culminating in a red-carpeted performance venue. It begins with the molding and draining of pulp to make thin paper, and then moves to the sound of seaweed harvested from the sea as it is spread out to dry, the memories of grilling laver with one's mother, the feel of starched ramie clothes and bedding, and the movement of unrolling the dried fabric.

At the end of the performance, the script returns to being a work of art, and the performer that reads it changes from the artist to the audience. The story, which flows in a linear progression with the artist's reading, becomes fragmented and reconstructed by the audience's individual readings through the installation.

Crisp
2023
digital color print
on paper, paper roll
10,000×100 cm,
steel structure
199.5×125×100 cm

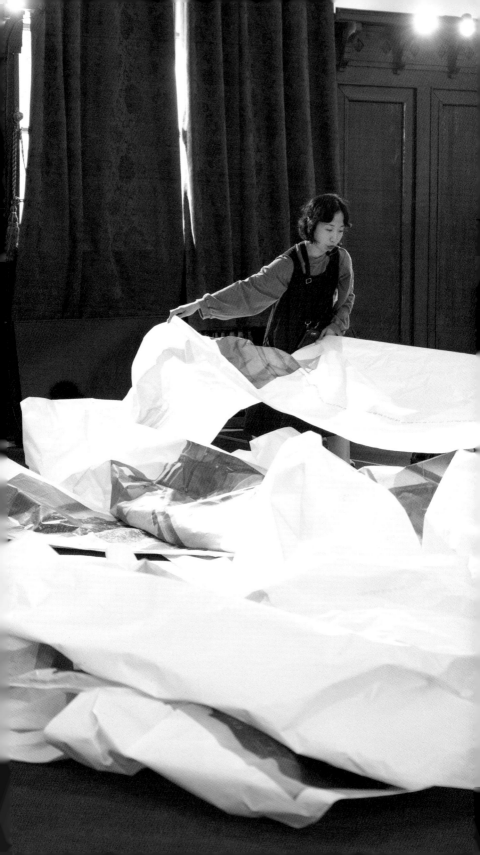

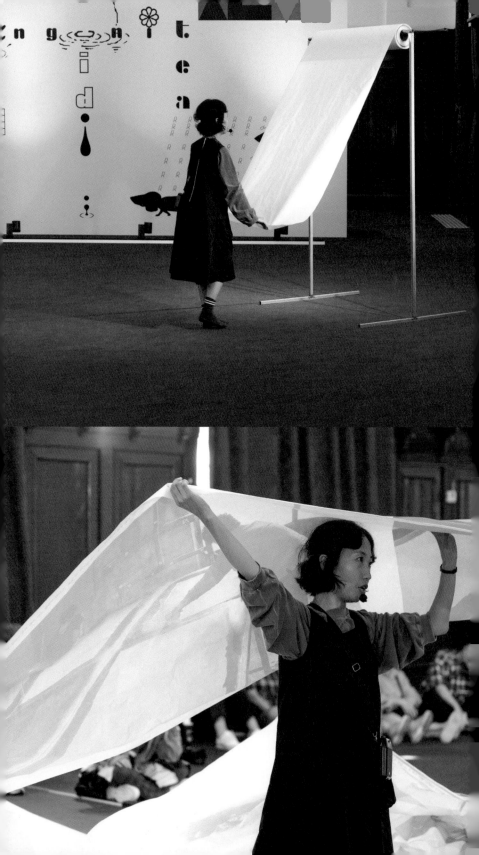

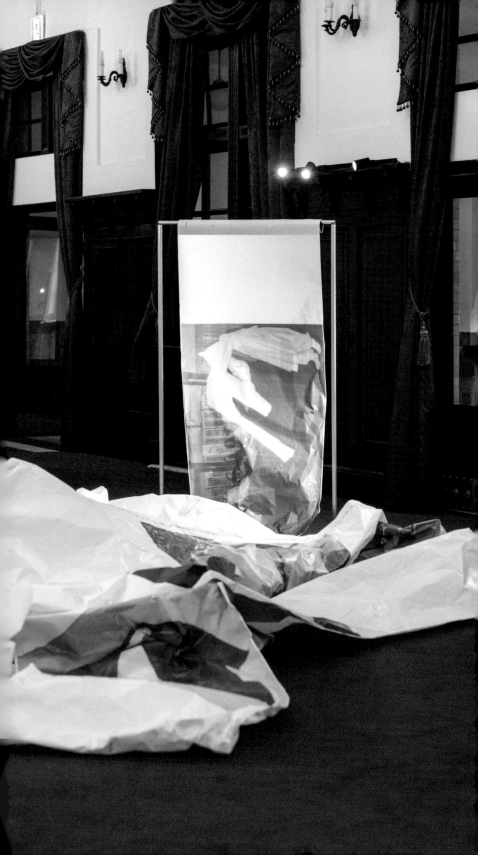

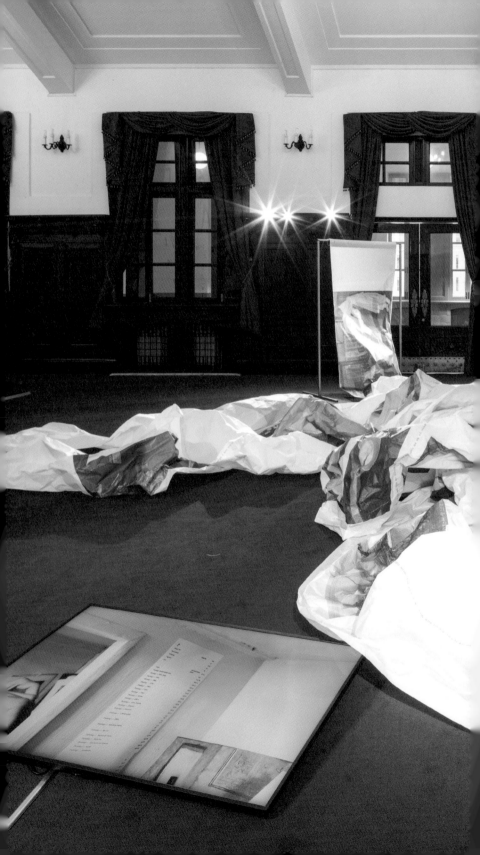

Jung

myung

이

Jung

이정명은 그래픽 디자이너 겸 활자 디자이너다. 글자꼴을 생각과 감정, 삶의 궤적을 가진 하나의 캐릭터로 보고, 실험적인 활자체를 연구하고 제작하는 '정-리 타입 파운드리'를 운영한다. 〈임팩트 니우〉, 〈오르비스〉, 〈융카〉 등의 활자체를 만들었다. 언어와 타이포그래피 형식의 상호 작용에 관심을 두고 글쓰기, 음악, 비디오 등 여러 형태로 개인 작업을 선보이며, 타이포그래피, 시각 예술, 현대적 글쓰기로 인간의 감정 범위를 탐구하는 실험적인 예술 저널 『리얼타임 리얼리스트』를 발행한다. 홍익대학교에서 산업 디자인을 공부하고 베르크플라츠 티포흐라피에서 석사 학위를 받았다. 헤릿 리트펠트 아카데미와 베르크플라츠 티포흐라피에서 학생들을 가르친다.

Lee Jungmyung is a graphic and type designer. Lee considers fonts as characters with thoughts, feelings, and life trajectories and runs the Jung-Lee Type Foundry, which researches and produces experimental typefaces. With her type foundry, she created typefaces including Impact Nieuw, Orbis, and Jungka. Her interest in the interplay of language and typographic forms led him to present her personal work in many forms, including writing, music, and video. She publishes *Real-Time Realist*, an experimental art journal that explores the range of human emotions through typography, visual art, and contemporary writing. She studied industrial design at Hongik University in Seoul and received a master's degree from Werkplaats Typografie. Currently, Lee teaches at the Gerrit Rietveld Academie and Werkplaats Typografie.

한국 서울 출생／네덜란드 암스테르담에서 활동

〈레터스(글자)〉는 십자말풀이나 그림과 글자를 조합한 리버스(rebus) 퍼즐의 형식을 취하며, 각각의 머리글자를 이미지로 보여 주면서 고유한 이야기를 드러낸다. 머리글자는 보통 글을 강조하거나 인쇄물을 아름답게 표현하기 위해 글의 시작 부분에 정교하게 장식해 넣는 대문자를 말한다. 글의 한 부분을 차지하며 공들여 장식된 대문자인 머리글자는 오랜 역사에 걸쳐 인접한 글과 복합적이고 상호 보완적이거나 뚜렷한 대비를 이루는 연결 고리를 형성해 왔다.

관객은 커다란 벽면에 설치된 〈레터스(글자)〉를 감상하면서 각각의 글자가 단어를 형성하고 소리를 생성하며 이미지로 구현되는 과정을 통해 상상력 넘치는 이야기를 만들 수 있다. 이 작품은 글자를 이야기꾼이자 축적의 주체로 여기며, 서사 안에서 무한한 이야기를 연계시킨다. 예를 들면 이런 식으로.

연못에서 즐겁게 피리를 불던 개구리가 왜가리에게 붙잡혔다.
"그 위에서 뛰어(SPRING ON IT)"

그 상황에서 벗어나려 필사적으로 애쓰며
"조준해(AIM)"

이정명／LEE Jungmyung

born in Seoul, South Korea／based in Amsterdam, Netherlands

LETTERS takes the form of crosswords and rebuses, employing image representations of each illuminated letter to unveil its unique story. An illuminated letter is an elaborate capitalization at the beginning of a text, usually to emphasize the text or to beautify the print. Throughout its extensive history, the illuminated letter—a laboriously adorned capital letter within a textual segment—forges intricate, complementary, or sharply contrasting connections with the adjoining text.

While looking at the giant wall display of *LETTERS*, visitors can create imaginative storytelling that takes place where each letter crafts stories as it shapes words, generates sounds, and culminates in imagery within a seamless cycle. The work is seen through the lens of letters as both storytellers and cumulative agents, coalescing boundless stories within their narratives. For example:

The frog, who joyfully played the flute in the pond, got caught by a heron.
"SPRING ON IT"

Desperately trying to escape from that situation,
"AIM"

결국 개구리는 자신이 불던 피리를 왜가리의 부리에 꽂아 "A"라는
글자를 만들며 가까스로 탈출에 성공했고
"피해(AVOID)"

거꾸로 뒤집힌 느낌표는 왜가리의 눈물로 변한 개구리의
결연한 의지를 시각화한다.
"눈물(TEAR)"

레터스(글자)
2023년
접착 시트, 420×840 cm

이정명／LEE Jungmyung

in the end, it managed to escape narrowly by putting
the flute he played in the heron's beak,
creating the letter "A,"
"AVOID"

and the upside-down exclamation mark embodies the frog's
determination, which turned into the heron's tears.
"TEAR"

LETTERS
2023
adhesive sheets,
420×840 cm

MAYBE

y e

or

n o

S p

BUZZING

i-dooOOWWO...

M o N L i g h t

Flute

$\dot{\square} = 51$
$\dot{\square} = 51$

Ludwig Van Beethoven

Piano

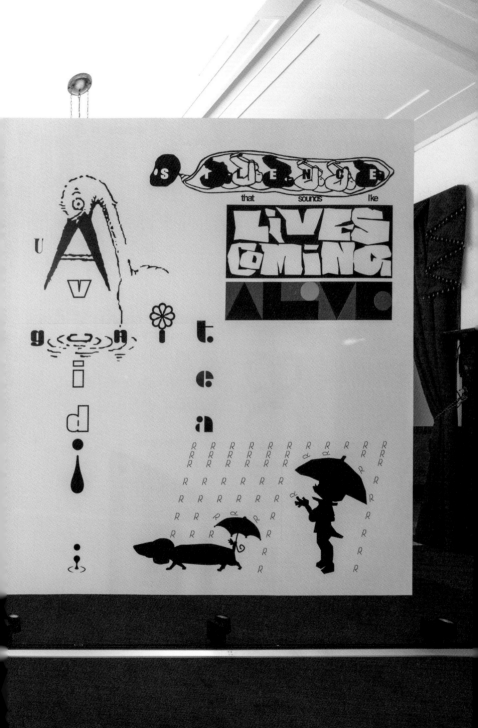

마니따 송쓰음은 그래픽 디자이너 겸
타이포그래퍼다. 방콕 예술 문화
센터의 전시 그래픽 디자이너로 일을
시작했고, 실험적인 매체를 뮤즈 삼아
다양한 예술가와 경계 없이 협업하며
디자인과 예술 영역을 자유롭게 오간다.
송쓰음의 디자인은 타이포그래피에
집중한 단행본 표지 디자인과 개인 작업
타자기 예술 시리즈로 대표되며,
타이포그래피의 여러 기법을 활용해
과학적 요소가 혼재하는 신(新)
기하학적 디지털 이미지를 선보인다.
2019년부터 국제 그래픽 연맹
회원으로 활동하고 있다.

마니따

Mani ta

음

송 쓰

SONG

SERM

Manita Songserm is a graphic
designer and typographer.
She began her career as an
exhibition graphic designer
at the Bangkok Art and Culture
Center (BACC), where she
collaborated with a wide range
of artists using experimental
mediums as her muse, moving
freely between the design
and art worlds. Her designs are
represented by her typography-
focused book cover designs
and personal work, the Typewriter
Art series, which utilizes several
techniques of typography
to create neo-geometric digital
images that mix scientific
elements. She has been an
Alliance Graphique Internationale
(AGI) member since 2019.

타자기 예술 시리즈는 마니따 송쓰음이 반복해 온 조판 작업에서 발견한 관심사들, 이를테면 글줄 사이, 글줄 길이, 여백의 흐름 같은 최소한의 타이포그래피 요소로 최대한의 실험을 이어 가는 개인 작업이다.

송쓰음은 타이포그래피로 매력적인 시각적 인상을 만들고 몰입감을 생성하는 데 주목한다. 그의 작품들은 방대한 정보를 한정된 지면에 배열하며 질서를 잡아가다가도 순서대로 규칙을 어기는 시도를 드러내고, 엄격한 그리드 곳곳에 반항의 요소를 숨겨 둔다. 이런 접근은 에너지 넘치는 복잡한 리듬 속에서 미세하지만 완전히 새로운 분위기를 연출하는 음들이 포착되는 전자 음악이나 실험적인 팝 음악을 선호하는 취향과도 닿아 있다. 타자기 예술 시리즈는 음악을 소재로 한 작품도 있지만 그렇지 않더라도 타이포그래피의 여러 요소를 반복하며 시각적 리듬을 만들어 글자가 진동하고 있는 듯한 공감각을 끌어낸다.

작가는 작업 의도를 묻는 말에 영감보다는 가설이나 실험, 관찰이나 반복으로 답하기를 선호한다. "정보를 분석하고 단어 뒤에 숨은 것들을 찾는 데 시간을 많이 쓰며 그 과정 자체에 영향을 받는다. 가설을 세우고 실험하고 실패하는 과정을 반복하며 전하려는 바와 시각적 인상이 아주 가깝다고 느낄 때까지 계속한다."

마니따 송쓰음／Manita SONGSERM

The Typewriter Art series is a work that experiments with minimal typographic elements such as line spacing, line length, and flow of margins, along with the artist's interest in typesetting work that she has been repeating over the years.

Songserm invests in creating a compelling visual impression with typography and creating a sense of immersion. Her works reveal attempts to organize vast amounts of information on a limited surface, to create order, but also to break the rules of order, hiding elements of defiance throughout the strict grid. This approach is in line with her preference for electronic and experimental pop music, where subtle notes are captured in energetic, complex rhythms that create a whole new mood. Some of the works in the Typewriter Art series are based on music, but even if they are not, they create a sense that the letters are vibrating since the repetition of different elements of typography creates a visual rhythm.

When asked about their intentions, Songserm is more likely to answer with hypothesis, experimentation, observation, or iteration than inspiration. "I spend a lot of time analyzing information and looking for things behind the words, and I'm affected by the process itself. I hypothesize, experiment, fail, and keep going until I feel the visual impression is very close to what I'm trying to convey."

타자기 예술 시리즈

에어 볼드 프로
2019년, 종이에 디지털 프린트,
49.3×29.3cm

레일웨이 얇은체
2019년, 종이에 디지털 프린트,
49.3×29.3cm

자프 딩뱃
2019년, 종이에 디지털 프린트,
29.6×20.9cm

**프레스티지 엘리트
스탠다드 볼드**
2019년, 종이에 디지털 프린트,
29.6×20.9cm

**프레스티지 엘리트
스탠다드 볼드 1–4번**
2019년, 종이에 디지털 프린트,
45×32cm (4)

두 영역 1, 2
2017년, 종이에 오프셋 인쇄,
55.4×37.1cm (2)

담당자분께
2015년, 종이에 디지털 프린트,
28.2×19.9cm (4)

테자다의 최후
2018년, 종이에 디지털 프린트,
18.5×27.3cm (6)

항상
2015년, 종이에 디지털 프린트,
21.9×43.8cm

캐리 ㄱ터 리스틱 1–6번
2019년, 종이에 디지털 프린트,
42×29.7cm (6)

마니따 송쓰음／Manita SONGSERM

Typewriter Art Series

Aire Bold Pro
2019, digital print
on paper, 49.3×29.3cm

Raleway Thin
2019, digital print
on paper, 49.3×29.3cm

Zapf Dingbats
2019, digital print
on paper, 29.6×20.9cm

Prestige Elite Std Bold
2019, digital print
on paper, 29.6×20.9cm

*Prestige Elite Std
Bold no.1–4*
2019, digital print
on paper, 45×32cm (4)

The Two Areas #1, #2
2017, offset print on paper,
55.4×37.1cm (2)

To Whom It May Concern
2015, digital print on paper,
28.2×19.9cm (4)

The End of Tejada
2018, digital print
on paper, 18.5×27.3cm (6)

Always
2015, digital print
on paper, 21.9×43.8cm

kar kt ˈrɪstɪk no.1–6
2019, digital print
on paper, 42×29.7cm (6)

#1
Know The Way

```
d
n
i
t
h
e
s
```

She giving up the cross
She'll end her faith in love
 And I know the way
 I know the way
 IIIIIIIIIIIIII
 I know the way
 I can believe in me

She giving up the cross
She'll end her faith in love
 I know the way
 I know the way
 YYYYYYYYYYYYY
 YYYYYYYYYYYYY
 I can believe in your home

#2
Talking To You

```
*******
How  *
To   *
Dream *
Well *
*******
```

*******Don't know what I want. Don't know what I need
************Don't know who I am. Don't know who I'll be
****************A simple shame indeed and in my sound track
****But it's a shame that gives my days the shame of having pride
****************Cast a pall all over my days since you passed away
****************Choose to say you left me in a state I can't escape
****************Choose to say I'm back I know I'll never. ever. be the same
****************Choose to say I love you and no I'll never ever be the same

I'm gonna have my way babe I
******(I think that I need you)
You get enough of my way and the way that
******(I need you)
I can't wait for you while I live my lifetime
Picture it as the same place as do without my boo
******(Life goes on and I'll forget all the things said about you)
You hate me
******(and I need you)
You breathe deep
******(and I'll be true)
You lie to me
******(That's just what you do)
Who said that I deserve that... I turn your mouth away
Always im my way
******(I was in your way boy)
Mmm the saint of the day?
******(I wasn't your saint)
Who will have my way now?
******(I can't go on with ya. oh)

World I need you. Won't be without you
******(You will say it'll never happen even after you tried to)
Ain't nobodies different. You know just what you're missing
******(it's not the same as having my way again)
that's not the same as having my way again
World I need you. Won't be without you
******(You will say it'll never happen even after you tried to)
Ain't nobodies different. You know just what you do to me
******(it's not the same as having my way again)

World I need you
??????????????????
 Did you love him
 Did you love him
 Did you love him
Like no other did boy?
????????????????????? Did you love him
 Did you love him
 Did you love him
Like no other did boy?
????????????????????? Will you love me like
 no other did
 b o y
 . .

#3
Seesaw

```
            Jamie          X              X

With you
            .....        With you
                                       With you
With you
            .....        With you
                                       With you
With you
            .....        With you

With you
    .         Like a seesaw
              On a seesaw            up and down
                              Up and down    up and down
                              with you
              Like a seesaw
              On a seesaw            up and down
                              Up and down    up and down
                              with you

I see pictures in my mind              IIIIIIIIII
I see fingers up your spine            IIIIIIIIII
I saw my heart break in two            IIIIIIIIII
I see her again with you

    .         A seesaw
              On a seesaw            up and down
                              Up and down    up and down
                              with you
With you
            .....        With you
                                       With you
With you
            .....        With you
                                       With you
With you
            .....        With you
                                       With you
With you

I can see it your eyes                 IIIIIIIIII
I see through your thin despise        IIIIIIIIII
She was always my best friend          IIIIIIIIII

i saw with her again                   IIIIIIIIII
I see pictures in my mind              IIIIIIIIII
i see fingers up your spine            IIIIIIIIII
I saw my heart break in two            IIIIIIIIII
I see her again with you

With you
                        With you           With you
With you
    .         Just stuff
              The world    just       .....
              I            just       .....
```

#4
Suns Irrupt

```
N
s
o
Indian
```

Old love ended from time
You'll remember me
```
s
o
```
Last stars. I follow them nowhere
They follow me
```
t
h
```

SUNS Irrupt SUN Irrupt SUNS Irrupt
SUNS Irrupt SUN Irrupt SUNS Irrupt
And I wake up and I wake up and I wake up
I wake up. I wake up. I wake up

Bleedings erased from design
Before there was
```
y
```
When you were swallowed in earth
I slept in a
```
w
h
```

SUNS Irrupt SUN Irrupt SUNS Irrupt
SUNS Irrupt SUN Irrupt SUNS Irrupt
And I wake up and I wake up and I w
And I wake up and I wake up and I wake up
I wake up. I wake up. I wake up
[x2]

Lost and it had to happen sometime
Gone but I'm waiting to be someone
[repeated]]]]]]]]]]]]]]]]]]]]]]]]

.
Old stars.
I follow them nowhere they follow me too
Old stars.
I follow them nowhere they follow me too
)

Sophie

소피

DOU

두

ALA

알라

소피 두알라는 시각 예술가 겸
크리에이티브 디렉터다. 야운데와
파리를 문화적 배경으로 하며
문화, 정체성, 진화, 감정, 문화의
렌즈로 디자인을 탐구한다. 의뢰받은
작업과 개인 창작 활동을 병행하며
디자인과 예술 영역을 오간다. 자기
세대와 그들의 투쟁, 더 밝은 미래를
향한 열망에서 영감을 얻는다.

Sophie Douala is a visual artist
and creative director. With the
cultural backgrounds of Yaoundé,
Cameroon, and Paris, France,
she explores design through
the lens of culture, identity,
evolution, emotion, and culture.
She balances commissioned
work with personal creative
endeavors, moving between the
worlds of design and art.
Her inspiration comes from
her generation, their struggles,
and their desire for a brighter
future.

"〈검은 토끼를 따라〉에서 소피 두알라는 우리를 꿈의 세계로 초대한다. 지난 2년간 일어난 시민의 권리와 인종 평등을 위한 투쟁, 금융 불안이나 사회 불안, 팬데믹, 그에 따른 무기력한 봉쇄 등 사회 혼란으로부터 영감을 얻은 소피는 '이상한 나라의 앨리스'라는 신화를 뒤집어 현실 세계를 반영하는 정치적 반전을 안겨 준다. 이것은 찬사와 우울감이 동시에 느껴지는 작품이다." —토마스 카스트로

〈검은 토끼를 따라〉는 전시장 2층 복도의 거대한 반원 창문 두 개를 가득 채운 그래픽 설치 작품이다. 소피 두알라는 긴 팬데믹의 시작과 조지 플로이드 살해 사건으로 각인된 2020년과 이후의 몇 년을, 잊었던 기억과 감정을 끌어올려 슬픔과 분노로부터 강해지는 법을 배운 시간이라고 말한다. 성찰과 깨달음을 위한 만트라라고 해도 좋을 이 작품은 그 시간을 반영하며, 시각 언어와 정서의 상호 작용을 실험한다. 〈검은 토끼를 따라〉는 작가 스스로 "전환, 진화, 시간의 단절, 일시 정지"라고 정의하는 매우 사적인 감정에서 출발하지만, 동시대에 같은 경험을 하며 살아가는 이들을 단번에 끌어들이면서 고통스러운 것과 화려한 것, 정치적인 것과 아름다운 것을 혼합한다.

이 작품은 토마스 카스트로가 기획한 그래픽 디자인 시리즈 '포스트 / 노 / 빌스'의 일환으로 2022년 6월부터 2023년 1월까지 암스테르담 스테델릭 미술관에서 처음 전시됐다. 작가와 큐레이터는 기존 작품의 분위기와 이야기 흐름을 유지하면서 문화역서울284라는 공간에 맞게 작품을 신중하게 재구성했다. 반복을 통해 율동적이고 운율적인 특성을 보이는 그래픽 패턴들은

소피 두알라 / Sophie DOUALA

"In 'Follow The Black Rabbit,' Sophie is inviting us to enter a dream world. Triggered by social shakedowns of the past two years— the struggle for civil rights and racial equity, financial and social insecurities, a health pandemic, and the resulting debilitating lockdowns—Sophie inverts the Alice in Wonderland myth giving it a political twist to reflect the real world. It is celebratory and melancholy at the same time." —Thomas Castro

Follow The Black Rabbit is a graphic installation that fills two huge semicircular windows in the hallway on the second floor of the exhibition space. Sophie Douala says that 2020 and the years that followed, marked by the start of the long pandemic and the murder of George Floyd, were a time of learning to be stronger from sadness and anger by drawing on forgotten memories and emotions. A mantra for reflection and enlightenment, the work reflects on that time and experiments with the interplay of visual language and emotion. *Follow The Black Rabbit* stems from a very personal emotion that the artist defines as "a transition, an evolution, a break in time, a pause." Yet, it blends the painful with the glamorous, the political with the beautiful, while bringing together people living through the same experiences at the same time.

It was originally presented in the Stedelijk Museum Amsterdam, June 2022—January 2023, as part of the graphic design series Post /

빛에 따라 전시장 복도에 색색의 그림자를 드리우고, 복도 끝에 설치된 비디오의 '안에서(within)'라는 단어와 연결되면서 긍정과 부정이라는 이분법 대신 불안정 자체를 긍정하는 성찰적 태도를 권한다.

검은 토끼를 따라
2022/2023년
접착 시트, 단채널 비디오,
컬러, 무음,
설치 약 425×850/
393×795cm, 1분 51초

소피 두알라／Sophie DOUALA

No/Bills, curated by Thomas Castro. The artist and curator carefully reorganized the work to fit the exhibition space, Culture Station Seoul 284, while maintaining the mood and narrative flow of the original work. The graphic patterns, which display a rhythmic and rhyming quality through repetition, cast colorful shadows across the exhibition hall depending on the light. They connect with the word "within" that appears in the video installed at the end of the corridor, proposing a reflective attitude that affirms instability instead of the dichotomy of affirmation and denial.

Follow The Black Rabbit
2022/2023
adhesive sheet,
single-channel video,
color, silent,
installation approx.
425×850/393×795cm,
1 min. 51 sec.

아스트리트

Astrid

리트

아스트리트 제메는 그래픽 디자이너다.
브뤼셀, 요하네스버그, 이스탄불을
문화적 배경으로 하며, 빈 응용 예술
대학교에서 공부하고, 네덜란드의
베르크플라츠 티포흐라피에서 석사
학위를 받았다. 디자인 작업과 함께
학생들을 가르치고, 타이포그래피와
그 발성에 주목해 연구를 지속하고 있다.
예술가들의 책을 펴내는 출판사
마르크 페칭어 북스를 공동 운영한다.

Astrid Seme is a graphic designer.
With cultural backgrounds
in Brussels, Johannesburg,
and Istanbul, she studied at the
University of Applied Arts
Vienna and earned her Master's
degree at the Werkplaats
Typografie in the Netherlands.
Alongside her design work,
she teaches students and
continues to research
typography and its vocalization.
She also co-runs Mark Pezinger
Books, a publishing company
for artist publications.

SEME

제 메

〈대시를 긋는 형상들〉은 한 권의 책이자 하나의 목소리이며, 역설적인—
그렇다고 해서 가장 역설적이지는 않은—문장 부호인 "엠 대시(—)"에
스카프를 두른 작품이다. 이는 다다이스트 예술가이자 시인인 엘사 폰프라이탁
로링호벤(1874 – 1927)과 그녀의 광적인 엠 대시 사용에 관한 오마주이기도
하다. 엠 대시(또는 엔 대시)의 목적은 다양하며—침묵의 차용, 불협화음 연기,
방해, 공간 점유 등을 위해 쓰인다. 엘사 폰프라이탁로링호벤 남작 부인의
시에서 엠 대시는 언어와 그에 관한 음향적 해석을 결합하는 언어 요소로 쓰인다.
아스트리드 제메는 이를 확대된 형태와 식자공의 태도로 타이포잔치에 건넸다.
　〈대시를 긋는 형상들〉과 함께 선보이는 오디오 작품에서는 문장 부호인
대시들이 제 목소리를 낸다. 이들은 차례로 돌아가며 자신들이 등장한
서지 사항, 연설과 인쇄의 역사를 내밀하게 말하고, 하인리히(폰클라이스트)와
크리스티안(모르겐슈테른), 거트루드(슈타인), 로렌스(스턴) 혹은 대시의
여왕인 에밀리(디킨슨)처럼 유명한 대시 애호가들에 관해서도 이야기한다.
　〈엠 대시 스카프〉는 별다를 것 없는 실패로부터 탄생했다. 엠 대시 하나가
갑자기 종잇장에서 떨어져 나와서는 엘사 남작 부인의 창의적인 정신을
입을 수 있는 형태로 구현해 버린 것이다—그 푹신한 표면은 종이 섬유와
잉크 가닥에서 탄생했다. 이 스카프를 착용한 사람은 한순간 스카프로 변신해
글쓰기와 퍼포먼스 사이를 오간다.

아스트리트 제메／Astrid SEME

born in Graz, Austria/based in Vienna, Austria

Figures for dashing is a book, is a voice, and is a scarf on a
paradoxical—if not the most paradoxical—punctuation mark:
the em dash. Moreover, it is a homage to Dadaist artist and poet
Elsa von Freytag-Loringhoven (1874 – 1927) and her manic use
of em dashes. The purpose of the em (or en) dash is wide-ranging
—as an appropriation of silence, as acting dissonance,
as an interruption, as occupying space. In Baroness Elsa von
Freytag-Loringhoven's poetry, the em dashes are linguistic
elements that conjunct language and its acoustic interpretation.
In an enlarged form and with a typesetter's manner, Seme
handed them over to Typojanchi.
　In Seme's accompanying audio piece, the dashes rise to speak.
One after the other, they tell us intimately about their bibliography,
their history in speech and printing, and of course, they do talk
about the likes of other well-known dashers such as Heinrich (von
Kleist) and Christian (Morgenstern) and Gertrude (Stein), and
Laurence (Sterne) or the queen of dashing herself Emily
(Dickinson).
　The em dash scarf came into being with an uncharacteristic
flop: Suddenly, the em dash has fallen from the page to become
a wearable embodiment of Baroness Elsa's creative spirit—its fluffy
surface brought into being from paper fibers and strands of ink.

대시를 긋는 형상들
2019년
사운드 설치(스테레오,
4분 25초), 대시 벽면
그래픽(접착 시트, 가변 크기),
단행본(제메, A., 『엘자
남작 부인의 엠 대시: 인쇄물,
시, 공연으로 만나는 대시 선집』,
마르크 페칭어 북스,
2019 / 2022년, 종이에
오프셋 인쇄, 무선철,
14.5×10 cm, 96쪽),
엠 대시 스카프(인조 모피,
220×32 cm, ed. 10 / 30)

협업
브라이언 데이(목소리)

아스트리트 제메 / Astrid SEME

Suddenly transforming into a scarf, the wearer oscillates between writing and performance.

Figures for dashing
2019
sound installation
(stereo, 4 min. 25 sec.),
dash wall graphics
(adhesive sheets,
dimensions variable),
book (SEME, A.,
*Baroness Elsa's em
dashes: An anthology of
dashing in print, poetry &
performance*, Mark
Fetching Books,
2019 / 2022, offset print
on paper, perfect binding,
14.5×10 cm, 96 pages),
the em dash scarf
(Teddy fur, 220×32 cm,
ed. 10 / 30)

Collaboration with
Brian Day (speaker)

36. Elsa's breathless use of the em dash might be inherited by Emily Dickinson who is beyond doubt the queen of dashing.

37. Virginia and Gertrude were dashing women, also. But Emily was the only one who could dash her brains out.

5. Yes, em dashes create clarity and emphasis.

신 SHIN

신동혁은 그래픽 디자인의 역사,
양식, 관습, 전통, 이론 따위를 재료 삼아
'지금, 여기'라는 맥락에 걸맞은 결과물로
갱신해 내는 데 관심이 많다.
2014년부터 그래픽 디자이너
신해옥과 함께 '신신'이라는 이름으로
활동하고 있다.

Dong

동 혁

hyeok

Shin Donghyeok is interested
in updating the history, styles,
conventions, traditions, and
theories of graphic design with
creative materials that are
relevant to the context of 'here
and now.' Since 2014, he has
been working as a member of a
duo 'Shin Shin' with graphic
designer Shin Haeok.

"〈신양장표음〉은 '글자가 말과 음을 동시에 품을 수 있을까?'라는 가벼운
호기심에서 출발했다. 이 생각은 '글자가 말소리와 더불어 높낮이가 있는 음계를
품으려면 어떤 조건이 필요할까?'로 이어졌고, 결국 아주 무모하게, 한글
제자 원리와 오선지에 음을 기록하는 방식을 한데 엮어 말과 음, 두 마리 토끼를
잡는 도구를 만들기로 했다."

　　〈신양장표음〉은 기본 자음 글자(ㄱ/ㄴ/ㄷ/ㅅ/ㅇ)에 획을 더해 만든
자음 일부(ㅎ/ㅊ)와 기본 모음 글자 세 개 중 하늘을 본뜬 글자(·)를
바탕으로 한글과 음계를 짝지어 음표로도 기능하는 새로운 개념의 활자체로,
작가는 원도를 그리는 과정에서 다음과 같은 몇 가지 원칙을 세운다.

- 이것은 활자체다.
- 오선지를 기준선으로 삼는다.
- 기본 자음 글자에 추가된 획은 가능한 한 음표로 치환한다.
- 근거가 불분명한 장식적 표현은 배제한다.
- 타자와 동시에 연주되도록 한다.

이 원칙을 공유하는 약 1,500자의 한글과 로마자 원도는 신동혁이 그렸다.
이를 바탕으로 한글과 로마자 폰트, 그리고 함께 쓸 문장 부호와 숫자,
특수 기호는 양장점의 장수영과 양희재가 만들었다. 완성된 〈신양장표음〉을

신동혁 / SHIN Donghyeok

"*Shin-Yang-Jang Phonogram* started from a mild curiosity:
can a letter hold both words and sounds? This led to the question,
'What would it take for a letter to have a pitch scale in addition
to speech sounds?' Ultimately, I decided to be a little reckless
and combine the principles of Korean writing and the way notes are
written on a stave to create a tool that catches two birds with
one stone."

　　Shin-Yang-Jang Phonogram is a typeface with a new concept
that combines Hangeul and the scale based on specific consonants
(ㅎ/ㅊ)—created by simply adding strokes to basic consonants
(ㄱ/ㄴ/ㄷ/ㅅ/ㅇ)—and vowel letter (·) with its form derived from
the sky—among three basic vowels each symbolizing the sky, earth,
and human. Below are several principles that were followed
while drawing its blueprint.

- This is a typeface.
- It is based on the musical stave.
- Potentially, additional strokes in the basic consonant letter
 are counted as one note.
- Avoid decorative presentations with unclear logic.
- Compose it as they can be played at the same time
 as they are typed in.

사용해 컴퓨터 자판을 치는 행위가 곧 연주가 되도록 하는 웹 사이트는 문정주가 개발했다. 관람객은 전시장에 설치된 컴퓨터 자판으로 글자를 입력해 화면으로 그 형태를 보는 동시에 글자가 연주되는 소리를 들을 수 있다.

신양장표음
2023년
혼합 매체, 활자체
〈신양장표음〉, 부클릿(신동혁,
『신양장표음』, 화원, 2023년,
종이에 오프셋 인쇄, 중철,
30×30cm, 24쪽), 웹 사이트,
COM의 피아노 테이블과
재즈 스툴

협업
장수영(한글 폰트 제작),
양희재(로마자 폰트,
문장 부호, 숫자, 기호 제작),
문정주(웹 사이트 개발)

제작 후원
문성인쇄

신동혁 ╱ SHIN Donghyeok

Shin Donghyeok devised the original drawings of approximately 1,500 Hangeul and Roman characters that share these principles. Based on his sketch, Yang-Jang's Yang Heejae and Jang Sooyoung created Korean and Roman fonts and punctuation marks, numbers, and special symbols to accompany them. A website to play the completed Shin-Yang-Jang Phonogram, reinventing the act of typing on a computer keyboard into a musical performance, was developed by Moon Jungju. Visitors can type letters on a computer keyboard installed in the exhibition and see the letters on the screen while hearing the sound of the letters being played. (Copyediting: LEE Miji)

Shin-Yang-Jang Phonogram
2023
mixed media, Shin-Yang-Jang Phonogram typeface, booklet (SHIN, D., *Shin-Yang-Jang Phonogram*, Hwawon, 2023, offset print on paper, saddle stitch binding, 30×30 cm, 24 pages), website, piano table and jazz stool of COM

Collaboration with
JANG Sooyoung (Hangul font creation), YANG Heejae (Roman font, punctuation marks, numbers, and symbols creation), and MOON Jungju (website development)

Sponsored by
Munsung

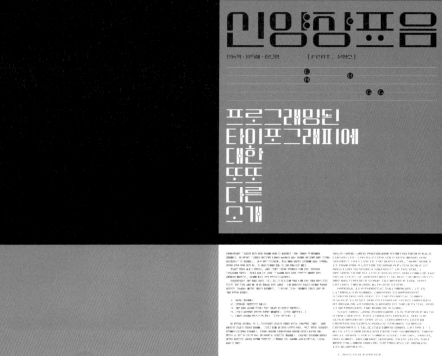

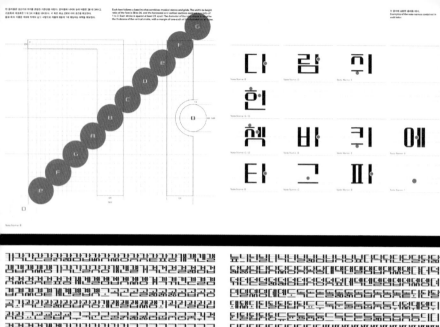

가를 했더니 미오리가 나고 , 도를 치
니까 올소리가 나 미올미을 하니둠뻭
넥디려

가를 했더니 미오리가 나고 , 도를 치
니까 올소리가 나 안녕하세요 만니 너
반가워~동해물과 백두산이 마르고 닳
도록

양

Yu-Chiao

위

차

오

YANG

양위차오는 구전 민담을 전문으로 하는 해설가 겸 서사 예술가다. 구비 문학, 드라마, 영화, 서사를 연구한다. 대만 전역에서 '세계의 민담'이라는 강연 형식의 정기 공연을 선보이고, 실험적인 음향 공연 시리즈 '아나모르포시스와 아나텍시스'(민담), '네크로만티아 디스퍼서스'(시)로 대만 안팎의 예술 축제와 공연에 참여해 왔다. 2019년부터 가오슝 영상 자료원과 국립 가오슝 예술 센터에서 학생들을 가르친다. 『힐향(肹響)』(2023)을 펴냈고, 여러 온·오프라인 매체에 갑골문에서 파생한 단편 소설과 산문을 활발하게 기고한다. 민담과 인공지능의 협업에 관심을 두고 미드저니로 만화 『까치의 죽음에 관한 목격자들』(2022)을 출판하고, 인공지능 협업 공연 〈언어의 춤: 공명하는 민담〉 (2023)에 참여했다.

Yang Yu-Chiao is a professional oral tradition narrator and narrative artist specializing in folktales. He studies oral literature, drama, film, and narrative. He presents regular performances throughout Taiwan in the form of lectures titled World Folktales and has participated in art festivals and performances in and outside of Taiwan with his experimental sound performance series Anamorphosis & Anatexis (folktales) and Necromantia Dispersus (poetry). Since 2019, he has taught at the Kaohsiung Film Archive and National Kaohsiung Center for the Arts. He has published *Xi Xiang* (2023), a collection of acoustic imaging poems, and actively contributes short stories and prose derived from bone inscriptions to various online and offline media outlets. With an interest in collaboration between folk tales and AI, he published a comic book titled *Witnesses of the Magpie's End* (2022) using Midjourney and participated in the AI collaboration performance *Dance of Words: Resonating Folktales* (2023).

〈칠판 스크리보폰〉은 쓰기 동작과 구전 해설, 칠판 표현이 합쳐진 독특한 형식의 공연이다. 양위차오는 네 가지 대만 민담과 이와 연계된 네 가지 한국 민담을 엮은 구술 즉흥 공연으로 관객을 이야기가 시작된 먼 과거로, 문자 대신 말로 이야기를 짓던 구술의 시대로 데려간다. 제목에서 '스크리보폰'은 라틴어에서 온 'scribo(쓰기)'에 그리스어에서 온 '-phone(소리)'을 조합한 것으로, 이 공연의 기획 의도를 보여 준다.

　양위차오에게 고대 문자, 특히 갑골문 같은 표의 문자나 상형 문자는 과거의 활동과 이야기의 흔적을 저장한 오디오 테이프와 같다. 그는 문자에 암호화되고 압축된 내용에 접근하기 위해 분필을 들고, 칠판에 각 민담의 메시지를 상징하는 갑골문, 한자, 한글 단어를 천천히 여러 번 쓰면서 이야기하고 노래하고 읊조리고 말한다. 이때 분필은 마치 레코드판의 홈을 따라가며 소리를 재생하는 축음기의 바늘과 같다.

　이 작품은 말이 가진 의미 대신 그 표면에 해당하는 소리나 문자로 서사를 전하는 실험이다. 공연은 작가가 직접 수집, 분류, 대조, 번역한 민담을 바탕으로 중국어로 진행된다. 하지만 작가는 기이한 발성과 어조를 단어를 변형해 중국어를 모국어로 하는 관객조차 그 뜻을 쉽게 알아채지 못하도록 만든다. 대신 가락, 장단, 목소리 연기, 몸동작, 즉흥 연주 등 구술적 특성에 기대어 섬세하게 소리를 전하고, 관객은 전시장에 제시된 한글 요약본으로 내용을 파악한 뒤 소리, 감정, 움직임을 따라 메시지를 유추하면서

양위차오／YANG Yu-Chiao

born in Taipei, Taiwan／based in Kaohsiung, Taiwan

Blackboard Scribophone is a performance that employs a unique format that combines the act of writing with oral commentary expressions drawn on a blackboard. Yang Yu-Chiao weaves together four Taiwanese and four Korean folktales in an oral improvisation performance that takes the audience back to the distant past when stories began, to the time of oral literature when people told stories through speech instead of letters. In the title, the word "scribophone" is a combination of the Latin word "scribo" (writing) and the Greek word "-phone" (sound), which shows the intention of the performance.

　For Yang, ancient texts, especially ideograms or hieroglyphics like bone inscriptions, are like audio tapes that store traces of past activities and stories. He uses chalk to access the encrypted and compressed content of the texts, and he talks, sings, chants, and recites as he writes slowly and repeatedly on the blackboard— bone inscriptions, Chinese characters, and Hangul words that symbolize the message of each folktale. During the performance, the chalk acts like a stylus on a phonograph that traces the grooves of a record and plays the sound.

　As such, this work is an experiment in telling a narrative with sounds or letters that correspond to the surface of words instead of their meaning. The performance is done in Chinese, based

암묵지에 기대어 다양한 상상의 길로 접어든다.

양위차오는 2018년부터 칠판 공연 시리즈를 선보여 왔다. 칠판에 글자를 쓰는 행위는 글씨를 지워도 그 흔적이 남고 그 위에 새로운 글씨가 쓰인다는 점에서 고고학적 지층을 연상시키며, 긴 시간 속에서 인간의 지식과 경험, 생각과 감정이 축적되고 변화해 온 방식을 새삼 생각하게 만든다.

"구전 민담은 인간이 어떤 사건이나 사물을 이해해 온 보편적인 인식을 담고 있고, 여러 나라의 민담은 비슷한 서사를 공유한다. 그것은 블록 쌓기와 비슷하다. 대만에 A·B·C·D 블록으로 이뤄진 민담이 있다면 필리핀이나 인도네시아에는 B·C 블록으로 이루어진 민담이 있고, 또 다른 나라에는 B·C를 포함하지만 다른 방향으로 전개되는 이야기가 있다. 구전 민담은 장단이나 관용적 표현 등을 사용해 기억하기 쉽게 설계돼 있어서 일단 이야기를 시작하면 타래가 풀리듯 자연스럽게 줄거리가 흘러나온다."

양위차오／YANG Yu-Chiao

on folk tales collected, categorized, collated, and translated by the artist himself. However, the artist uses bizarre vocalizations and tones to transform words so that even native Chinese audiences cannot easily grasp their meaning. Instead, he delicately conveys sounds in anticipation of the spoken word: melodies, long and short phrases, vocalizations, body movements, and improvisations. The audience understands the content from the Korean summary provided in the exhibition hall, and then infer the message from the sounds, emotions, and movements, relying on the tacit knowledge to enter various imaginative paths.

Since 2018, Yang Yu-Chiao has presented a series of blackboard performances. The blackboard is reminiscent of an archaeological formation in that even when you erase the writing, a trace remains and new writing is written over it. It reminds us of the way human knowledge, experience, thoughts, and emotions have accumulated and changed over time.

"Oral folklore conveys the universal way humans have made sense of events or things, and folk tales from different countries share similar narratives. It's similar to building things with blocks. If there's a Taiwanese folk tale made of blocks A·B·C·D, here are folk tales with the B·C blocks in the Philippines or Indonesia while other countries might have stories that include B·C but unfold

칠판 스크리보폰
2023년
사운드 설치(스테레오, 120분),
칠판용 나무 구조물,
220×242×6cm (5)

양위차오／YANG Yu-Chiao

in different directions. Oral folklore is designed to be easy
to remember, with pauses and idioms. Once the storytelling stars,
the plot flows naturally like a skein of yarn being unwound."

Blackboard Scribophone
2023
sound installation (stereo,
120 min.), wood structures
with blackboard surface,
220×242×6cm (5)

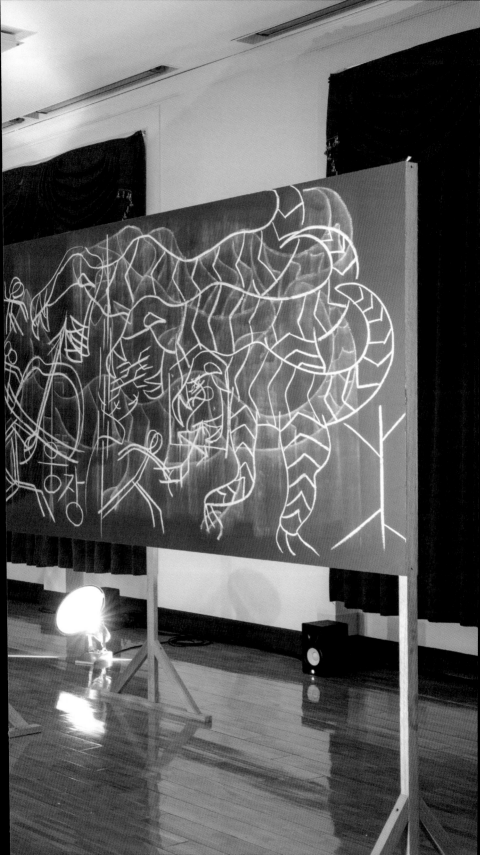

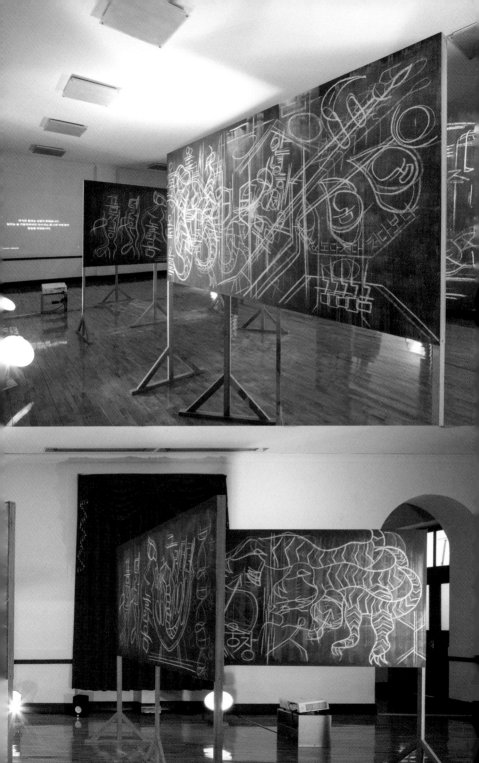

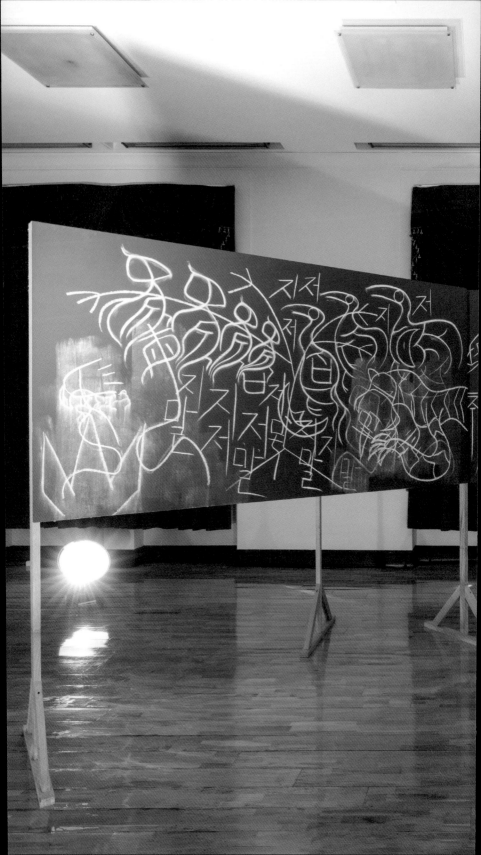

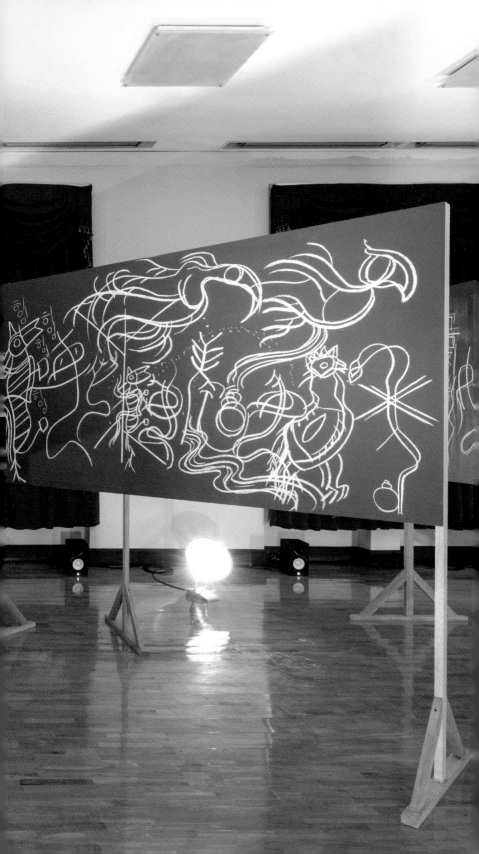

Sooji

이수지는 서울과 암스테르담을 오가며 미술과 디자인, 평면과 오브제의 경계 없이 작업한다. 홍익대학교에서 산업 디자인을 공부하고 에인트호번 디자인 아카데미에서 정보 디자인으로 석사 학위를 받았다. 2016년부터 형식의 개인화를 탐구하며 도구를 짓고 그로부터 평면 결과물을 얻는 과정을 거쳐, 현재는 조형적 결과물을 얻는 도구 연구에 주력하고 있다. 개인전 《Goodbye to the art》(라임스톤 북스, 마스트리흐트, 2023), 《Form forming, Formation》(인천아트플랫폼, 인천, 2023), 《Liminal Phase》(OCI미술관, 서울, 2022)를 열었다. 2019년 얀 반 에이크 레지던시를 시작으로 여러 레지던시에서 창작 활동을 이어 왔고 2023년에 난지미술창작스튜디오에 입주했다.

이

Lee Sooji divides her time between Seoul and Amsterdam, working without boundaries between art and design, two-dimensional and object-based works. She studied industrial design at Hongik University and earned a master's degree in information design from Design Academy Eindhoven. Since 2016, she has been exploring the personalization of form, building tools, and getting two-dimensional results from them. Currently, she is focusing on researching tools that achieve sculptural results. She has held solo exhibitions *Goodbye to the art* (Limestone Books, Maastricht, 2023), *Form forming, Formation* (Incheon Art Platform, Incheon, 2023), and *Liminal Phase* (OCI Museum of Art, Seoul, 2022). Since her first residency at the Jan van Eyck Residency in 2019, she has continued to participate in various artist residencies. In 2023, she was selected as a resident artist at SeMA Nanji Residency in Seoul.

수지

이수지는 종이에 손바느질로 격자 구조를 짠 다음 다시 그 위에 검은색 실로
활자와 면을 수놓으며 조형를 만든다. 전시에 선보이는 일련의 작품은
작가가 2016년부터 2022년까지 진행한 〈그래픽을 공예하는 매우 사적인
방법론〉의 평면 결과물들로, 활자와 그래픽을 오로지 손으로 구현한다는 형식을
공유한다.

　　"활자는 인쇄를 목적으로 만들어졌고 요즘은 대부분 컴퓨터 시스템으로
구현된다. 우리는 자판으로 문서를 작성할 때 흔히 무엇을 '쓴다'라고
표현하지만 정확하게는 쓰는 것이 아니라 누르거나 치는 것이다. 나는 말 그대로
활자를 쓰기로 했다."

　　작가는 직접 '글자 쓰는 기계'를 제작하고 이를 사용해 기하학적
모양과 수학적 비례를 갖춘 활자체 보도니를 그 조형 규칙에 따라 정확하게
쓰려고 시도하지만, 결국에는 글씨와 달리 손으로 '쓸 수 없는' 활자의
특성을 재확인했다.

　　작품 형식을 완성한 다음에는 무엇을 쓸 것인가의 문제가 등장했는데
내용에 무게가 실릴수록 보는 이의 시선은 어떤 식이든 방향성을 갖게 되고
원래 전하고자 하던 바는 이미 그곳에 없는 '과정'이 되어 결과물 뒤로 사라졌다.
이후 작가는 시간과 함께 증발한 그 과정의 흔적을 남기기 위해 화면에서
내용을 비우고 형식을 담는 방법을 탐구하기 시작했다.

이수지／LEE Sooji

Lee Sooji creates the lattice structure by hand-stitching on paper,
then embroidering the lettering and cotton with black thread.
The series of works in the exhibition are two-dimensional outputs
produced between 2016 and 2022, which are from the artist's
ongoing work, *A very personal methodology of crafting the graphic*.
The works share the format of being exclusively handmade with
type and graphics.

　　"Type was created for the purpose of printing and is nowadays
mostly implemented by computer systems. When we write on a
keyboard, we often say we are "writing" something, but technically
we are not writing; we are pressing or striking. I decided to literally
write the type."

　　The artist built her own "writing machine" and attempted
to use it to write Bodoni, a typeface with geometric shapes
and mathematical proportions, precisely according to its rules
of composition. However, she ultimately reaffirmed the nature
of type, which, unlike writing, cannot be "written" by hand.

　　Once she had the format of the piece completed, the question
of what to write emerged. However, the more heavy the content
became, the more the viewer's gaze was directed in some way.
The original message became a "process" that was no longer in its
place, disappearing behind the result. The artist explored ways

전시에 선보이는 작품들은 그 결과물로, '글자를 이미지로 대하기'라는
실천의 일부다. 이수지는 의도적으로 의미를 배제하면서 글자를 도형과 같은
이미지로 취급하고, 아직 단어가 되지 못한 글자를 관념화된 이미지로 다룬다.
손바느질이라는 공예 기술이 지니는 시간성 위에 반복과 변주로 쌓아 올린
활자와 그래픽, 평면에서 이탈하려는 듯한 구성 요소는 작품 표면에 드러난 의미
없음(얄팍함)과 대비되는 과정의 지난함, 즉 형식이 그곳에 있었음을 드러내는
시도이자 그 자체로 작가가 전하려는 내용이 된다.

콤포지션 01
2022년, 종이, 잉크, 실,
81×183 cm
콤포지션 02
2021년, 종이, 잉크, 실,
91×61 cm
콤포지션 03
2021년, 종이, 잉크, 실,
61×61 cm
콤포지션 04, 05
2021년, 종이, 잉크, 실,
91×56 cm

빅 블랙 스퀘어스 01, 02, 03
2021년, 종이, 잉크, 실,
81×56 cm
익스트루딩 03, 04
2023년, 종이, 실,
91×56 cm

이수지／LEE Sooji

of emptying the screen of content and capturing form in order
to leave a trace of the process that has evaporated with time.
　　The works on display are the result of this practice of "treating
letters as images." By deliberately excluding meaning, Lee treats
letters as images like shapes, and letters that have not yet become
words as conceptualized images. The typography, graphics, and
out-of-plane components, layered with repetition and variation on
top of the temporality of the craft of hand-stitching, become an
attempt to reveal the great difficulty of the process—the fact that
the form has been there, in contrast to the meaninglessness
(shallowness) of the surface of the work, which is itself what the
artist is trying to convey.

composition 01
2022, paper, ink, thread,
81×183 cm
composition 02
2021, paper, ink, thread,
91×61 cm
composition 03
2021, paper, ink, thread,
61×61 cm

composition 04, 05
2021, paper, ink, thread,
91×56 cm
*big black squares
01, 02, 03*
2021, paper, ink, thread,
81×56 cm
extruding 03, 04
2023, paper, thread,
91×56 cm

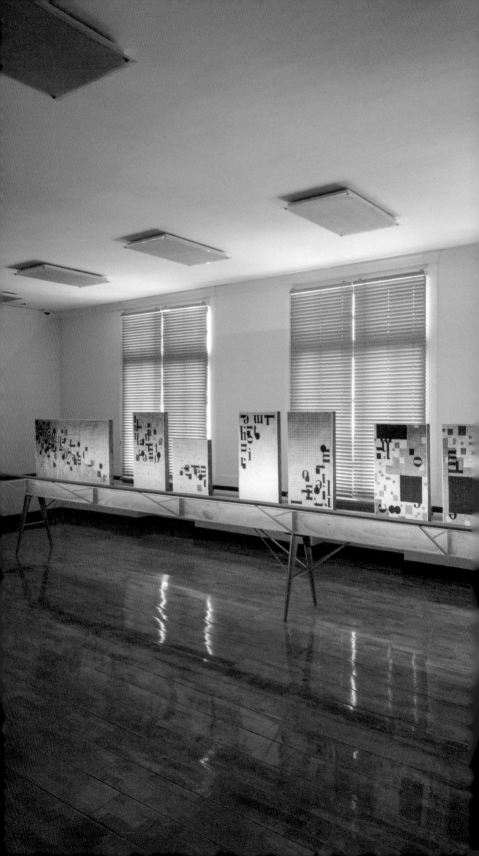

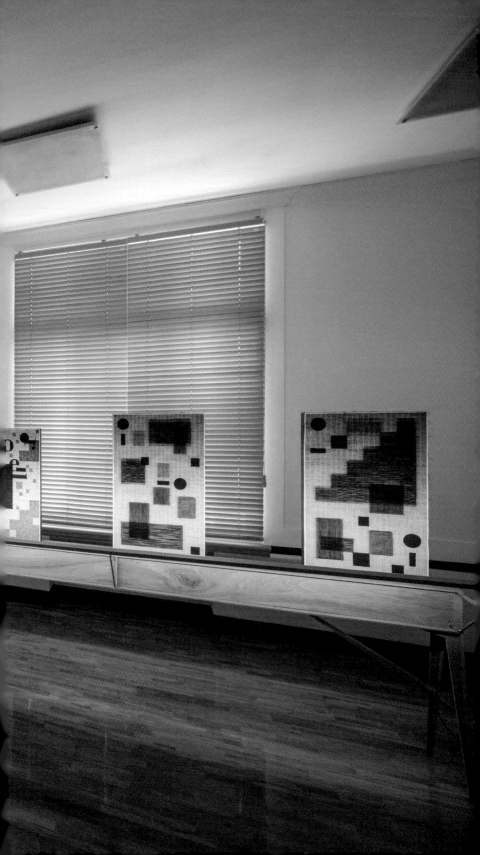

문정주는 그래픽 디자이너 겸
개발자다. 서울과학기술대학교와
서울시립대학교 디자인 전문 대학원에서
시각 디자인을 공부했고, 그래픽
디자인과 프로그래밍 언어를 주요
도구로 시청각 커뮤니케이션
분야의 작업을 선보인다. 각각의 관심
분야를 연결해 정리된 결과물로
내놓는 것을 좋아하고, 귀여운 것을
보고 듣는 데서 활력을 얻는다.

Moon Jungju is a graphic designer
and developer. He studied visual
design at Seoul National
University of Science and
Technology and the University of
Seoul Graduate School of Design.
He presents his work in the field
of audiovisual communication,
using graphic design and
programming languages as his
main tools. He enjoys connecting
his interests to an organized
output and is energized by seeing
and hearing cute things.

한국 서울 출생／한국 서울에서 활동

〈소리로 타이포그래피하기〉는 관객들이 작가가 제시한 글을 낭독하면 그 말소리를 문자로 변환해 화면 안에 실시간으로 조판하는 방식으로 말하기와 타이포그래피 사이의 연결성을 부여한다. 같은 글을 읽어도 그 소리는 발화자의 음색, 음높이, 세기, 타이밍(속도)에 따라 모두 다른 음성 값을 가지며 때로는 잘못 읽는 오류가 발생하기도 한다.

문정주는 이처럼 소리를 이루는 다양한 구성 요소를 매개 변수로 사용해 화면 안의 특정 판면 위에 여백을 만들거나 활자의 크기, 굵기, 위치 같은 타이포그래피 요소로 변환하면서 눈에 보이지 않는 소리에 시각적 '성격'을 부여한다.

'말하는' 읽기를 '보는' 읽기로 전환하는 이 작품은 말이 가진 시간성을 화면 안에 구체화하는 동시에, 소리 내어 읽는 행위는 발화자의 해석과 신체성에 기대는, 발화자 중심의 수행적 과정임을 말한다.

문정주／MOON Jungju

born in Seoul, South Korea／based in Seoul, South Korea

Typography with Sound creates a connection between spoken word and typography, as the audience reads out the words presented by the artist, which are then translated into letters and typeset in real-time on the screen. Even if the same text is read, the sounds all have different phonetic values depending on the speaker's timbre, pitch, intensity, and timing (speed), sometimes resulting in misreading errors.

Using these various components of sound as parameters, Moon Jungju gives visual "character" to invisible sounds by creating blank space on certain screen panels or converting them into typographic elements such as the size, weight, and position of type.

The work shifts from a "spoken" reading to reading to be "seen," materializing the temporality of speech on the screen while suggesting that the act of reading aloud relies on the interpretation and physicality of the speaker, which is a performative process that is centered around the speaker.

소리로 타이포그래피하기
2023년
인터랙티브 설치, 웹 사이트,
마이크, 오디오 인터페이스,
보면대, 인쇄물

글 제공
김정현, 더 그레잇
커미션(전민경), 박상훈,
스튜디오 도감(김남주, 지강일),
욱림솔훈(김대욱, 김유림,
오은솔, 이영훈), 움직이는
세상(박다현, 윤신혜, 임나리),
이슬기

문정주 / MOON Jungju

Typography with Sound
2023
interactive installation,
website, microphone,
audio interface, music
stand, printed papers

Collaboration with
Studio DOHGAM (JI Kangil,
KIM Namjoo), KIM
Junghyun, LEE Seulki,
Moving World (LIM Nari,
PARK Dahyun, YOON
Shinhye), PARK Sanghoon,
The Great Commission
(Zoe CHUN), and
Wooklimsolhoon (KIM
Daewook, KIM Yoolim, LEE
Younghoon, OH Eunsol)

PARK

Chul

박

박철희는 서울에서 햇빛스튜디오를
운영하는 그래픽 디자이너.
한글 레터링 작업을 좋아한다.

Park Chulhee is a graphic
designer who runs Sunny Studio
in Seoul. He likes doing lettering
works in Korean.

hee

철희

"소리가 없는 영화를 보는 것은 괴롭다. (…) 완성된 한 편의 영화를 제삼자가 마음대로 해석해서 재편집할 기회는 흔치 않다. 작업 과정에서 모종의 죄책감을 느꼈고 여전히 좋은 일을 했다고는 생각되지 않는다. 그런 마음을 담아 일본 성우 야마데라 코이치가 모 인터뷰에서 더빙에 관해 한 말을 제목으로 인용했다."

〈더 좋게 만들기는 어렵지만 망치기는 쉽다〉는 1920년대에 만든 것으로 추정되는 이규설 감독의 무성 영화「근로의 끝에는 가난이 없다」에 스톱모션 방식으로 소리 요소를 문자로 올린 작업이다. 박철희는 무성 영화를 상영할 때 스크린 귀퉁이에서 대사와 몸짓으로 영화에 생동감을 불어넣는 변사와 같이 모듈형 타이포그래피를 일종의 '타이포그래피 변사'로 사용했다.

박철희／PARK Chulhee

born in Gwangju, Jeollanam-do, South Korea / based in Seoul, South Korea

"It is painful to watch a movie without sound. (…) It is not so often that one has the opportunity to re-edit a completed movie and have it interpreted by a third party. I felt a bit guilty during the process and still don't think I did a good work. With that in mind, I took the title from a quote by Japanese voice actor Yamadera Koichi about dubbing in an interview."

It's hard to make it better, but it's easy to mess up is a stop-motion lettering of sound elements to the silent film There Is No Poverty at the End of Labor, directed by Lee Gyuseol, which is believed to have been produced in the 1920s. Park Chulhee uses modular typography to act as a kind of "typographic interpreter," in the same way that a film interpreter at a screening of a silent movie would bring the movie to life with dialog and gestures.

**더 좋게 만들기는 어렵지만
망치기는 쉽다**
2023년
단채널 비디오, 흑백, 무음,
12분 50초

박철희／PARK Chulhee

***It's hard to make it better,
but it's easy to mess up***
2023
single-channel video,
black and white, silent,
12 min. 50 sec.

Korean Film Archive
한국영상자료원

프로젝트 파트너
이 작품은 한국영상자료원이 소장한
무성 영화에 타이포그래피로
청각성을 더한 작업입니다.

Project Partner
The work adds the audibility to
a silent film from the Korean
Film Archive.

오케이오케이 서비스는 서울과
암스테르담에 기반을 둔 독립
스튜디오다. 파리스 카심과 미 킴
부이가 운영하며, 디지털 콘텐츠에 관한
모든 영역을 다룬다. 주로 브랜드,
문화 기관, 개인과 일하며 인터랙션
디자인과 개발, 크리에이티브 코딩,
3D 디자인, 생성형 브랜딩 설루션에
관한 탐구적인 작업을 선보인다.

오케이

OKOK

오
케이

Services

OKOK Services is an independent
studio based between Amsterdam
and Seoul. The studio is run
by Faris Kassim and My Kim Bui,
covering all areas of digital
content. The studio works
primarily with brands, cultural
organizations, and individuals,
showcasing exploratory work
in interaction design and
development, creative coding,
3D design, and generative
branding solutions.

서비스

〈평행의 거리〉는 한국전쟁 시기에 만들어진 몇 안 되는 영화 중 하나인 「태양의 거리」(1952)를 재해석한다. 전쟁이 삼팔선 부근에서 교착 상태에 빠졌을 때, 극장 구경은 가장 인기 있던 오락거리 중 하나였다. 이 사실은 전쟁 중에도 일상은 지속되고 모든 것을 잃은 상황에서도 피난민들이 새로운 도시에 모여 삶의 재미를 추구했다는 것을 방증한다.

　〈평행의 거리〉는 이 지점에서 출발해 전쟁의 잔혹함 속에서도 일상을 이어 가는 시민들의 삶에 주목한다. 오케이오케이 서비스는 우선 영화의 오리지널 프레임들을 3D 공간에서 해체하고, 프레임들은 앞쪽에, 전쟁 당시의 일상을 보여 주는 신문 광고나 영화 포스터들은 그 뒤쪽에 배치한다. 이러한 프레임 중첩은 필름과 일상의 경계를 흐리는 시도다. 두 번째는 영화 속 클립들의 중첩이다. 클립들은 특정한 시간 순서를 따르지 않으며 이는 시간성을 무너뜨리는 시도다. 선형적 시간을 따르지 않고 돌아가는 클립들은 우리의 현재 속에 과거와 미래가 모두 넘실대고 있음을 나타낸다.

오케이오케이 서비스／OKOK Services

Distance of Parallels reinterprets The Street of Sun (1952), one of the few films produced during the Korean War. Theater-going was a popular entertainment when the war was at a stalemate at the 38th parallel. This implies that life goes on even during a war and that refugees who lost everything still pursue small entertainment in the new city that they found themselves in.

　Taking a point of departure from above, *Distance of Parallels* pays attention to the lives of refugees who persist in everyday life despite the brutality of the war. Firstly, the work deconstructs the frames of the film into a 3D space, then positions the original frames at the forefront and newspaper advertisements and film posters (through which we can glimpse at the everyday lives during the war) at the back. Such overlapping is an attempt to blur the border between film and life. The second overlapping is the overlapping of clips from the film. The clips do not follow any chronological order. This overlapping is an attempt to deconstruct temporalities. Clips, rotating without any specific order, demonstrate that the past and the future both ebb and flow in our present.

평행의 거리
2023년
단채널 비디오, 흑백, 무음,
1분 57초

협업
길희연

오케이오케이 서비스／OKOK Services

Distance of Parallels
2023
single-channel video,
black and white, silent,
1 min. 57 sec.

Collaboration with
Alex Heeyeon KIL

프로젝트 파트너
이 작품은 한국영상자료원이
소장한 소리가 유실된 영화에
타이포그래피로 청각성을
더한 작업입니다.

Project Partner
The work employs
typography to add audibility
to a film that has lost its
soundtrack. The film is
provided by the Korean
Film Archive.

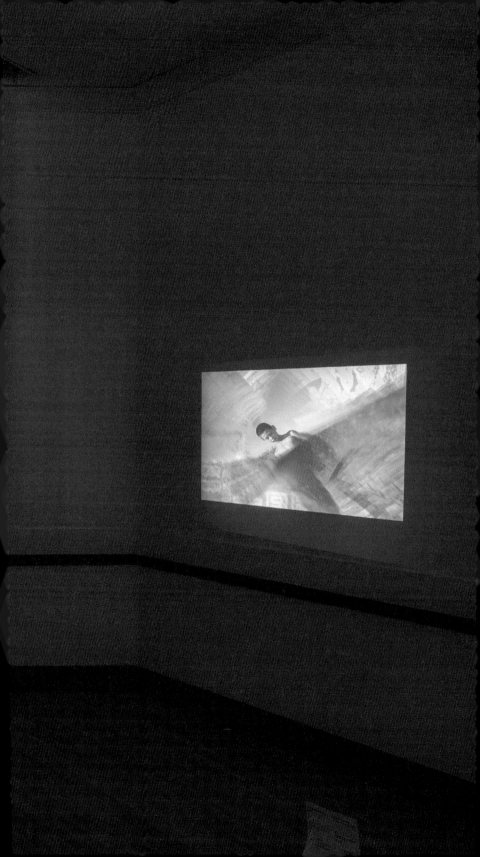

Go
eun

고
은

박

인

PARK

박고은은 그래픽 디자이너 겸
도시 속 사라진 것들의 이야기를
수집하는 데 흥미를 느끼는 연구자다.
서울대학교에서 시각 디자인을
공부하고, 에인트호번 디자인
아카데미에서 정보 디자인으로 석사
학위를 받았다. 복잡한 정보 데이터를
관찰하는 과정에서 새로운 이야기를
발견하는 데 관심이 많다. 단행본
『사라진 근대건축』(2022)을 썼고,
《걷기, 헤매기》(국립아시아문화전당,
광주, 2023),《최근 그래픽 디자인
열기(ORGD) 2022》(wrm space,
서울, 2022) 등의 전시에 참여했다.

Park Goeun is a graphic designer
and researcher interested in
collecting stories of lost things
in cities. She studied visual
design at Seoul National
University and holds a master's
degree in information design
from Design Academy Eindhoven.
She is interested in discovering
new stories in the process of
observing complex information
data. She has written a
monograph, *Erased Korean
Modern Architecture* (2022),
and participated in exhibitions
such as *Walking, Wandering*
(Asia Cultural Center, Gwangju,
2023) and *Open Graphic
Design (ORGD) 2022* (wrm space,
Seoul, 2022).

〈노래하고 춤추던 정원〉은 한국과 홍콩의 최초 합작 영화인 「이국정원」(1957)을 소재로 한다. 이 영화는 소리가 유실돼 지금은 영상 필름과 대본만 전해진다.

「이국정원」의 여자 주인공 이름은 우연하게도 '방음(方音)'이다. 문자 그대로 한 자씩 풀이하면 '모서리 또는 방향' 그리고 '소리'다. 사라진 소리를 대신해 화면에 어지럽게 흐르는 문자열의 움직임에 귀를 기울이면, 영화 속 주인공의 몸짓 사이로 익숙한 소리의 질감들이 느껴지는 듯하다.

박고은／PARK Goeun

The Garden of Singing and Dancing is based on Love with an Alien (1957), the first joint film between South Korea and Hong Kong. The soundtrack was lost, and only the video footage and script survived.

Notably, the female lead in Love with an Alien is coincidentally named Fang Yin (方音). The literal meaning of the name, when translated, is composed of Chinese characters that mean "corner or direction" and "sound." As we listen to the dizzying movement of the sequence of letters on the screen in place of the missing sound, we can hear the familiar textures of sound through the gestures of the movie's protagonist.

노래하고 춤추던 정원
2023년
웹 사이트

박고은／PARK Goeun

*The Garden of Singing
and Dancing*
2023
website

Korean Film Archive
한국영상자료원

프로젝트 파트너
이 작품은 한국영상자료원이
소장한 소리가 유실된 영화에
타이포그래피로 청각성을
더한 작업입니다.

Project Partner
The work employs
typography to add audibility
to a film that has lost its
soundtrack. The film is
provided by the Korean
Film Archive.

Moon

강

GANG

강문식은 계원예술대학교, 헤릿
리트펠트 아카데미, 예일 대학교에서
그래픽 디자인을 공부하고, 2018년부터
한국에 머무르며 작업을 선보여 왔다.
그래픽 디자이너라는 직업 정체성을
구심점으로 마주치는 예기치 못한 상황,
다양한 변수, 쉽게 지나칠 수 있는
사소한 흔적 같은 것들에 반응하며
새로운 잠재성을 만들 수 있는 사잇길을
찾아가고 있다.

sick

문 식

Gang Moonsick studied graphic
design at Kaywon University
of Art and Design, Gerrit Rietveld
Academie, and Yale University
and has been living and working
in Korea since 2018. As a graphic
designer, he responds to
unexpected situations, various
variables, and trivial traces that can
be easily overlooked and searches
for silent paths that can create
new potentials.

한국 서울 출생 / 한국 서울에서 활동

〈감사한 분들〉은 디자이너가 다루는 시각 요소가 소리와 어떻게 관계 맺고 소리를 어떻게 대체하며, 또 어떤 다른 상상이 가능한지를 살핀다. 강문식은 이 방식을 적극적으로 활용해 문자화된 정보에서 소리를 상상하고 재생산하며, 보고 읽는 경험으로 영화적 이미지가 어떻게 다르게 발생하는지를 이야기한다.

강문식 / GANG Moonsick

born in Seoul, South Korea / based in Seoul, South Korea

Thanks to addresses how the visuals a designer works with relate to sound, how they replace it, and what other imaginings are possible. In this work, Gang examines how cinematic images arise from the experience of reading and re-imagining sounds from that textualized information.

감사한 분들
2023년
단채널 비디오, 컬러, 무음,
5분 7초

협업
이상우(글), 이민형(영상),
김종문(수어), 김혜경(움직임)

강문식／GANG Moonsick

Thanks to
2023
single-channel video, color,
silent, 5 min. 7 sec.

Collaboration with
YI Sangwoo (text),
LEE Minhyung (video),
KIM Jongmoon
(sign language), and
KIM Hyekyoung
(movements)

(허리 아래에서 들려오는
꼬마아이들의 속삭임)

감사한 분들
김민준
이서준
김도윤
최예준
정시우

감사한 분들

오서준
백수아
김재원
이지율
최승희
정다인
강준우
박예림
김유찬
이주아
곽민우
서하린
임동현
문유나
송준우
오하린
박주원
최서현
정태명
조미영

약은 잘 챙겨 드시고 계세요?
(열리는 화장실 문)

『그래픽』 50호

『그래픽』은 주류를 넘어선 그래픽 디자인의 새로운 흐름을 탐구하고 관련 현상에 통찰력을 제공하는 그래픽 디자인 전문지다. 매호 하나의 주제에 집중해 심도 있는 접근 방식을 취하고, 외부 자금 지원에 의존하지 않고 에디터십의 독립성을 유지하며 창의적인 기사를 만든다. 한국, 유럽, 미국, 아시아와 그 외 지역에 배포된다.

GRAPHIC

#50

GRAPHIC (ISSN 1975-7905) aims to explore emerging trends in graphic design beyond the mainstream and provide insights into phenomena around graphic design. Each edition takes an in-depth approach by focusing on a single theme. The magazine maintains its editorial independence and produces innovative articles without raising external funding. It is distributed in Korea, Europe, America, Asia, and other regions.

2007년 1월 창간 / 한국 서울에서 발행

프로파간다에서 발행하는 독립 잡지 『그래픽』은 타이포잔치 2023과 협업해 그 50번째 호를 '타이포그래피와 소리'를 주제로 한 특별 호 형태로 제작했다. 『그래픽』 50호는 전시에 드러나지 않지만 타이포잔치 사이사이 2022–2023 《사물화된 소리, 신체화된 문자》에서 출발해 타이포잔치 2023 《따옴표 열고 따옴표 닫고》를 완성하는 동안 기획 팀이 여러 갈래로 영향을 받은 작가와 작품, 도움받은 글과 책 등 타이포잔치 2023의 참고 문헌이라 불러도 좋을 콘텐츠들을 10편의 글과 200여 쪽의 이미지로 재구성해, 전시 도록과는 다른 관점에서 독자와 관람객이 타이포그래피와 소리라는 주제를 깊고 넓게 경험하도록 돕는다.

『그래픽』 50호／GRAPHIC #50

GRAPHIC, an independent magazine published by Propaganda, collaborated with the Typojanchi 2023 planning team to produce its 50th issue as a special issue on the theme of typography and sound. *GRAPHIC #50* reorganizes the artists and works that influenced the planning team, as well as the articles and books that helped them, although they were not represented in the exhibition while organizing Typojanchi Saisai 2022–2023: Materialized Sound, Embodied Text and staging Typojanchi 2023: Open Quotation Marks, Close Quotation Marks. The magazine operates as a bibliography of Typojanchi 2023, reorganizing the content into ten texts and more than 200 pages of images, allowing readers and visitors to experience the theme of typography and sound from a different perspective than the exhibition's catalog.

founded in January 2007 / published in Seoul, South Korea

『그래픽』50호
2023년
종이에 오프셋 인쇄, 무선철,
30×23cm, 264쪽

『그래픽』50호／GRAPHIC #50

GRAPHIC #50
2023
offset print, perfect
binding, 30×23cm,
264 pages

GRAPHIC

프로젝트 파트너
이 작품은 타이포잔치 2023과
『그래픽』의 공동 프로젝트로
기획되었습니다.

Project Partner
This work was conceived
as a joint project between
Typojanchi 2023 and
GRAPHIC.

GRAPHIC

#50

보이스: 타이포잔치 2023 메모들
VOICE: Notes from the Typojanchi 2023

『그래픽』50호 GRAPHIC #50

2023년
종이에 오프셋 인쇄, 무선철,
30 × 23 cm, 264쪽

2023
offset print, perfect binding,
30 × 23 cm, 264 pages

프로젝트 협력
이 작품은 타이포잔치 2023과
계간 『그래픽』의 공동
프로젝트로 기획되었습니다.

Project Cooperation
This work was conceived
as a joint project between
Typojanchi 2023 and a
quarterly magazine, GRAPHIC.

GRAPHIC

39

Pro

gram

프로

그램

공연 1
종이울음

폭 1미터, 길이 100미터의
대형 두루마리를 대본으로 하는
낭독 공연.

작가
손영은

일시 / 장소
1회. 9월 20일(수) 오후 2시
2회. 9월 23일(토) 오후 2시
문화역서울284 / 2층 그릴

공연 2
칠판 스크리보폰

대만과 한국의 민담을 바탕으로 쓰기
동작과 구전 해설, 칠판 표현을 합친 구술
즉흥 공연.

작가
양위차오

일시 / 장소
1회. 9월 20일(수) 오후 4시
2회. 9월 23일(토) 오후 4시
문화역서울284 / 2층 회의실

프로그램 / Program

Performance 1
Crisp

A recitation performance
using a large scroll measuring
one meter in width and 100
meters in length as its script.

Artist
SOHN Youngeun

Date and Venue
September 20 (Wed.), 2:00 p.m.
September 23 (Sat.), 2:00 p.m.
Culture Station Seoul 284 /
Grill (2F)

Performance 2
Blackboard Scribophone

A unique oral improvisation that
combines writing actions, verbal
commentary expressions, and
blackboard drawings from
Taiwanese and Korean folktales.

Artist
YANG Yu-Chiao

Date and Venue
September 20 (Wed.), 4:00 p.m.
September 23 (Sat.), 4:00 p.m.
Culture Station Seoul 284 /
Meeting Room (2F)

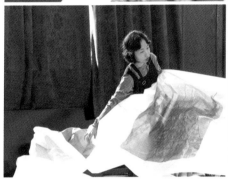

공연 3
라숙

작가의 데스크톱에 익숙한 디지털 환경을
재현한 후 해킹하거나 작동 오류를
일으키며 자유로운 사용자 경험을
유도하는 실시간 스트리밍 현장 공연.

작가
헤르디마스 앙가라

일시 / 장소
1회. 9월 24일(일) 오후 6시 30분
2회. 10월 7일(토) 오후 6시 30분
3회. 10월 8일(일) 오후 6시 30분
문화역서울284 / 1층 3등 대합실

워크숍
대체 텍스트 워크숍

비장애인의 웹 사용자 환경에서
시각적으로 드러나지 않는 대체 텍스트를
직접 작성하며 그 역할과 필요성을
공유하는 워크숍.

작가
새로운 질서 그 후

일시 / 장소
1회. 10월 6일(금) 오전 11시–12시 30분
2회. 10월 6일(금) 오후 2시–3시 30분
문화역서울284 RTO

Performance 3
RASUK

A live-streamed on-site
performance that recreates a
familiar digital environment on the
artist's desktop, which is then
hacked and malfunctioned to create
a liberated user experience.

Artist
Herdimas ANGGARA

Date and Venue
September 24 (Sun), 6:30 p.m.
October 7 (Sat), 6:30 p.m.
October 8 (Sun), 6:30 p.m.
Culture Station Seoul 284 /
The 3rd Class Waiting Room (1F)

Workshop
Alt Text Workshop

A workshop to share the role and
necessity of writing alt text that is
not visualized in the web user
experience for non-disabled people.

Artist
After New Order

Date and Venue
October 6 (Fri),
11:00 a.m.–12:30 p.m.
October 6 (Fri), 2:00 p.m.–3:30 p.m.
Culture Station Seoul 284 RTO

대화
제3작품집

테레사 학경 차의 『딕테』를 이어 쓰고,
다시 쓰고, 다르게 쓴 『제3작품집』에 관한
관람객과의 대화.

작가
김뉘연·전용완

일시/장소
10월 6일(금) 오후 5시
문화역서울284 RTO

강연
회색 연구

회색을 프로토콜 삼아 활자 영역과
소리 영역을 교차시킨 리서치 결과물을
공유하는 '렉처 퍼포먼스'.

작가
이한범

일시/장소
10월 13일(금) 오후 5시
문화역서울284 RTO

프로그램/Program

Conversation
The Third Thing

An engaging dialogue with the
audience about *The Third Thing*
(2023), a work that explores,
revises, and reimagines Theresa
Hak Kyung Cha's *DICTEE* (1982).

Artist
KIM Nuiyeon & JEON Yongwan

Date and Venue
October 6 (Fri), 5:00 p.m.
Culture Station Seoul 284 RTO

Lecture
Gray Studies

A lecture performance presenting
research findings about the
connections between typography
and sound, using gray as the
protocol for the creative production.

Artist
LEE Hanbum

Date and Venue
October 13 (Fri), 5:00 p.m.
Culture Station Seoul 284 RTO

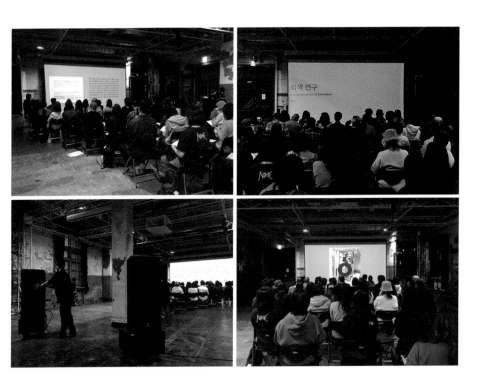

팝업 서점
더 북 소사이어티

타이포잔치 2023 기간 동안 더 북
소사이어티가 전시장 1층에서 선보인
팝업 서점. 참여 작가들의 책과 작품집,
더 북 소사이어티가 전시 주제에 맞춰
선별한 도서들, 타이포잔치 2023
개막과 함께 발행된 『그래픽』 50호 등
70여 권의 책으로 구성.

후원사 전시
우아한형제들, 〈배민글림체 백수백복도〉

타이포잔치 2023 후원사이자
배달의민족 운영사인 우아한형제들이
〈배민 글림체〉를 활용해 장수를
상징하는 100개의 '수' 자와 만복을
상징하는 100개의 '복' 자를 수놓은 병풍
〈배민글림체 백수백복도〉를 전시.

프로그램／Program

Pop-up Bookstore
The Book Society

During the exhibition, The Book
Society operates a pop-up
bookstore on the first floor of the
venue. It features over 70 books,
including participating artists'
books and catalogs, curated books
in response to the exhibition theme,
and *GRAPHIC #50*, released with
the launch of Typojanchi 2023.

Sponsor Exhibition
Woowa Brothers Corp.,
Baemin Geullim Baeksubaekbokdo

Woowa Brothers Corp., a Typojanchi
2023 sponsor and operator of the
Baemin, presents *Baemin Geullim
Baeksubaekbokdo*, an embroidered
folding screen with 100 "su (수)"
characters symbolizing longevity
and 100 "bok (복)" characters
symbolizing happiness, using
Baemin Geullim, an illustrated
Hangeul letter.

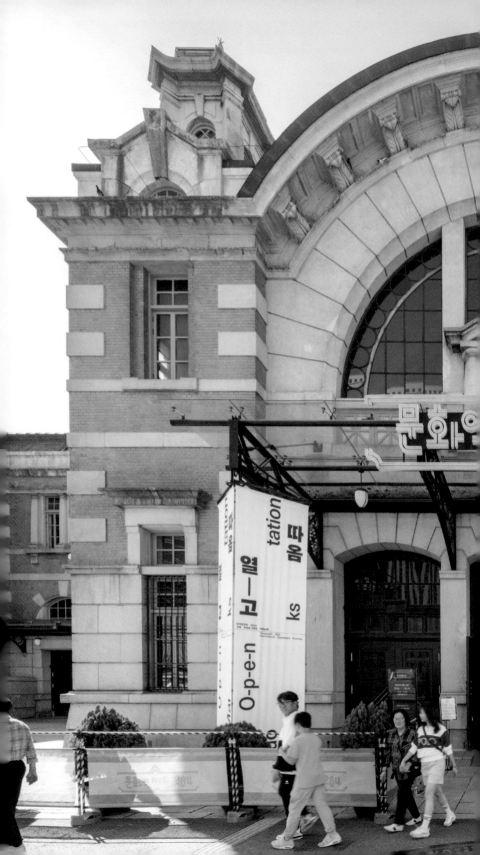

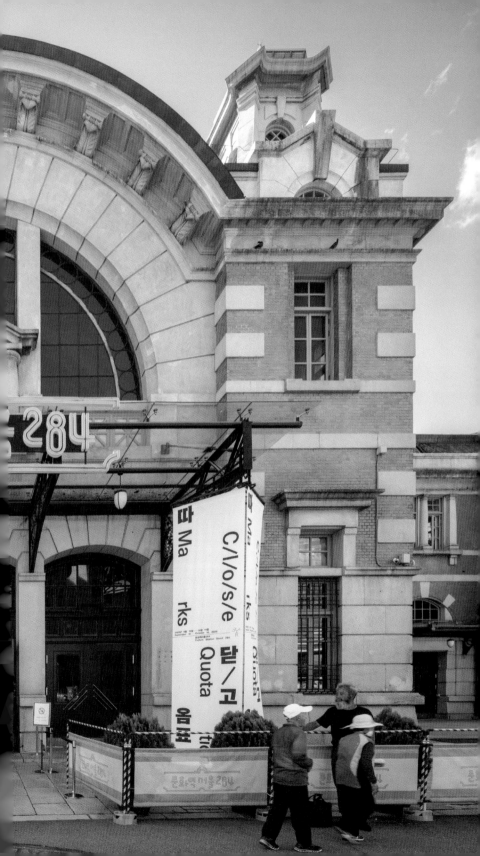

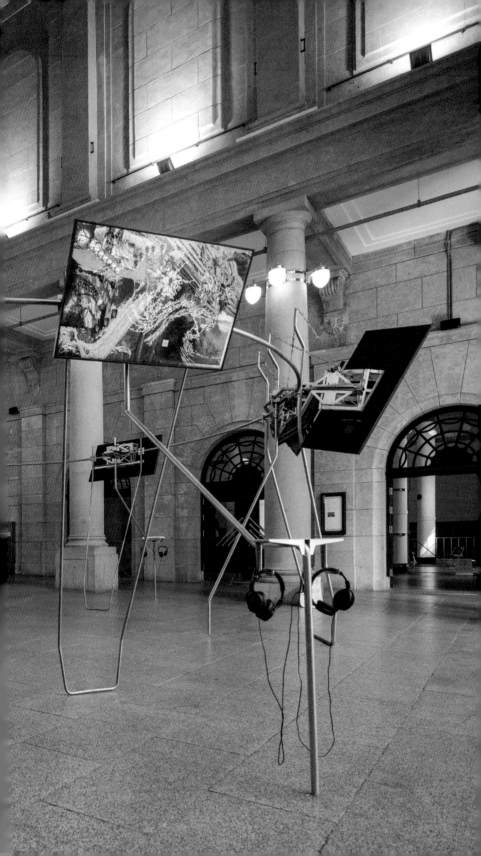

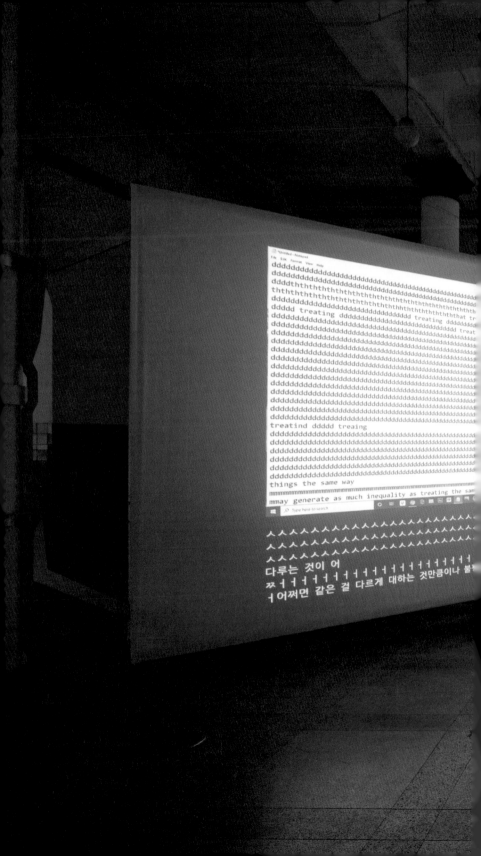

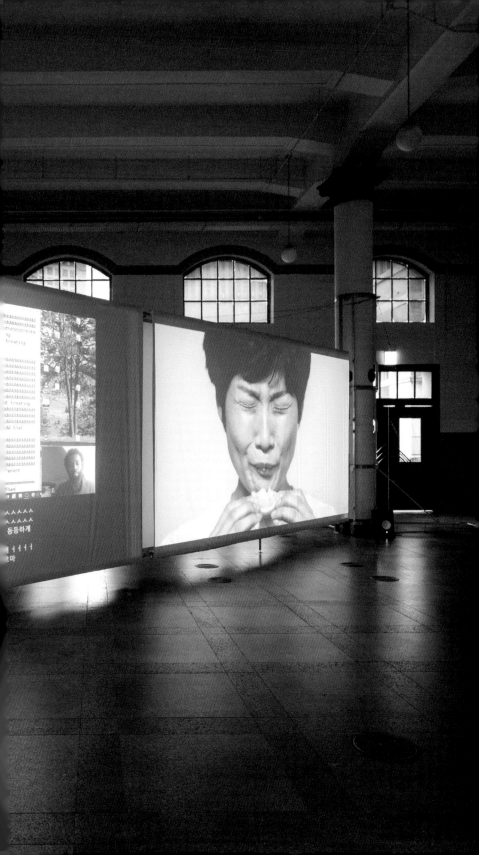

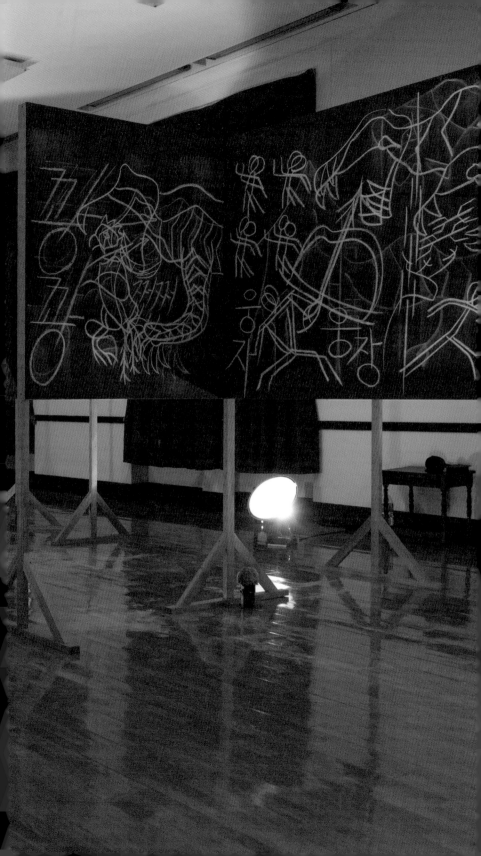

타이포

잔치

sai

타이포잔치 사이사이 2022-2023
국제 타이포그래피 비엔날레
《사물화된 소리, 신체화된 문자》

2022년 9월 2일(금)-9월 4일(일)
문화역서울284 RTO

예술 감독
박연주

큐레이터
신해옥
여혜진
전유니

협력 큐레이터
김쥬리

코디네이터
전하은

그래픽 디자인
프론트도어

공간 디자인
팔렛스케이프 /
HG-Architecture

사진·영상
글림워커스

웹 사이트 개발·
사운드 디자인
문정주

모션 디자인
민경무

편집
이정신

번역
서울셀렉션

통역
박재용

문자 통역
에이유디
사회적협동조합

타이포잔치 사이사이 2022-2023은
타이포잔치 2023 국제 타이포그래피
비엔날레에 앞서 그 주제어인
'타이포그래피와 소리'를 여러 각도에서
탐색한 사전 행사다.
　　타이포잔치 사이사이 2022-
2023은 '사물화된 소리, 신체화된
문자'라는 제목 아래 강연·워크숍·공연을
선보였다. 디자인뿐 아니라 문학,
음악 등 다양한 분야에서 활동하는
창작자들이 참여한 이 행사는, 소리가
받아쓰기·타이핑·인쇄·코딩 같은
과정을 거쳐 시각화 혹은 사물화되고
문자가 재생·낭독·퍼포먼스·공연 등의
행위를 통해 신체화되는 과정 안에서
타이포그래피의 역사를 만나고 현재를
살피며 미래를 상상해 볼 수 있는
창의적인 장면들에 주목했다.

sai

As a preliminary event in anticipation of Typojanchi 2023: International Typography Biennale, Typojanchi Saisai 2022–2023 stereoscopically explored the biennale theme, "Typography and Sound."

Under the title "Materialized Sound, Embodied Text," Typojanchi Saisai 2022–2023 invited creators in various fields, from design and literature to music. The event creatively highlighted processes where sound is visualized or materialized through dictation, typing, printing, and coding and where letters turn into sound through acts including playback, recitation, and performance as a way to encounter the history of typography, examine its present, and imagine its future.

Typojanchi Saisai 2022–2023 International Typography Biennale — Materialized Sound, Embodied Text

September 2 (Fri.)–4 (Sun.), 2022
Culture Station Seoul 284 RTO

Artistic Director
PARK Yeounjoo

Curators
JEON Yuni
SHIN Haeok
YEO Hyejin

Associate Curator
Julie KIM

Coordinator
JEON Haeun

Graphic Design
front-door

Scenography
Palletscape /
HG-Architecture

Photograph and Video
glimworkers

Website Development and Sound Design
MOON Jungju

Motion Design
MIN Kyungmoo

Editing
LEE Jeongsin

Translation
Seoul Selection

Interpretation
Jaeyong PARK

Real-Time Captioning
Aud Social Cooperative

강연 1
음n음o음d음e음s음

「음n음o음d음음e음s음」은 문학·출판·디자인을
아우르며 폭넓은 리서치와 방대한 아카이브
작업을 선보여 온 연사와 함께 문학 작품,
특히 시에 주목해 문자와 소리가 교차하는
지점들을 탐색하며 소리·시·그래픽 디자인을
광범위하게 연결한다.

이 강연은 소리 시의 타이포그래피적
에너지를 감각하는 워크숍 「시s시o시u시n시d시i
시n시g시」와 짝을 이루며, 음악을 중심으로
문자와 소리의 관계를 들여다보는 「강연 2:
연주할 수 없는 악보, 보기 위한 음악」과도
완벽하게 공명한다.

"「음n음o음d음e음s음」은 영국 시인 폴라
클레어의 핵심 개념과 작품을 출발점으로 삼아
'인터미디어의 태양'* 아래에서 감각과 지성이
뒤섞이는 경험, 즉 예술과 시, 디자인의 문턱을
넘나드는 여정을 선사한다. 강연에서 선집
『구체시를 쓰는 여성들: 1959–1979』는
구체시·소리 시·시각 시의 기존 경계에 의문을
품고 그 경계를 해체하는 도구로 활용되며
선구적이고 실험적인 작가와 소리 예술가
(sonosopher) 이를테면 애니아 록우드,
릴리 그리넘, 조지 브레히트, 존 케이지, 앨리스

Lecture 1
음n음o음d음음e음s음

Having invited a speaker who has
produced works based on extensive
research and archives spanning the fields
of literature, publishing, and design,
음n음o음d음e음s음 highlighted points of
text-sound intersection in poetry, drawing
broad connections between sound,
poetry, and graphic design.

This lecture is paired with the
workshop 시s시o시u시n시d시d시i시n시g시,
which explores the typographical energy
of sound poetry. It also perfectly
resonated with the lecture "The
Unplayable Score, Music for the Eyes,"
which examines the relationship between
text and sound in music.

"Using some of poet Paula Claire's key
notions and works as a starting point, this
presentation will offer a journey at the
threshold of art, poetry, and design,
where senses and intellect blend under
the intermedia Sun.* The anthology
Women in Concrete Poetry: 1959–1979
will be used as a tool to question and
deconstruct the conventional boundaries
of visual, sound, and concrete poetry —
while the works of pioneer experimenters
and sonosophers such as Annea

놀스, 애나 할프린, 백남준, 샬럿 무어먼, 폴린 올리베로스의 작품은 감각의 영역에서 (타이포)그래픽의 개념을 깊이 생각하게 만든다. 스코어와 교점은 우리 삶에서 시를 구체화하는 데 어떻게 활력을 불어넣을까?"

Lockwood, Lily Greenham, George Brecht, John Cage, Alison Knowles, Anna Halprin, Nam June Paik, Charlotte Moorman, and Pauline Oliveros will call us to reflect on (typo)graphic notation in the sensorial field. How do scores — and nodes — energize the materialization of poetry in our lives?"

*
1995년 딕 히긴스가 제시한 벤 다이어그램 '인터미디어 차트'를 말한다. 히긴스는 장르간 경계를 넘나들며 다양한 매체가 섞이고 융합하는 예술적 특성을 '인터미디어'라는 용어로 정의했다.

강사
알렉스 발지우(교육자 / 글 쓰는 디자이너 / 장서광)
진행
신해옥(타이포잔치 2023 큐레이터)
알렉스 발지우
교육자, 글 쓰는 디자이너, 장서광(특히 하이델베르그 GTO52 인쇄기 시대의 책). 집단 창의성을 발휘할 수 있는 공간을 디자인하거나 다양한 전달 방식을

실험하는 데 관심이 있다. 로잔예술대학교, 리옹 국립고등미술원, 파리 'DOC!'와 파리미술대학교, 교토 빌라 쿠조야마 또는 바로 서점에서 책을 읽거나 놀거나 강연 중인 그를 쉽게 발견할 수 있다. 모니카 드 라 토레와 『구체시를 쓰는 여성들: 1959–1979』를 공동 편집했다. 책을 너무 사랑한다면, 그가 올리비에 르브런과 전 세계를 돌며 진행 중인 편집 인형극 시리즈 비블리오매니아를 찾아보라.

*
Refers to the Intermedia Chart — a Venn diagram proposed by Dick Higgins in 1995. Higgins coined the term "intermedia" to refer to the property of artworks that amalgamate and integrate different media to transcend the boundary of their genres.

Speaker
Alex BALGIU
(Educator / Designerwriter / Bibliomaniac)
Moderator
SHIN Haeok (Curator of Typojanchi 2023)
Alex BALGIU
Alex Balgiu is an educator, designerwriter, and bibliomaniac about the age of a Heidelberg GTO 52. He

is also concerned with designing spaces for collective creativity and experimenting with various modes of transmission. You can catch him reading, playing, and disseminating in Lausanne (Écal), Lyon (Énsbal), Paris (Doc & Pca), Kyoto (Villa Kujoyama), or the bookshop next door. Or you can pick up *Women in Concrete Poetry: 1959–1979*, a collection of outstanding concrete poems by women that was edited together with Mónica de la Torre. Do you love books too much? Then join Bibliomania, an ongoing series of editorial puppet shows created with Olivier Lebrun, touring all over the world.

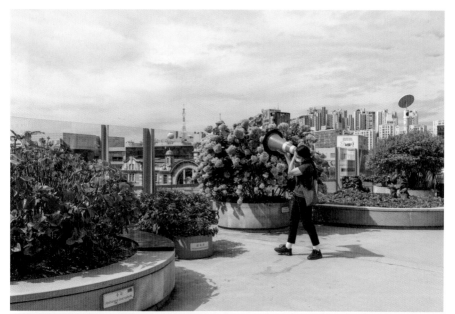

워크숍
시s시o시u시n시d시i시n시g시

소리 시를 배우고 직접 지어도 보는 흥미로운
시간을 통해 타이포그래피의 열린 에너지를
경험하는 워크숍이다. 참가자들은 문화역서울284
주변을 산책하며 도시의 소리와 문자를 채집하고
타자기·복사기·가위 등을 활용해 채집한
소재를 재구성한 뒤 그 결과물들을 한데 모아
'타이포 성가'를 완성한다.

Workshop 1
시s시o시u시n시d시i시n시g시

This workshop, where participants learn
about and compose their sound poetry,
offers an experience of the open energy
of typography. Participants walk around
Culture Station Seoul 284 collecting
sound and text sources from the urban
environment, then sensibly reconstruct
the collected sources into "typochants"
using equipment such as typewriters,
copiers, and scissors.

"「시s시o시u시n시d시i시n시g시」는 여러분을
'시l시i시l시v시i시l시n시g시'의 시간으로 초대한다.
우리는 애니아 록우드가 그랬던 것처럼,
도시를 살아 있는 생명체로 보고 도시에 흐르는
소리 에너지를 담은 시「말라만」을 온몸으로
감각해 본다.
　　워크숍은 서울의 거리를 거닐며 도시의 소리
에너지를 타이포그래피 관점에서 듣는 것으로
시작해 이후 문화역서울284 RTO에 모여
이렇게 감지한 소리를 다양한 멀티그래픽 도구를
활용해 감각적으로 해석하고 표현한 뒤 그
결과물들을 모아 '타이포 성가'를 합주한다.
굿모닝, 숨 쉬는 시!"

"시s시o시u시n시d시i시n시g시 invites you
to tune in to the 시l시i시l시v시i시l시n시g시,
and—following in the steps of Annea
Lockwood—to sense the poetry of
"malaman," the flow of sound-energy of
the city, envisioned as a living organism.
　　Beginning with a session of
typographic listening by walking the
streets of Seoul, we will then work to
sensorially translate and broadcast these
perceptions through a variety of
multigraphic tools—culminating in a
collective lunchtime typochant at Cultural
Station Seoul 284. Good morning,
breathing poem!"

강사
알렉스 발지우(교육자/
글 쓰는 디자이너/장서광)
진행
신해옥(타이포잔치 2023
큐레이터)

Speaker
Alex BALGIU
(Educator/
Designerwriter/
Bibliomaniac)

Moderator
SHIN Haeok (Curator
of Typojanchi 2023)

강연 2
연주할 수 없는 악보, 보기 위한 음악

악보는 소리를 불러내는 기호로 가득 차 있지만 어떤 악보는 그로부터 벗어나 다른 길로 향한다. 그들은 기호를 읽는 대신 눈으로 보기를, 그리고 소리 내는 대신 머릿속에서 상상하기를 요청한다.

　이 강연은 서양 음악사에서 형성된 문자적 악보의 긴 흐름과 20세기 들어 달라진 기보 양상을 소개하고, 특히 그래픽 기보를 매개로 1950–1960년대에 본격적으로 등장한 기보 실험을 들여다본다. 강연 후에는 그래픽 디자이너가 대화자로 참여해 타이포그래피와 음악의 접점에서 다양한 사례를 공유한다.

"독일 작곡가 디터 슈네벨이 발표한 '모-노, 읽기 위한 음악'(이하 '모-노')이라는 책이 있다. 본문을 보면 텍스트, 기호, 오선보, 그림, 사진 등 다양한 요소가 등장한다. 이 책은 음악적인 것을 모아 놓은 단행본 『모-노, 읽기 위한 음악』일까, 아니면 「모-노, 읽기 위한 음악」으로 표기해야 할 음악 작품일까?

　악보는 시간 속에서 울리고 사라지는 소리의 구조를 기호화해 지면에 고정해 놓은 것으로 그것을 특정한 논리로 구현하면 기록자가 상상한 소리를 재현할 수 있다고 여겨졌다. 하지만 '모-노'는 악보라는 그 공통 문자 체계에서 벗어날 뿐 아니라 악보가 해오던 역할에서도 훌쩍

Lecture 2
The Unplayable Score, Music for the Eye

A musical score is often filled with symbols that dictate the sounds, but some scores deviate from this convention to pave their own paths. Instead of requiring a musician to read symbols to make sounds, these scores demand visual observation and imagination.

This lecture introduces the evolution of textual scores in the context of the long history of Western music and how the practice of notation changed during the 20th century, paying particular attention to the graphics-mediated notational experiments that largely emerged in the 1950s and 1960s. A graphic designer joins the post-lecture conversation to share various examples of cases in which typography and music intersect.

"German composer Dieter Schnebel published a book titled Mo-No: Music to Read ('Mo-No'). Introduced inside the book are symbols, text, music sheets, pictures, photographs, and various other elements, which make readers question, 'Is this book a publication or a piece of music?'

A musical score is a symbolized structure of sounds — sounds that will resonate and then disappear with time —

벗어난다. '모-노'에 담긴 요소들은 기존 악보처럼 무언가를 지시하는 것일까, 아니면 그 자체로 무언가를 표현하는 것일까? 소리가 없더라도, 청각적 연상을 촉발하는 텍스트나 이미지, 기호를 읽는 행위 또한 그 자체로 음악을 향유하는 것이라고 말할 수 있을까?"

imprinted on paper. A popular belief is that, if implemented with a certain logic, the sound of the score can be reproduced as it has been imagined by the composer. However, Mo-No diverges from a musical score in terms of not only the common writing system but also how far it is from its conventional role. Do the elements in Mo-No dictate something as the elements in a conventional musical score do, or do they express something all on their own? Despite the absence of sound, could the act of reading into the text, images, and symbols that trigger auditory associations be considered a musical endeavor in and of itself?"

연사
신예슬 (음악 비평가)
대화
신동혁 (그래픽 디자이너)
진행
여혜진 (타이포잔치 2023 큐레이터)

신예슬
음악 비평가. 헤테로포니 동인. 음악학을 공부했고, 유럽 음악과 그 전통을 따르는 근래의 음악에 관한 의문으로부터 비평적 글쓰기를 시작했다. 『음악의

사물들: 악보, 자동 악기, 음반』을 썼고 종종 기획자, 드라마터그, 편집자로 일한다.

Speaker
SHIN Yeasul (Music Critic)
Panelist
SHIN Donghyeok (Graphic Designer)
Moderator
YEO Hyejin (Curator of Typojanchi 2023)

SHIN Yeasul
A music critic and a member of the collective Heterophony, Shin Yeasul studied musicology, after which she began to write critical essays out of doubt about European music and contemporary music following its tradition. Among her major written works is *The Things of Music: Musical Score, Automatic Musical Instruments, and Recording*, and she currently participates in various projects as a curator, dramaturg, and editor.

공연
문장 부호 이어말하기

서로 다른 영역에서 활동하는 여섯 명의 창작자가 각각 10분이라는 짧은 시간 동안 자신의 영역에서 문장 부호를 다뤄 온 경험을 각자의 언어와 문법으로 공유하며 문장 부호에 관한 새로운 상상을 자극한다.

Performance
Punctuation Medley

Punctuation Medley invites six speakers who are active in diverse fields to use their own language and grammar to share how punctuation is dealt with in their respective fields. All within the 10 minutes they are each assigned, the speakers encourage the audience to imagine punctuation in a new way.

1
'점點' 하나에 울고 웃는, '월점치기'라는 '업業'
김민정(편집자 / 시인)

1
The Punctuating Work: Laughing and Crying over a Single Dot
KIM Minjeong (Poet / Editor)

2
문장 부호의 함정에 빠지지 않고 말하는 방법
이수성(성우 지망생 / 전직 작가)

2
How to Dodge Punctuative Traps While Speaking
LEE Soosung (Aspiring Voice Actor / Former Artist)

3
문장 부호의 권력: 줄임표로 처리되는 말들에 관하여
신인아(그래픽 디자이너)

3
The Power of Punctuation: On Words Omitted by Ellipses
SHIN In-ah (Graphic Designer)

4
문장 부호에 진심인 편
채희준(글자체 디자이너)

4
Quite Serious about Punctuation
CHAE Heejoon (Type Designer)

5
가사지 뒷면의 쉼표, 줄－표 / 빗금
이랑(아티스트)

5
Commas, Dashes, and Slashes on the Backside of a Lyric Sheet
LEE Lang (Artist)

6
작지만 전부 들리도록
서경수(음악가)

6
Quietly but Clearly
SEO Kyungsoo (Musician)

문장 부호 통역사. 1-2-3-4-5(디자인 스튜디오)

Punctuation Interpreter. 1-2-3-4-5 (Design Studio)

문장 부호 통역사

「문장 부호 이어말하기」에는 디자인 스튜디오 1-2-3-4-5가 '문장 부호 통역사'로 참여해 연사들의 발화나 연주에서 감지한 문장 부호를 실시간 그래픽으로 스크린에 띄운다.

1-2-3-4-5는 '문장 부호의 실제 모양은 사용하지 않는다'라는 규칙 아래 각각의 발표 내용과 짝을 이루는 문장 부호 그래픽 세트를 개발했다. 행사장에서는 이를 바탕으로 (말)소리의 간격·강약·호흡 등에서 문장 부호를 유추해 말과 음악의 흐름 사이사이에 그래픽을 얹으며 음가 없는 문장 부호를 시각화한다.

1-2-3-4-5

디자인·개발 스튜디오. 최건혁, 이지수, 정다영, 손아용이 함께 일한다. 동시대의 다양한 작업자·예술가와 협업해 프로젝트에 적합한 시각물을 제공한다.

Punctuation Interpreter

Punctuation Medley invites the design studio 1-2-3-4-5 to act as a punctuation interpreter that will graphically display the punctuations detected in the presenters' speeches and musical performances on a screen in real-time.

1-2-3-4-5 developed several sets of punctuation graphics that "do not feature the actual punctuation marks themselves" to accompany each of the presentations. Inside the event venue, the studio visualizes the non-phonetic punctuations using these graphics, inferring the punctuations based on the intervals, emphases, and rhythm of the presenter's voice or performance to insert graphics in between the flow.

1-2-3-4-5

1-2-3-4-5 is a design and development studio composed of Choi Gunhyuk, Lee Jisu, Jung Dayoung, and Son Ayong. The studio works with various professionals and artists of the contemporary era to provide visuals suited to each project.

문장 부호 이어말하기 1
'점點' 하나에 울고 웃는, '윌점치기'라는 '업業'

시인이자 편집자인 연사가 문장 부호를 쓰고 지움에 있어 그간 어떻게 작업을 해왔는지 분야별 도서의 다양한 실례를 보여주고, 각각 어떤 차이가 있는지 그 변화무쌍한 과정을 함께 좇아 나간다. 그 시간 속에서 저마다 알고 있고 쓰고 있던 문장 부호를 스스로 다시금 바라보게 유도한다.

"문장 부호는 작가와 편집자가 서로의 신뢰를 확인하는 기호다. 정해진 약속 안에서 문장 부호를 고르는 일은 신뢰를 바탕으로 한 놀음이라 텍스트 안에서 선택된 기호는 그 둘의 관계를 증명해 보이는 도구가 되기도 한다. 둘 사이가 믿음으로, 대화로 점철된 관계라면 편집자는 작가의 텍스트 속 문장 부호를 고르는 일에 제 판단을 기저로 나름의 원칙을 세울 수 있다. 작가가 찍어 온 쉼표의 자리를 줄임표로 대신할 수 있고, 작가가 찍어 온 마침표의 자리에 느낌표로 그 마무리의 감정에 호소를 더할 수도 있다. 단, 텍스트를 씹어 삼킬 정도로 편집자가 완전히 읽어 냈다는 판단하에 이 모든 일은 벌어져야 한다. 더불어 텍스트의 주인이 편집자가 아닌 작가라는 사실 또한 원고를 받아 든 순간부터 원고가 책으로 그 물성이 바뀔 때까지 잊지 말아야 한다.

Punctuation Medley 1
The Punctuating Work: Laughing and Crying over a Single Dot

By showing diverse examples of book genres, the speaker provides an opportunity to follow the changeable process of modifying punctuation to see how she has added and removed punctuation as a poet and editor, and what difference such acts have made. This encourages the audience to reflect on the punctuation marks they recognize and use in their own ways.

"Punctuation marks are symbols through which the writer and editor confirm their trust in each other. The game of choosing punctuation marks within a consensual frame of rules is built on trust, which is why certain marks selected for certain texts sometimes attest to the relationship between the writer and editor. If the relationship is built on trust and communication, the editor can rely on their judgment to establish a principle for selecting punctuation marks within the writer's text. The editor can replace certain commas with ellipses and certain periods with exclamation marks for an added appeal to emotions. But these changes should be made only when the editor is convinced that they have

반면 작가의 입장에서 텍스트 안에 찍어 넣어야 할 문장 부호를 마주할 때는 그 마음의 가짐부터가 다르다. 이를테면 자연이랄까. 나무가 자라는 이유를 우리가 분석할 때 나무의 아름다움을 느끼나. 비가 내리는 양을 우리가 가늠할 때 비의 아름다움이 커지나. 꽃이 피었다 지는 데서 우리가 통곡할 때 꽃의 아름다움이 진해지나. 다분히 절로 그러할 때의 깊은 아름다움. 스스로 그러함의 아름다움은 수라는 꾀가 백지처럼 하얗기만 할 때다. 스스로 그러함의 아름다움은 계산기 발명 같은 걸 도모할 여력을 태생부터 타고나지 않을 때다. 그렇게 온전히 제 몸에 제 몸을 실어 펜의 작두를 타는 일. 그것이 작가의 쓰기라는 행위라 할 적에 쓰고자 하는 사유로 극도로 미친 상태인 몸과 마음을 텍스트 안에서 맘껏 뛰놀게 해주는 데 있어 막다른 어떤 골목에 서거나 돌아와야 할 반환 지점에 섰을 때 저도 모르게 흔들게 되는 깃발 같은 것, 그것이 쉼표나 줄임표나 물음표나 느낌표라 했을 때 왜 거기서 붉은 기를 꽂고 왜 거기서 푸른 기를 꽂으며 왜 거기서 검은 기를 꽂고 왜 거기서 노란 기를 꽂는지 그건 작가가 설명할 수 없을 적에 더 호기심이 증폭되는 일, 설명할 수 없음이 어쩌면 흰 종이가 검은 물로 뱉을 수 있는 가장 정직한 진심이 아닐는지.

편집자든 작가든 그들 손에 쥐어진 문장 부호는 비유컨대 일종의 무구(巫具)라 할 수 있을 것이다. 순간순간 바꿔 가며 왜 그걸 쥐고 왜 그걸 흔드는지 분명한 건 책의 시작과 동시에 텍스트의 영(靈)에 붙들린 편집자와 작가는 이것이 서로에게 굿(good)이 되는 일이라는 믿음 가운데 신명 나는 한판 굿을 벌인다는 거. 세상의 거의 모든 책은 다 그 과정을 뚫고 우리에게 도착한 뜨거움이라는 거!"

김민정
편집자. 시인. 20여 년째 활자를 수저로, 종이를 그릇으로 밥상을 차려 먹으며 살고 있다. 1999년 『문예중앙』을 통해 등단해 네 권의 시집과 한 권의 산문집을 펴냈다. 1998년 잡지사 기자를 시작으로 오늘까지 문학 관련 출판 기획 및 편집자를 행하고 있다. 작고 소중한 출판사 난다의 대표다.

completely read and digested the text. From the moment the editor picks up the manuscript until it is materialized into a book, they must also never forget the fact that the text belongs to the writer and not the editor themselves.

On the other hand, the writer is in a completely different mindset when faced with the question of which punctuation mark to use in their text. The choice must come naturally, so to speak. A tree does not take on added beauty when we analyze its growth, nor does rain when we measure its amount, nor a flower when we grieve its fall. They are only so profoundly beautiful when they grow, pour, and fall as intended by nature. The beauty of a naturally derived result achieves depth only when it is devoid of tricks and wiles—that is, when it inherently lacks the capacity to devise, invent, or calculate. Like a shaman's ritual of dancing on a blade, the act of writing is like dancing with one's full weight on the blade of the pen, possessed by the will to express. And as this ritual allows the writer to freely roam within the text, punctuation marks serve the role of shamanic props, such as the 'banners of the guardian gods of five directions,' unwittingly picked up and waggled by the writer when they find themselves at a dead end or a turning point. In this sense, it is when the writer cannot explain why they chose a red flag here, a blue flag there, or a black or yellow flag here and there that the reader's curiosity is heightened. Perhaps this kind of inexplicability is the most honest form of sincerity that white paper can spit out in black ink.

For the editor and writer alike, the punctuation marks they hold in their hands are forms of shamanic tools. So, why does a shaman choose to switch to different banners at different points of a gut (shamanic ritual)? What is clear is that, at the beginning of each book, the editor and writer, possessed by the spirit of the text, lead an exhilarating gut under the conviction that it will do each other 'good,' and that almost every book in this world is a form of passion, delivered to us through this intense process."

KIM Minjeong
Kim Minjeong has dedicated the past 20 years of her life to editing and writing poetry. Debuting in 1999 through the literary magazine *Munye Joongang*, Kim has published four poetry collections and an essay book. Since her first job as a magazine journalist in 1998, she has worked as a publication planner and editor focused on literature and is the CEO of Nanda, a small but influential publisher.

문장 부호 이어말하기 2
문장 부호의 함정에 빠지지 않고 말하는 방법

Punctuation Medley 2
How to Dodge Punctuative Traps While Speaking

성우들은 대본에서 대사뿐 아니라 호흡의 양, 호흡의 속도, 호흡의 온도 같은 요소까지 읽어 내 이를 말로 재생한다. 대부분 대본을 쓴 사람과 그것을 읽고 연기하는 사람이 다르기 때문에 음악에서 악보가 그렇듯 같은 대본을 100명이 읽으면 100가지 다른 목소리가 만들어진다. 대본을 쓴 작가가 상상한 말은 과연 정확하게 재생될 수 있을까? 텍스트를 읽고 말로 재생하는 과정에서 문장 부호는 어떤 역할을 할까?

"대본을 받으면 문장 부호를 어떻게 처리할지 생각하는 데 시간을 많이 쓴다. 더빙은 화면에 입을 맞추는 작업이라 고민이 없지만 오디오 드라마라면 상황이 다르다. 대본에 느낌표가 일곱 개쯤 찍혀 있다면 그건 소리를 아주 크게 내라는 뜻일까, 아니면 내적 에너지에 관한 정보일까? 줄임표가 세 개일 때, 다섯 개 일 때, 열 개 이상일 때 그 각각의 차이는 어떻게 표현할 수 있을까?

　글에서는 의미를 정확하게 하기 위해 띄어쓰기와 쉼표를 사용하지만 그 문장을 소리

Voice actors reproduce scripts through speech by reading not only lines but also elements like the amount, pace, and temperature of breath. A scriptwriter doesn't usually voice their own script. Thus, a script, like a musical score, can be read in a hundred different voices depending on the actor. Can the words in a script be reproduced exactly as imagined by its writer? What roles do punctuation marks play in the process of reproducing text in the form of speech?

"When I receive a script, I spend hours deciding how to handle the punctuation marks. I don't worry about dubbing, which is the process of syncing dialogues with lip movements on screen, but audio dramas are different. If there are seven exclamation marks in a script, do they mean to make a very loud voice, or do they just contain information on inner energy? How do I vary my expression of ellipses when some have three dots and others have five or over ten dots?

　When writing text, we use word

내서 말할 때는 쉼표에서 쉬는 게 의무 사항이 아니고 띄어쓰기가 있어도 꼭 띄어 읽지 않는다. 텍스트를 읽어 주는 음성 합성 기술이 처음 등장했던 것도 어색했던 것도 기계는 모든 공백을 띄어 읽고 모든 쉼표에서 쉬기 때문이다. 그래서 성우의 세계에서는 '문장 부호의 함정에 빠지지 말라'라는 말을 자주 한다."

spacing and commas to articulate the meaning of sentences, but when we read it aloud, we don't need to pause at every comma and comply with word spacing. This explains why the voice generated by TTS (text to speech) technology sounded awkward at first, as machines pause between all words and at all commas. So, in the world of voice actors, we often say 'Don't be trapped by punctuation marks.'"

이수성

성우 지망생. 전직 작가. 서양화를 전공했고 십수 년간 미술 작가로 활동하며 조각과 설치 작품을 선보였다. 지금은 텍스트를 말로 바꾸는 작업, 즉 목소리로 연기하는 성우 활동을 하고자 공부 중이다. 성우라는 직업은 듣는 이의 머릿속에 그림을 그리는 작업이자 납작하게 누워 있는 활자를 일으켜 세워 살아 움직이게 하는 일이라 생각한다.

LEE Soosung

A former artist who is now an aspiring voice actor, Lee Soosung majored in Western painting in college and has created sculpture and installation works as an artist for over a decade. Lee is currently studying to become a voice actor, or someone who turns text into speech. He considers voice acting a job of drawing pictures in a listener's mind and propping up letters lying flat to make them come to life.

문장 부호 이어말하기 3
문장 부호의 권력: 줄임표로 처리되는 말들에 관하여

영화감독 라울 펙은 다큐멘터리 「야만의 역사」 (2021)에서 "역사적 서사는 모두 침묵과 뒤엉켜 있다"라고 말한다. 침묵당한, 듣지 않기로 결정한 목소리는 어떻게 들을 수 있나? 그것은 완전히 다른 방식의 듣기를, 언어를, 이해를, 세계를 요구한다.

연사는 그래픽 디자인의 서사에서 침묵을 해체해 온 여러 사례를 공유하며 과연 우리는 들리지 않는 목소리와 대면할 용기가 있는지, 그 말들을 들을 준비가 되어 있는지 질문한다.

"어떤 ……………………………… 반복한다.
…………………………………………………
반복한다.
……………………………………………………
……………… 없다.
……………………………………………………
……………… 생각하는 ……… .
……………………………………………………
…… 기다린다.
…………………… 가둬 버린, ……………
………… .

Punctuation Medley 3
The Power of Punctuation: On Words Omitted by Ellipses

Film director Raoul Peck said, "Any historical narrative is a particular bundle of silences" in his documentary miniseries Exterminate All the Brutes (2021). How can people hear a voice that is silenced, inaudible, or decidedly unheard? To do so requires a completely different hearing method, language, and understanding of the world.

Through several examples of cases in the history of graphic design in which silence was broken down, the speaker asks whether we are truly ready to face the unheard voices and what they have to say.

"A certain …………………………………
is repeated.
…… repeated ……………………………………
…………… .
There is no ……………………………………
…………………………………… .
……………………………………… thinking
………………………… .
… wait ……………………………………

신인아
그래픽 디자이너. 고양이
마크니의 반려인이자
스튜디오 오늘의 풍경을
운영한다. 돈을 잘 벌고 싶은
반자본주의자로 늘 자아
분열의 위기에 처해 있다.
카카오임팩트, 청년 허브,
여성예술인연대 등 주로
변화를 꾀하는 개인이나
조직과 함께해 왔다.

SHIN In-ah
Shin In-ah is a graphic
designer who lives
with her cat, Makkuns,
and runs the studio
Scenery of Today.
As an anti-capitalist
who dreams of making
a lot of money, Shin
is always on the verge
of an ego split. She has
mostly worked with
individuals and
organizations that
pursue change, such
as the Kakao Impact
Foundation, Seoul
Youth Hub, and the
Association of Women
Artists.

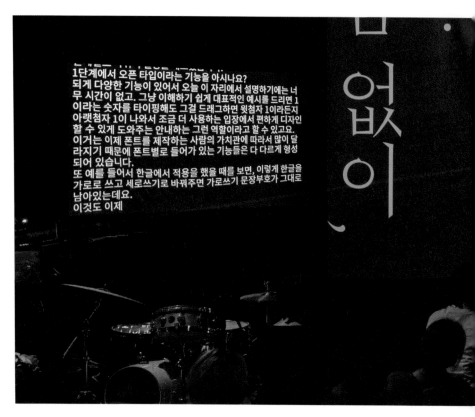

1단계에서 오픈 타입이라는 기능을 아시나요?
되게 다양한 기능이 있어서 오늘 이 자리에서 설명하기에는 너무 시간이 없고. 그냥 이해하기 쉽게 대표적인 예시를 드리면 1이라는 숫자를 타이핑해도 그걸 드래그하면 윗첨자 1이라든지 아랫첨자 1이 나와서 조금 더 사용하는 입장에서 편하게 디자인할 수 있게 도와주는 안내하는 그런 역할이라고 할 수 있고요.
이거는 이제 폰트를 제작하는 사람의 가치관에 따라서 많이 달라지기 때문에 폰트별로 들어가 있는 기능들은 다 다르게 형성되어 있습니다.
또 예를 들어서 한글에서 적용을 했을 때를 보면, 이렇게 한글을 가로로 쓰고 세로쓰기로 바꿔주면 가로쓰기 문장부호가 그대로 남아있는데요.
이것도 이제

문장 부호 이어말하기 4
문장 부호에 진심인 편

디지털 조판 시스템에서 문장 부호는 종종 능동적인 타이포그래피 재료로 활용된다. 연사는 디자이너가 텍스트를 다룰 때 고려하는 문장 부호의 타이포그래피적 역할과 함께, 폰트 제작자와 사용자의 접경 지대에서 문장 부호가 어떤 시각적 논의를 발생시키는지 말한다.

"때로 유난해 보일 수 있지만 글자체 디자이너에게는 일상적이고 당연한, 문장 부호를 그릴 때 고려하는 예민한 지점들이 있다. 가령, 편집 디자이너 중에는 인디자인에서 한글을 조판할 때 글줄이 따옴표로 시작하면 단락의 왼쪽 정렬이 깔끔하지 않아서 따옴표를 글 상자 밖으로 빼는 분들이 있다. 따옴표 뒤에 나오는 글자의 초성이 'ㅅ'이면 여는 따옴표와 초성 사이의 공백이 넓은 게 신경쓰이고 'ㅁ'이면 너무 붙어 있는 게 거슬려 미세 조정을 한다. 문장 부호를 직접 그리는 편집 디자이너도 있다. 이런 사용자들에게는 한글 폰트 안에 세로쓰기용 문장 부호가 있는 게 당연하고, 라틴 알파벳 폰트 안에도 대문자용 문장 부호와 소문자용 문장

Punctuation Medley 4
Quite Serious about Punctuation

In digital typesetting, punctuation marks are often used as an active element of typography. The speaker talks about what visual discussions are generated by punctuation marks in the borderland between type designers and users, along with the typographical roles of punctuation marks — something designers consider when dealing with text.

"Although it may seem fussy sometimes, there are some sensitive points that type designers routinely and naturally consider when designing punctuation marks. For example, when a paragraph begins with a quotation mark in Korean text, some editorial designers will take it out of the text frame in InDesign so that the left side of the text block can be nicely aligned without space. They also fine-tune the spacing between a quotation mark and certain initial consonants, as the space may seem too wide when the mark is followed by 'ㅅ' and too narrow when followed by 'ㅁ.' Some editorial designers even use self-designed punctuation

부호가 따로 있어야 한다. 글자체 디자이너로서 사용자의 이런 필요가 늘 궁금하다. 사용자들의 섬세하고 예민한 요구가 많아질수록 한글 폰트도, 한글 타이포그래피도 더 아름다워질 거라 생각한다."

marks. These types of users need Korean fonts to include punctuation marks for vertically oriented text, and Latin script fonts to include both uppercase and lowercase punctuation marks. As a type designer, I always like to know what fonts users need. I believe that as users make more and more detailed and specific demands, hangeul fonts and typography will become more beautiful."

채희준
글자체 디자이너. 계원예술대학교에서 한글 타이포그래피를 전공했다. 폰트를 생산하는 일에 집중하며 디자인 스튜디오 포뮬러의 일원으로 활동한다. 〈청월〉, 〈청조〉, 〈초설〉, 〈고요〉, 〈신세계〉, 〈탈〉, 〈클래식〉, 〈기하〉, 〈오민〉을 출시했고, 미세한 차이를 감지하고 연구하는 과정을 통해 글자체를 만드는 것을 좋아한다.

CHAE Heejoon
Chae Heejoon is a type designer who majored in hangeul typography at Kaywon University of Art & Design. Focusing on creating fonts, Chae works as a member of the design studio Formula and has launched the fonts Cheongwol, Cheongjo, Choseol, Goyo, Sinsegye, Tal, Classic, Kiha, and Ohmin. He likes to create new typefaces by detecting and studying subtle differences.

문장 부호 이어말하기 5
가사지 뒷면의 쉼표, 줄표 — / 빗금

질문. 줄글이 가사가 되려면?

답: 1. 노래 박자에 맞춰 줄글을 낭독한다.
 2. 1을 반복하며 글자 사이사이 숨 쉴 구간을 찾아 표시한다.
 3. 호흡에 맞게 단어를 바꾸거나 글자 수를 다듬는다.
 4. 줄글 위에 표시한 것들을 지우고 남은 글자만 새로 타이핑한다.
 5. 가사 완성.

이랑의 노래「세상 모든 사람들이 나를 미워하기 시작했다」의 가사 창작 과정을 시청각 자료와 함께 복기하면서 노래가 위의 과정대로 만들어졌는지 확인해 본다.

"노래를 부를 때 호흡은 가장 중요한 요소라서, 만들 때 글자 수를 잘 맞춰야 한다. 호흡에 맞게 말을 맞추고 어디서 숨을 쉴지 표시하고 그 과정들을 기록하는데 이때 문장 부호를 많이 쓴다. 가사는 시와 비슷하다. 가사에는 문장 부호가 거의 없지만 그 대신 호흡에 맞춰 줄 바꿈을 한다. 무대에 서면서 알게 된 사실은, 공연을 할 때 긴장하면 숨이 짧아져서

Punctuation Medley 5
Commas, Dashes, and Slashes on the Backside of a Lyric Sheet

Question: How can prose become lyrics?

Answer: 1. Recite a prose piece to the rhythm of a song.
 2. While repeating 1, find and mark breathing points between letters.
 3. Change words or adjust word count based on the breathing points.
 4. Erase the marks on the prose piece and type the remaining letters anew.
 5. Complete the lyrics.

By looking at singer-songwriter Lee Lang's process of writing the lyrics for Everyone in the World Began to Hate Me through audiovisual materials, the audience can verify whether the song was written through such a process.

"As breathing is one of the most crucial elements in singing a song, counting syllables is important in songwriting. I use punctuation marks a lot when arranging phrases to match my breath, marking breathing points, and making notes of

가사를 만들 때 정해 둔 숨구멍을 따라가지 못할 때가 있다는 것이다. 긴 노래는 숨구멍을 찾는 일이 아주 중요하다."

such details. Lyrics are similar to poems. There is little punctuation in them, but their lines break according to the rhythm of the breath. What I have learned from performing on stage is that when I'm nervous, my breath becomes so short that I can't adhere to the breathing points that I set for myself when I wrote the lyrics. For longer songs, determining breathing points is all the more important."

이랑
아티스트. "한 가지만 하라"라는 말을 많이 듣는 사람이지만 한 가지 일만으로는 먹고살기 어렵기 때문에 다섯 가지 정도의 일을 하고 있다. 정규 앨범 『욘욘슨』, 『신의 놀이』, 『늑대가 나타났다』를 발표했고, 지은 책으로 『대체 뭐하자는 인간이지 싶었다』, 『오리 이름 정하기』, 『좋아서 하는 일에도 돈은 필요합니다』 등이 있다. 이랑은 본명이다.

LEE Lang
Lee Lang is an artist who often told to "do just one thing," but has around five jobs as a single job is often insufficient to make a living. Lee has released three full albums—Yon Yonson, Playing God, and There Is A Wolf—and published books including *Who Do You Think You Are*, *How To Name The Duck*, and *A Job That I Enjoy Doing Also Needs Money*. Lee Lang is her real name.

문장 부호 이어말하기 6
작지만 전부 들리도록

드럼은 두드려 소리를 낸다는 점에서 가장
원초적인 악기다. 밴드에서 드럼은 흔히 멜로디
악기를 보조한다고 여겨지지만 리듬을 주도하는
드럼의 박자가 흔들리면 연주 전체가 흔들린다.
바로 그런 점에서 드럼은 단어와 단어 사이에
맥락을 부여하고 서술의 리듬을 관장하는 문장
부호와 닮아 있다. 「문장 부호 이어말하기」의
피날레는 때때로 모호하고 부정확한 언어 대신
너무 명확해서 오히려 언어가 되지 못하는* 음악,
그중에서도 재즈 드럼의 독백으로 행사장의
공기를 서술한다.

"드럼을 작은 소리로 속삭이며 말하듯 연주한다.
타악기의 울림을 최소화하면 작은 글자가 그렇듯
공간에 여백을 만든다.
　　'개미가 기어가듯이 작게 드럼을 칩시다.'
　　한 아이는 갸우뚱했고 다른 아이는
(속삭이며) 개미가 기어갈 때 소금 떨어지는
소리가 난다고 했다. 악보를 펼쳐 하얀 소금을
떨어뜨려 보진 않았지만 왠지 말렛(mallet)으로
몽실몽실, 간지럼을 태우듯 아기자기한 연주를

Punctuation Medley 6
Quietly but Clearly

A drum is the most primitive musical
instrument in that it is beaten to make
sounds. In a band, a drum is often
considered an assistant to melodic
instruments, but if a drummer cannot
choose the correct rhythm and keep time,
the band loses balance. In this regard,
a drum is similar to punctuation, which
provides context between words and
controls the rhythm of narratives. Rather
than language, which is sometimes
ambiguous and imprecise, the finale of
Punctuation Medley describes the
atmosphere of the venue through a jazz
drum solo—a kind of music considered
too precise to be a language.*

"I play the drum quietly as if I'm whispering.
Minimizing the resonance of percussion,
like using small fonts, makes room for
negative space.
　　'Let's play the drum quietly,
like crawling ants,' I told some children
I was teaching.
　　One child tilted their head while
another said softly that when ants

하고 싶다. 10분의 시간 동안 공간을 채울 타악 소리들은 행진곡 비슷하겠지만 곡이 아닌 그저 행진하는 소리로 전달될 수 있다."

crawl, they make the kind of sound that salt makes when it's sprinkled. I have never tried sprinkling salt on sheet music, but the description makes me want to roll my mallets like they're feathers. The percussion that will fill the space during the 10 minutes of provided time might sound like a march, but instead of a musical piece, the sound could be delivered just as a marching sound."

*

위화, 『문학의 선율』, 음악의 서술, 문현선 옮김(푸른숲, 2019), 371.

서경수

음악가. 재즈 음악을 기반으로 연주를 시작했다. 처음에는 재즈가 일부러 비켜나는 음악인 줄 알고 반했는데 너무 체계적이라 놀랐고 지금도 계속 놀라고 있다. 추상적인 결말을 좋아하고 우연이 만든 즉흥성에 관심이 많다.

O와 X로 이뤄진 악보가 좋고 앞에서 보면 위아래를, 옆에서 보면 원을 그리는 자세가 좋다. 드럼에 한정한 이야기다. 하고 있는 여러 일 중에 아이들에게 드럼을 가르치는 일이 있다.

*

Hua Yu, *Melody of Literature, Description of Music*, Korean edition, trans. Mun Hyeonseon (Prunsoop, 2019), 371.

SEO Kyungsoo

Seo Kyungsoo is a musician who began his career with jazz. At first, Seo believed that the genre intentionally avoids precision, but he was—and still is— shocked that it is so systematic. He likes abstract endings and is interested in improvisation created by accidents. He has a fondness for musical scores comprising Os and Xs and the drum-playing motion, which looks like a vertical motion from the front but is actually a round motion when seen from the side. One of his many jobs is to teach drumming to children.

타이포잔치 2023
국제 타이포그래피 비엔날레 《따옴표 열고 따옴표 닫고》

예술 감독
박연주
큐레이터
신해옥, 여혜진, 전유니
협력 큐레이터
김쥬리
코디네이터
이주현
**공간 설계·가구
디자인·설치**
중간공간제작소
(김건태, 민덕기, 장기욱)

설치 도움
강혜경, 길아름, 김광철,
김미소, 김병구, 김보경,
김준형, 나희원, 박서진,
이범항, 이영석, 임예찬,
최인혜, 허나경

전시 아이덴티티
프론트도어
**도록·웹 사이트·부클릿
편집**
전유니, 이주현, 이정신
**도록·웹 사이트·부클릿
디자인**
프론트도어
번역
서울리딩룸(박재용)
웹 사이트 개발
문정주
자막·모션 디자인
와우산 지키미
사진·영상
글림워커스

미디어 설치
올미디어
작품 운송
솔로몬아트
시공
새로움아이
운영
에스씨지엠

Typojanchi 2023
International Typography Biennale — Open Quotation Marks, Close Quotation Marks

artistic director
PARK Yeounjoo
curators
JEON Yuni
SHIN Haeok
YEO Hyejin
associate curator
Julie KIM
coordinator
LEE Juhyun
**space design, furniture
design, and Installation**
In-between
Space Works:
KIM Guntae
MIN Dukki
JANG Kiwuk

installation assistants
CHOI Inhye
GIL Ahroom
HEO Nagyeong
KANG Hyegyeong
KIM Bokyoung
KIM Byeong Gu
KIM Joonhyung
KIM Kwangcheol
KIM Miso
LEE Beomhang
LEE Youngseok
NA Heewon
PARK Seojin
RIM Yechan

exhibition identity
front-door
**catalog, website, and
booklet editing**
JEON Yuni
LEE Juhyun
LEE Jeongsin
**catalog, website, and
booklet design**
front-door
translation
Seoul Reading Room:
Jaeyong PARK
website development
MOON Jungju
**subtitles and motion
design**
Wau Mountain
 Guardian
photography and video
gilmworkers

media technology
All-media
**transport and art
handling**
Solomon Art
construction
Saeroum i
operation
SCGM

2023년 9월 19일(화)–10월 14일(토)
문화역서울284

주최
문화체육관광부
주관
한국공예·
　디자인문화진흥원
국제 타이포그래피
　비엔날레 조직위원회

협력
국립한글박물관
한국타이포그라피학회
조직위원회
유정미
장동광
김영수
김홍필
최슬기
안병학
이재민
김광철
사무국
류경진
이홍규
황동호

프로젝트 파트너
『그래픽』
한국영상자료원
전주국제영화제

후원
두성종이
네덜란드 크리에이티브
　인더스트리즈 펀드
우아한형제들
주한 네덜란드 대사관
안그라픽스
일본국제교류기금
　서울문화센터
대만 국가문화예술기금회
미디어 후원
네이버
월간 〈디자인〉
비애티튜드

September 19 (Tue.) – October 14 (Sat.), 2023
Culture Station Seoul 284

hosted by
Ministry of Culture,
　Sports and Tourism
organized by
Korea Craft &
　Design Foundation
Organizing Committee
　of International
　Typography Biennale

in cooperation with
National Hangeul
　Museum
Korean Society of
　Typography
organizing committee
YU Jeongmi
CHANG Dong-kwang
KIM Young-soo
KIM Hongpil
CHOI Sulki
AHN Byunghak
LEE Jaemin
KIM Kwangchul
administration office
RYU Gyeongin
LEE Hongkyu
HWANG Dongho

project partners
GRAPHIC
Korean Film Archive
JEONJU International
　Film Festival

sponsors
Doosung Paper
Creative Industries
　Fund NL
Woowa Brothers
　Corp.
Embassy of the
　Kingdom of the
　Netherlands
Ahn Graphics
The Japan
　Foundation, Seoul
National Culture and
　Arts Foundation
media sponsors
NAVER
Monthly Design
BeAttitude

GRAPHIC

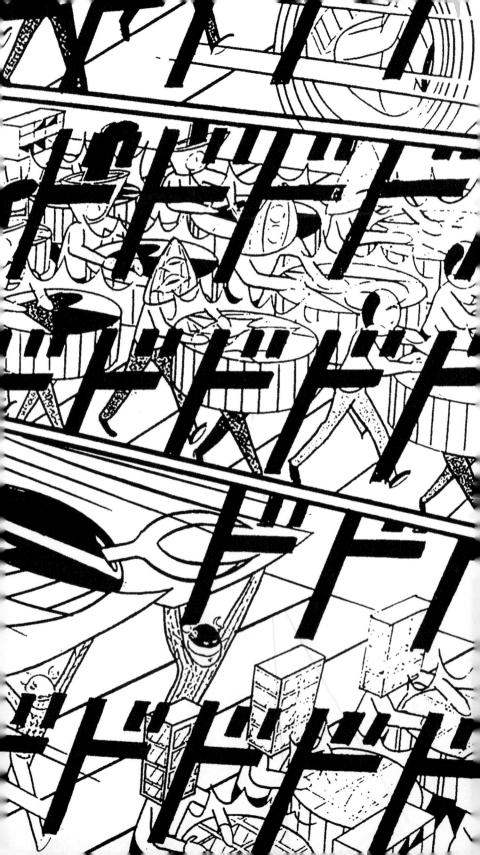